Introduction

By Alice Snape

I've always been fascinated by people and enjoyed glimpsing them from afar, spying on what they're up to. When I travel to a new city, my favourite thing to do is to find a little café and sit sipping a cup of coffee, watching the world go by. I love looking at what someone has chosen to wear or their hair colour, wondering why I might be drawn to that person's particular style, the way they walk or hold themselves. I make up little stories about them in my mind – perhaps they are on their way to a meeting, to call on a friend, to hang out at the park or to go to work? This fascination is why I fell in love with street-style photography. I love that it captures a moment, a city, a person, at that exact point in time. Street-style photos tell a story – tiny but complete – of a place and the people in it.

As a heavily tattooed woman, I also, of course, can't help but notice the ink on people's skin. When my ink is hidden under sleeves and trousers, people often say they would never suspect I was tattooed, as I don't look 'the type'. In some cases, stereotypes influence their judgement, or perhaps fear of the unknown, but the assumption seems to be that tattoos are for ruffians, thugs or prostitutes. But I love tattoos because they are inclusive, they're for everyone. Tattoos have no 'type'. Male, female, fat, thin, tall, short – none of it makes a difference. It doesn't matter if you work in a hospital, shopping mall or an office. You can choose when, where or how you get tattooed. And each person makes an individual choice about how they want to dress, whether to hide their ink away, allowing it to discreetly poke out of a trouser leg, or keep it fully on show – as you will discover over the following pages.

Maybe you got tattooed just for you – to mark a moment in time – never wanting to show another soul. Perhaps you got tattooed as an extension of your personal style, using tattoos to enhance the clothes you wear. Or perhaps you don't give a damn about either, and your tattoo journey is a spiritual quest to discover something deeper about yourself. This book explores it all, capturing the people and the motives behind the tattoos.

For me, I have become much more confident in my own sartorial choices since I started putting ink into my skin. My tattoos make me more confident. I no longer see the imperfections; I see beautiful designs that tell a story of my life journey – my evolving tastes, my everlasting loves, my memories. I also love that I can now wear a simple outfit, such as jeans and a T-shirt, and still feel like my individual style and personality shine through. I have even been complimented on my amazing 'patterned tights', when I was wearing sheer black deniers. I love that tattoos can change a simple outfit and elevate it to a completely new level.

Each tattoo brings back a memory of when and where it was done. When I went to NYC with my husband, I booked in to get tattooed by Cris Cleen at Saved Tattoo. Not only did I love his designs, I loved his whole attitude towards tattooing. When he goes to work, he puts on a smart outfit to convey his professionalism and his respect for his customers. I had thought I was only going to get one piece from him, but I fell in love with two designs in his book, so I got them both. Cris then kept the studio open late for my husband to get tattooed too, even though he hadn't booked in. We spent the evening chatting and hanging out,

in a moment of unexpected friendship. My husband and I both still love our tattoos five years later, and will forever cherish that NYC memory. You can find Cris Cleen and his classic dress sense in the pages of this book, along with a host of fashionable, iconic and fiercely individual men and women.

What I have loved about writing this book is not only capturing a sense of each city, but also working with different photographers in each location, whom we briefed to capture their city through their own lens. The result doesn't just provide a snapshot; it communicates a particular vision, with each photographer contributing his or her own unique style and interpretation of what 'street style' looks like.

Alongside the imagery, I have so enjoyed delving further into what motivates each of the people we've photographed, and gathering snippets of their life stories. In this volume of *Tattoo Street Style*, I'll introduce you to some prominent figures in the tattoo world, such as Wendy Pham in Berlin, Angelique Houtkamp in Amsterdam and Grace Neutral in LA. But we've also spoken with regular inhabitants of the eight cities we have featured – people I would never have discovered if I hadn't written this book, everyone from students to stylists, curators to copywriters. In my everyday life, I often wish I could stop people in the street and find out more about them – this book has given me the chance to do just that. In Amsterdam, Loena Maas, who is trans, shared that her tattoos have helped her get power back over her own body. Berlin stylist Flora Amelie Pedersen talks honestly about occasionally questioning her decision to become heavily tattooed, a revelation you wouldn't expect from someone who portrays such confidence. For Laurence

Sessou, in Brighton, tattoos and scarification represent a months-long spiritual journey. Nick Rutherford, of Melbourne, told us his tattoos were 'hand-poked drunk' in his mate's kitchen.

I invite you to flick through these pages and take a glimpse at tattoo culture today. Look closely. Are the matching tattoos we captured exactly the same? Or are there slight differences due to placement and skin type? Or do tattoos look different because of the outfit that individual has chosen to wear on the day we took their portrait? Do tattoos look different in LA to how they do in Amsterdam? Is style different in Melbourne and Brighton? Can you spot similar style statements in Paris and London?

It has been a joy to curate this compendium of tattoos and fashion in eight of my favourite places around the world – cities I have lived in, loved spending time in and dream of returning to. I love that it will immortalise this period in time. I love that, one day, someone will look at it as a historical document, in the way that I have looked at old photos of tattooed women from the 1940s. What feels so thoughtfully current now as you flick through the pages will one day be but a memory of our own moment in time.

As we travel around the eight cities in this book, I hope it will provide endless inspiration for you to continue on – or perhaps even start – your own tattoo journey. And whatever the motivation behind the ink, it doesn't matter – the tattoos you collect are always just for you, even if you choose to wear something that reveals them completely to the world.

– *Alice Snape*

London, beautiful London. The capital of the UK and, arguably, the creative capital of tattoo culture. It's a city that somehow manages to combine historical grandeur with contemporary edge, and a healthy dose of grit. A city where many people have fallen in love with tattooing. It's a vibrant, diverse place to live or visit – and there are so many wonderful places to get tattooed, with a multitude of talented artists to create intricate works of art on your skin. Tattoo collectors travel from all over the world to get tattoos from artists in the metropolis. Styles are eclectic, and a tattooed arm poking out of a jacket or a delicate inking popping out of a trouser leg is commonplace. It is the perfect city to begin our round-the-world journey capturing tattoo street style. Tattoos and fashion are woven into the fabric of the city; from academics and bakers to bloggers and designers, London is full to the brim of stylishly inked characters. This is London's tattoo scene.

London

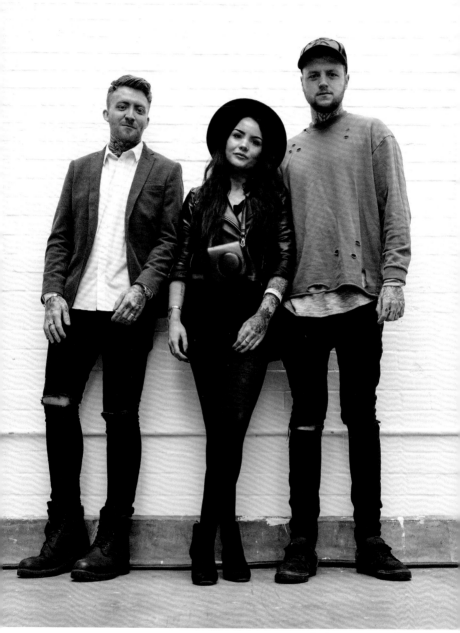

Joshua Atkinson ↙
Tattooist at Body Art
by Design
Spotted: Tattoo
Collective London
Style: Traditional
Tattoo by Billy Parsons,
Body Art by Design

Kirsty King ↓
Executive Complaints
Spotted: Tattoo
Collective London
Style: Geometric
Tattoo by Billy Parsons,
Body Art by Design

Billy Parsons ↘
Tattooist at Body Art
by Design
Spotted: Tattoo
Collective London
Style: Traditional
Tattoo by Joshua Atkinson,
Body Art by Design

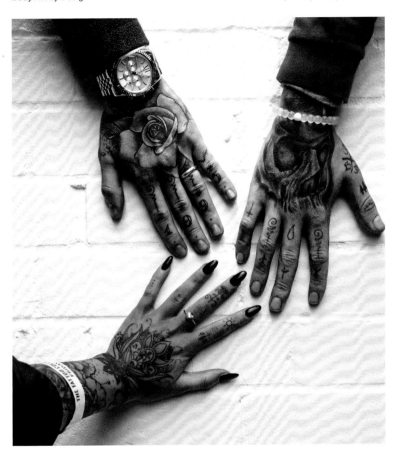

Monami Frost
Entrepreneur
Spotted: Tattoo Collective London
Style: Dark Trash Realism
Tattoo by Anrijs Straume,
Bold As Brass

'I am always positive; that is my mindset for everything. I like everything to be perfect all the time.'

– Monami Frost

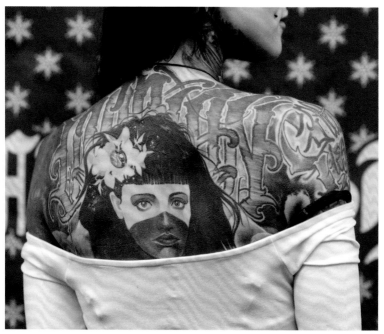

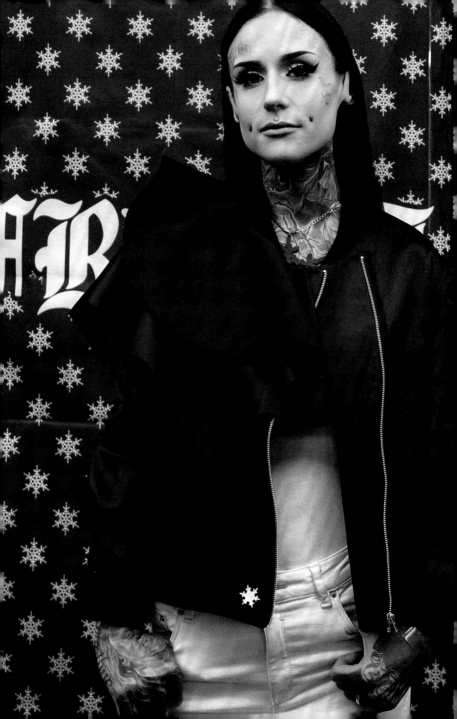

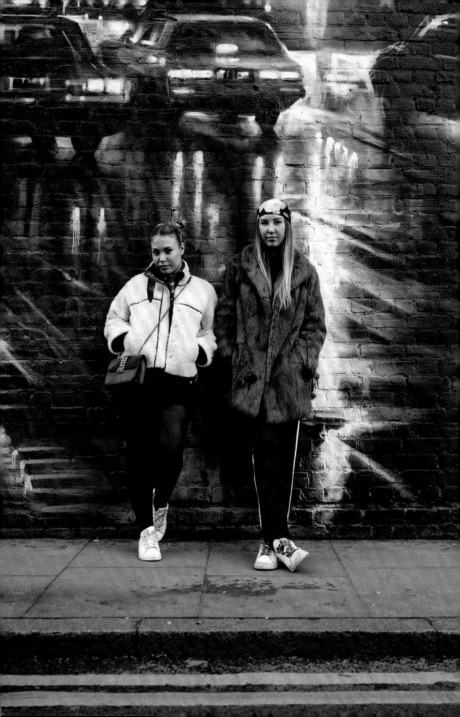

Nais Demaraus ↙
Student
Spotted: Brick Lane

Leusa Forsyth ↘
Student
Spotted: Brick Lane

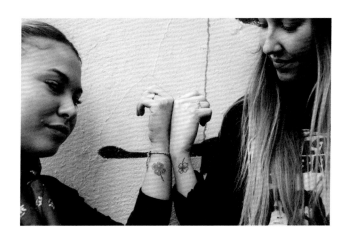

↓ Jessie Paddick
Cake Creator
Spotted: Absolutely Vintage,
Brick Lane

→ Rachel Peppiette
Bar Manager
Spotted: Tattoo Collective London
Style: Japanese

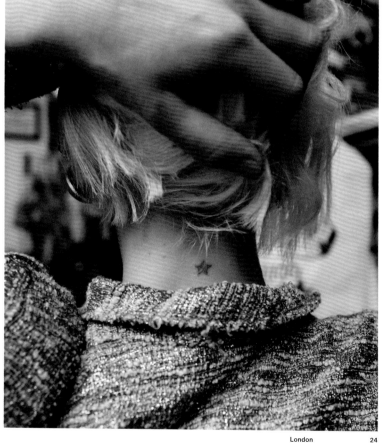

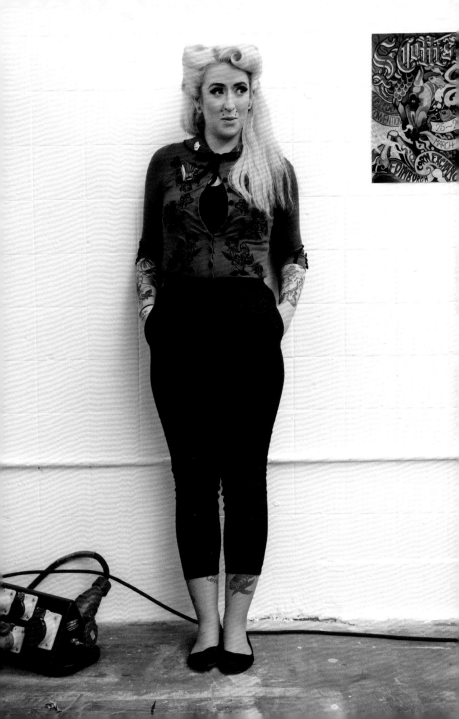

Jondix
Tattooist at Seven Doors
Spotted: Tattoo Collective London
Style: Traditional
Tattoo by Filip Leu,
The Leu Family's Family Iron

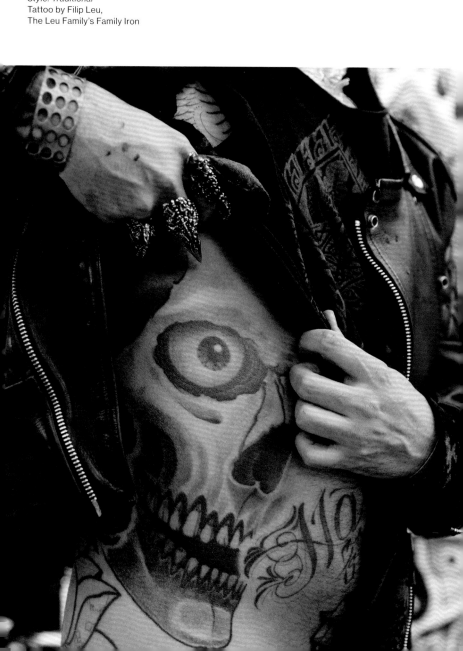

Luke Hallows
Barber
Spotted: Tattoo Collective London
Style: Japanese
Tattoo by (scissors) Jake
Applegate, Dead Slow and
(head) Ade, Axios Tattoo Studio

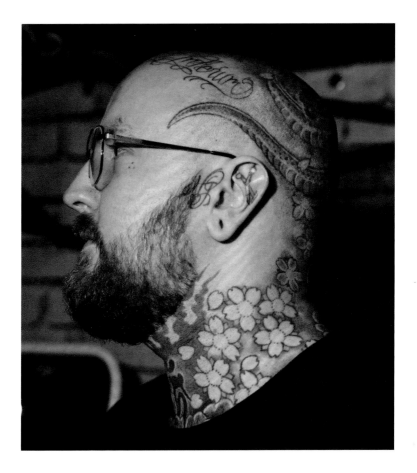

Alice Snape
Editor
Spotted: Brick Lane

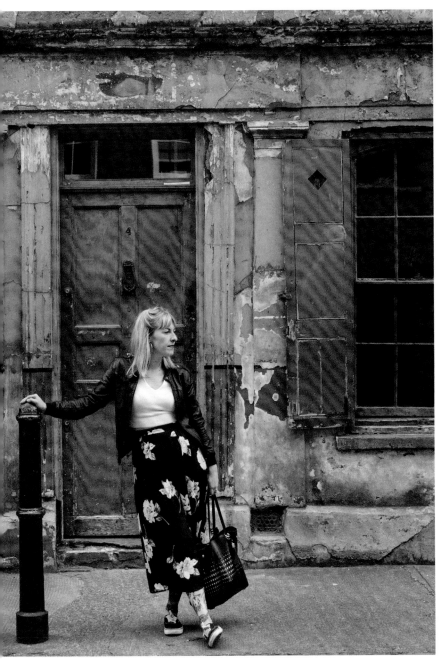

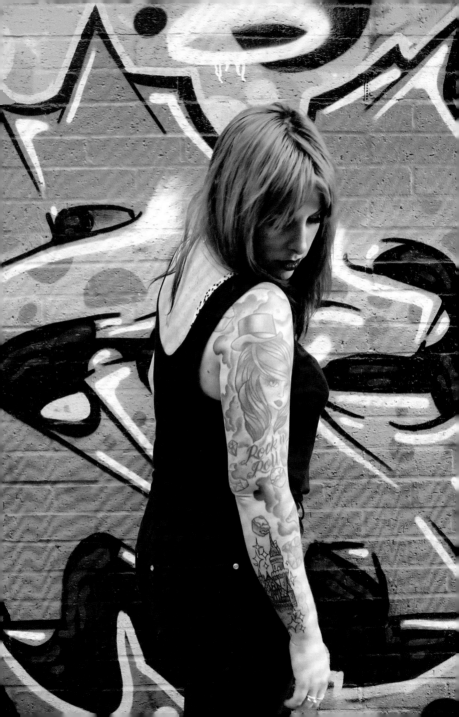

Kat Williams
Editor of *Rock 'n' Roll Bride*
Style: Neo-Traditional
Tattoo by Ashlea Peach

'I'm a wedding blogger and my
advice to tattooed brides-to-be
is: be proud of your ink. Your
tattoos are part of who you are,
so why would you cover them
up on one of the most important
days of your life?'

– *Kat Williams*

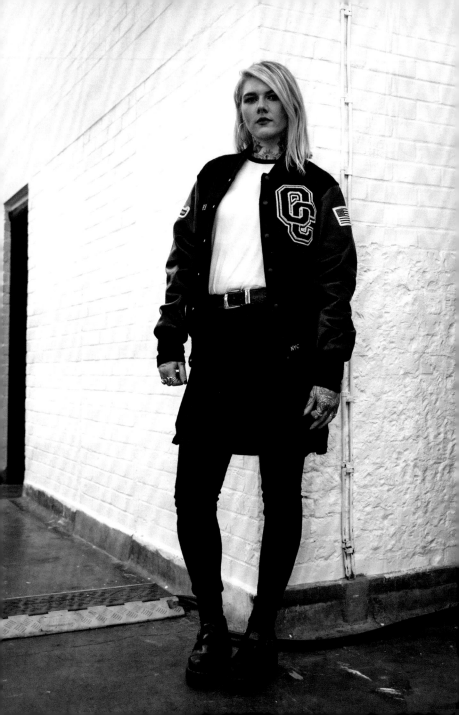

Nicola Mary Wyatt
Fashion Designer
Spotted: Tattoo Collective London
Style: Dark Illustrative
Tattoo by Kelly Violet,
Parliament Tattoo

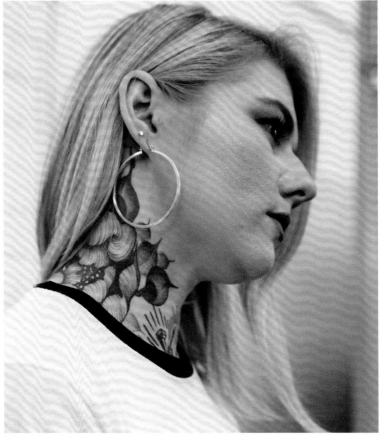

James Redfern
Barber
Spotted: Tattoo Collective London
Style: Traditional
Tattoo by Matty D'Arienzo

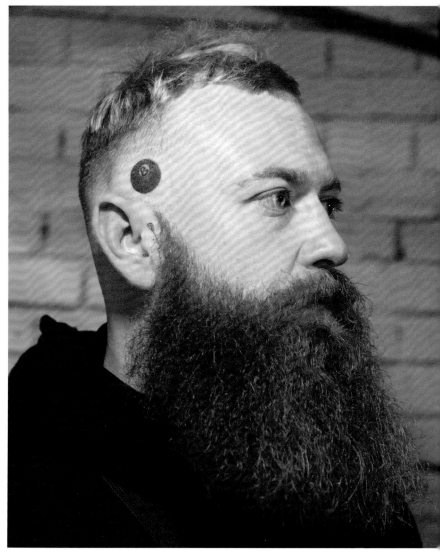

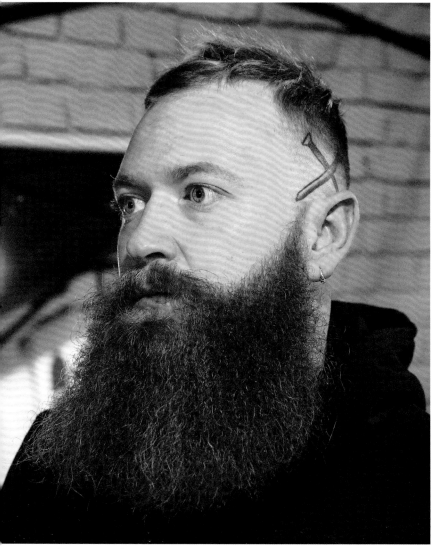

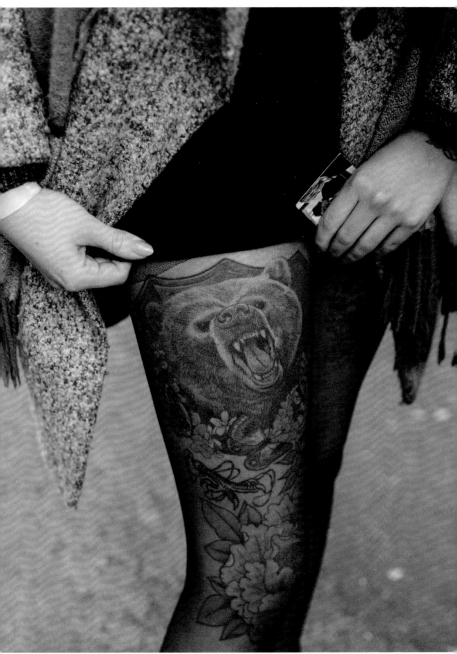

Freya Smyth Callard
Tattooist at Epona Art
and Tattoo
Spotted: Brick Lane

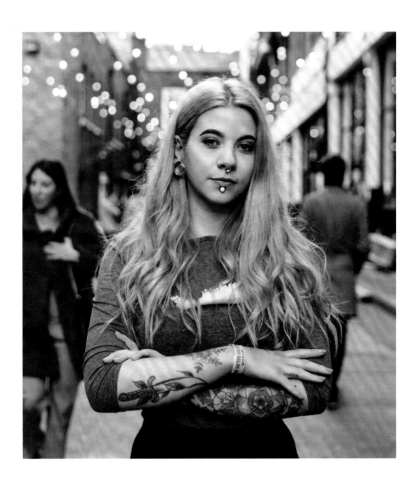

FILL TO THIS LEVEL

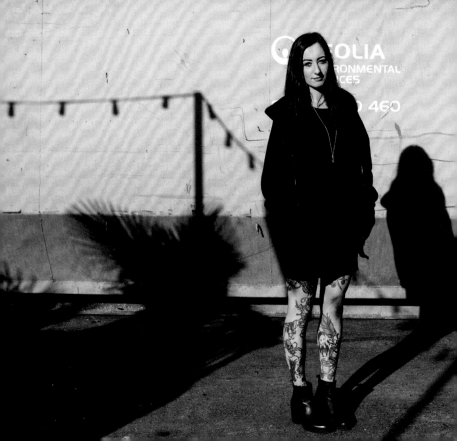

NO FIRES

Holly Montana Devine
Manager at Love Hate
Social Club
Spotted: Brick Lane

↓ **Ze Aya**
Assistant at Good Times Tattoo
Spotted: Tattoo Collective London
Tattoo by Jose Vigers

→ **Jessica Alviani**
Visual Merchandiser
Spotted: Blitz, Hanbury Street

'I enjoy collecting work from artists I like. I let them do what they want – that's how they create the best work.'

– *Ze Aya*

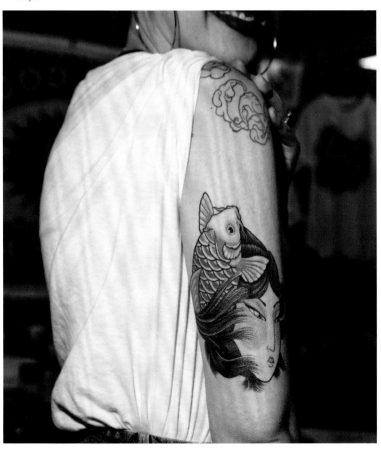

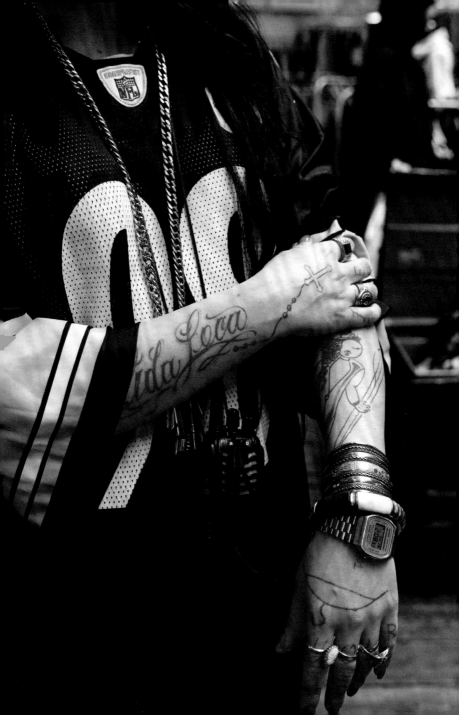

Keely Rutherford
Tattooist
Spotted: Brick Lane
Tattoos by Philip Yarnell,
Skynyard Tattoo

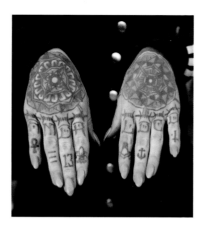

I've always been into art and dreamed of a career where I could be creative. When I was younger, I started getting tattoos here and there – they were all horrendous, though. That's when I thought, one day I'd love to be a tattoo artist myself.

Tattoos have most definitely become part of who I am. The tattoo world consumes me; I live and breathe tattoos. I'm so grateful to have this lifestyle. I can travel all over the world, making tattoos and seeing lots of different cultures and places.

The way I dress and the way I tattoo is cute and colourful. My work is traditional, so it's bold and bright. And the way I dress … well, I'm originally from Essex, so I would describe it as 'trashy chav'. I love tattooing food, castles and scenes in hearts. I'm super lucky as my clients all have amazing imaginations, so every tattoo I create is fun and enjoyable.

Right now, Blackwork and Prison-style tattoos are trendy with the hipsters. But I'd like to think that a good, solid tattoo, no matter what the subject matter, is going to stand the test of time. That being said, originality is important. People casually ripping off other artists' work is not acceptable. It's lazy and disrespectful to the artist and to the client who has paid to have a custom piece.

I detest it when non-tattooed people ask the following questions:
'Do they go all the way down?'
'What about when you're old?'
'What do they mean?'
Eff off!

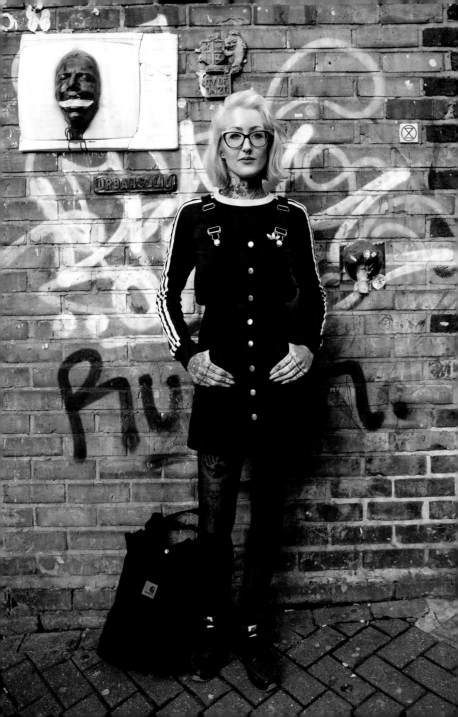

Laura Oakes
Designer
Spotted: Tattoo Collective London
Style: Traditional
Tattoo by Madam Butterfly's

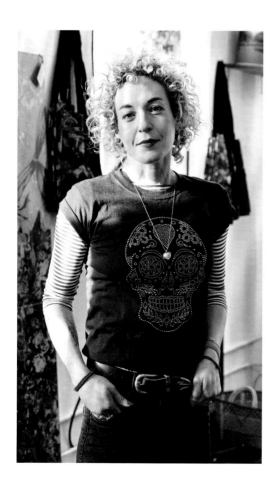

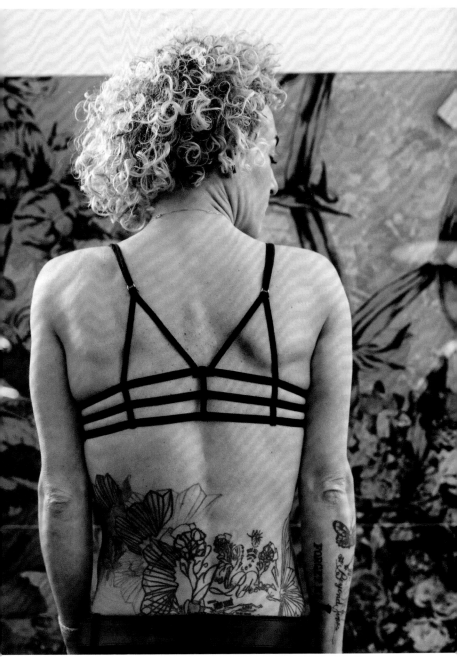

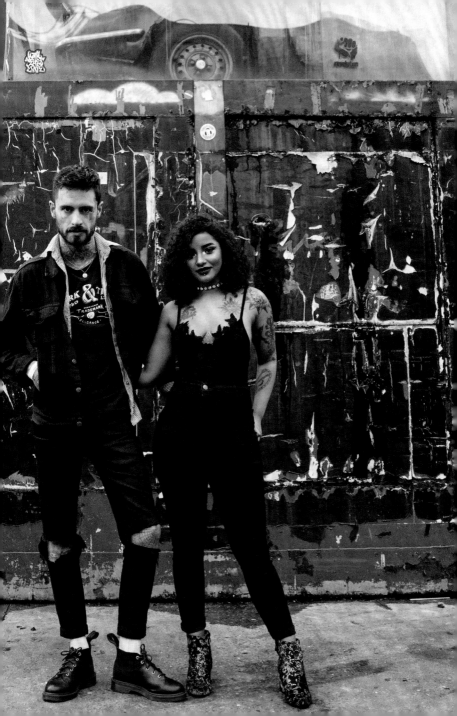

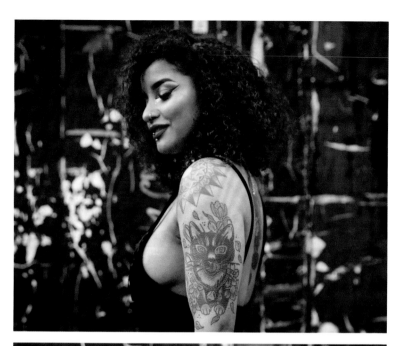

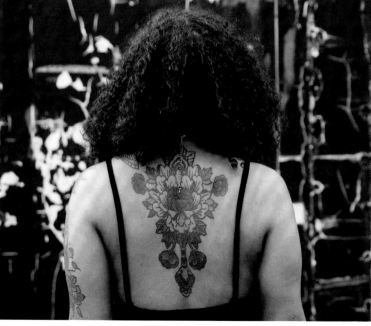

← Rianna Anoff
Make-up Artist
Spotted: Brick Lane
Style: Neo-Traditional
Tattoos by (cat) Dean Smith,
Kat Walk Ink and (back) Max
Rathbone
←

↓ Dean Smith
Tattooist at Kat Walk Ink
Spotted: Brick Lane
Style: Traditional
Tattoos by Gary Sutton
←

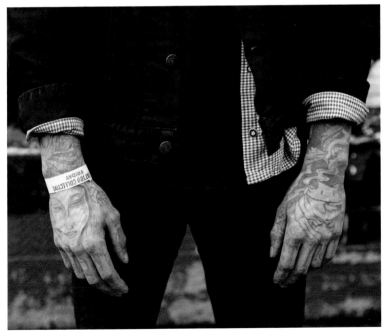

Vüdü Dahl
Make-up Artist
Spotted: Tattoo Collective London

'My neck is a moth and butterfly
mixed together. It represents life
and death. You can't have one
without the other.'

– *Vüdü Dahl*

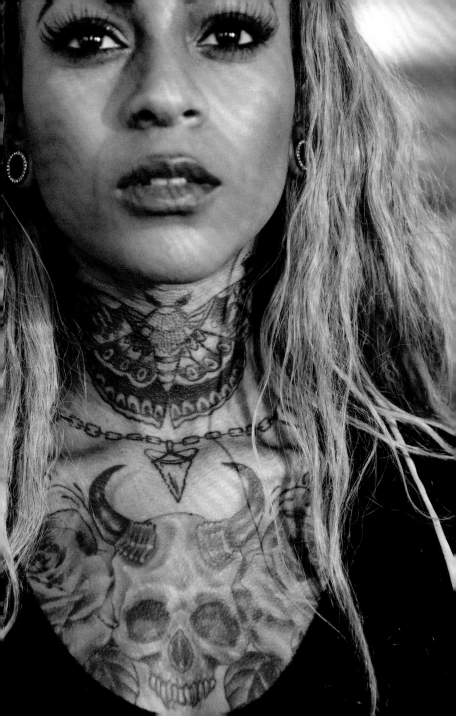

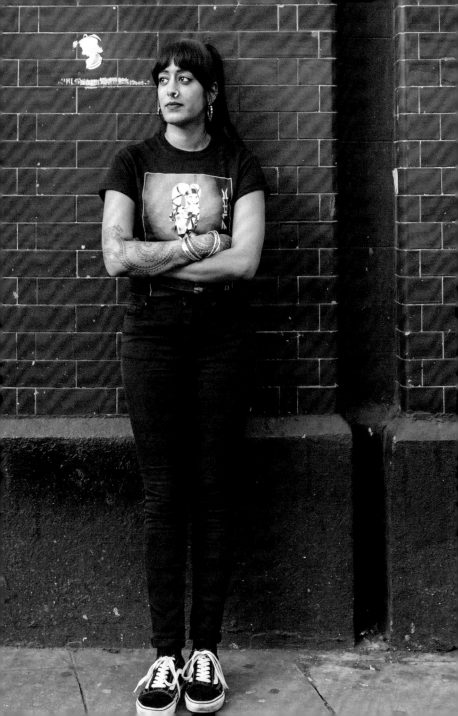

Manni Kalsi
Tattooist
Spotted: Brick Lane
Style: Mehndi
Tattoo by Saira Hunjan

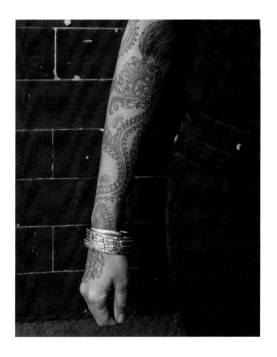

Rosey Jones
Visual Artist
Spotted: Brick Lane

'Who doesn't love looking nice
without having to make an
effort? They just make me feel
so much more confident.'

– *Rosey Jones*

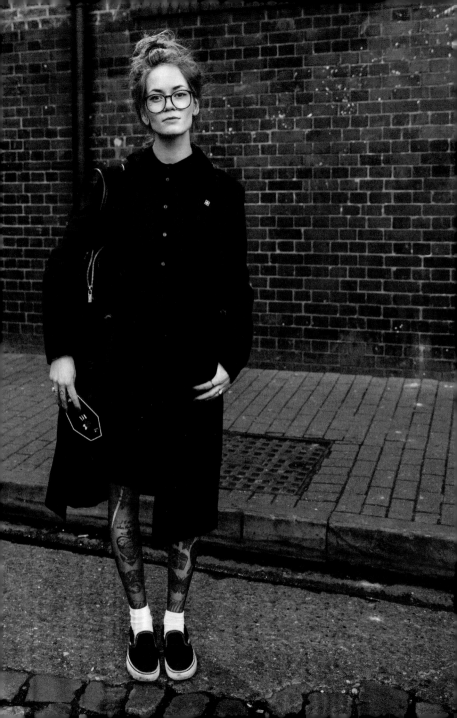

Lizzy Guy
Assistant Editor at *Total Tattoo*
Spotted: Tattoo Collective London
Style: Traditional
Tattoo by Alex Whiley,
Hope & Glory Tattoo

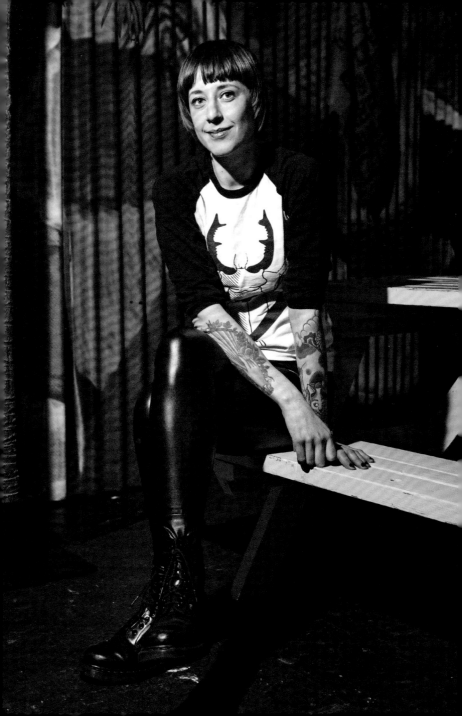

Bethany Rutter
Social Editor at navabi.co.uk
Spotted: Walthamstow

I wasn't that interested in tattoos before I started really reflecting on what I wanted my image and identity to be. I guess for a long time I only knew people with what I perceive to be bad tattoos. But then, at some point, I was getting to know interesting people and found myself really excited by their tattoos and the choices they had made in style and image and artist.

I definitely feel much more into my body now I'm tattooed. I don't know if they're part of who I am as a person but they've made my body the body I want to have.

My style is quite varied but generally revolves around colour and print – eye-catching stuff without being overtly feminine. There's always something that brings it down from being extremely high femme.

I set up a blog on fat fashion, archedeyebrow.com, because I felt like there was room for my style, my image, online. I read the plus-size fashion blogs that were around at the time, pre-2011 when I set mine up, and loved them, and felt like I had something to add to that conversation. It speaks to anyone who's interested in clothes or bodies or women.

I don't think you can live a really satisfying life if you're not in touch with who you are, whether or not you're able to fully embrace it yet. If you're not confident in your body, that's OK – you're more than your body. But if you want to feel more at ease with people's eyes on you, it helps to see your body as one in a million bodies just like it by following women who have bodies like yours. The internet is so great for that and it opens you up to a whole world of people who can form part of your community. It shows you body types that the mainstream media absolutely never will.

I'll definitely get more tattoos, but I'm now trying to slow myself down to one a year. I have about 13 now and am trying not to cover all my prime real estate before I'm 30 because I know I'm going to have cool ideas constantly for the rest of my life and need skin to put them on!

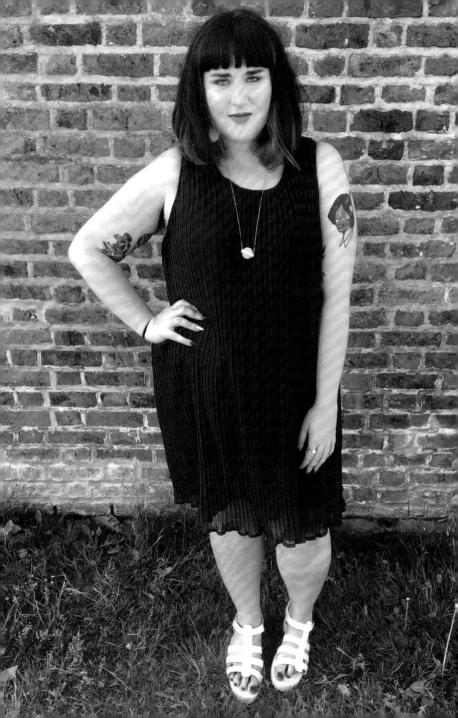

Lucy Korzeniowska
Art History Student/
Gallery Worker
Spotted: Near Old Street
Style: Illustrative

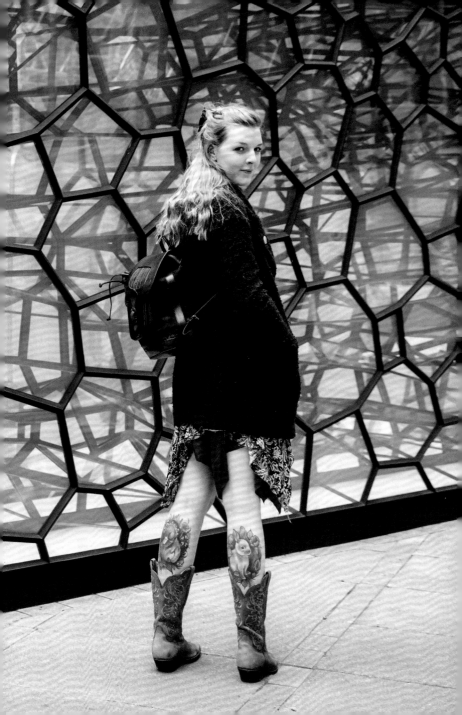

↓ Sian Rusu
Business Owner
Style: Realism/Watercolour
Tattoos by (right arm) Den
Yakovlev, Negative Karma
and (left arm) Radu Rusu,
Atelier Four

→ Charissa Gregson
Tattooist at Bath Street
Tattoo Collective
Spotted: Tattoo Collective London
Style: Japanese/Neo-Traditional

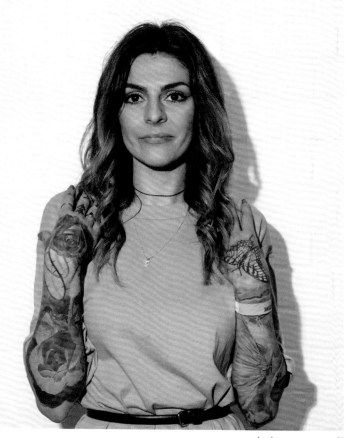

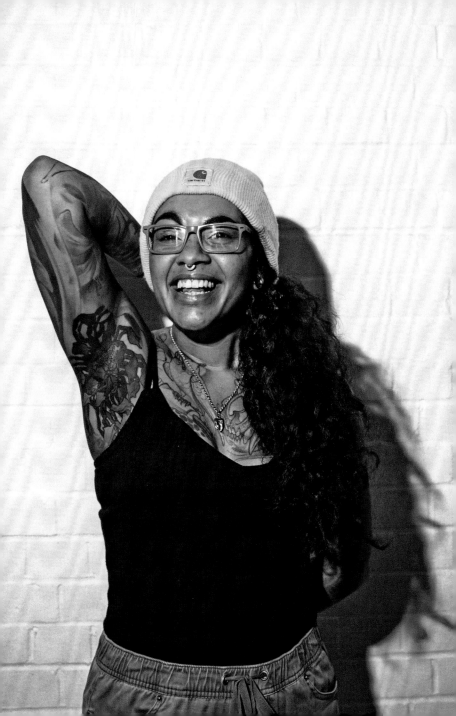

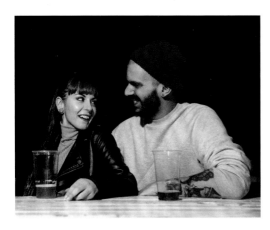

←→ **Valentina Fenu**
Make-up Artist
Style: Traditional

←↓ **Stefano Abagnave**
Tattooist at Inkfact
Tattoo Studio
Spotted: Tattoo
Collective London
Style: Traditional
Tattoo by Gianmavro Spanv

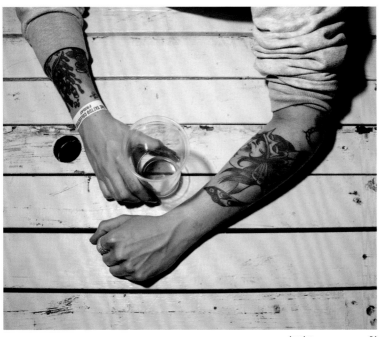

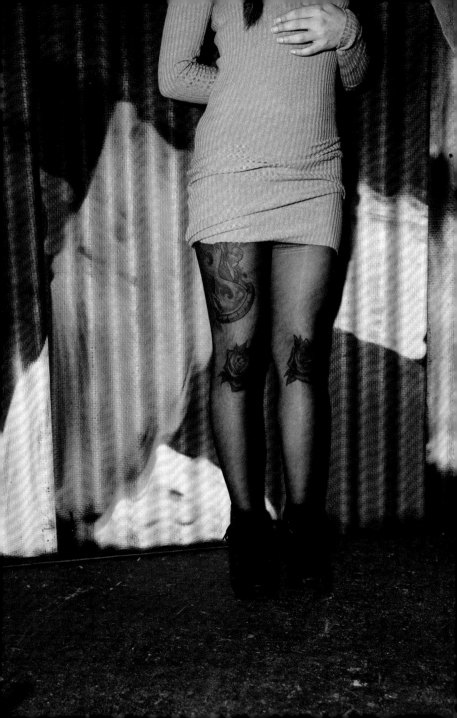

Matt Lodder
Lecturer, University of Essex
Style: Old-School/American
Traditional
Tattoo by Peter Lagergren,
Malmö Classic Tattooing

Surely everyone remembers their first tattoo, don't they? When I was growing up, I always got told two cautionary tales: one was about my great-grandmother, who'd been tattooed around the turn of the century by her brother, who'd brought a tattoo machine home. She asked him if it would wash off – he assured her it would! The other was about my grandad, who used to tell me he woke up in a tattooist's chair in Jakarta as they were about to tattoo a fly on the end of his nose! He escaped just in time.

Both those stories, rather than putting me off, got me so intrigued by tattoos, and growing up in the 1980s, obsessed with tattooed WWF wrestlers and Guns N' Roses, just sealed the deal. I started buying imported American tattoo magazines when I was about 13 or 14 and knew from poring over the amazing work in them that I wanted to get tattooed by an American. I finally got my first tattoo at a convention in France, by an American guy called Jack Mosher. In hindsight, I literally could have got the piece – a couple of black stars – anywhere in this country, but it was the start of a love affair with classic American tattoo designs. I'm a historian of tattooing by profession, so most of my design inspiration is from old flash and photographs.

The actual process of getting tattooed is a rather tedious, wearying impediment to actually having a tattoo. I can't even imagine not being a tattooed person, though ... Carrying these pictures and stories and moments and pieces of history with me is an important, magical, romantic thing.

Tattoos are not part of me, they're things I have. I'm proud to wear them and of course being tattooed is a part of my identity, but the images themselves are at least as defining of the artists who made them as they are of me. I would probably describe my style as '1940s gas station attendant on a date'.

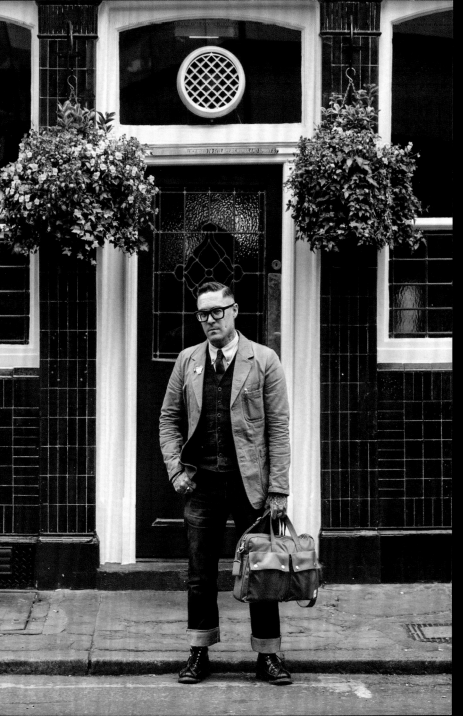

Alexis Barbuto
Student
Spotted: Brick Lane

↓ **Remy Nurse**
Junior Tattooist
Spotted: Tattoo
Collective London
Style: Illustrative

→ **Ben Haggerly**
Decorator
Spotted: Tattoo
Collective London
Style: Traditional
Tattoo by Adam Collins,
Sphinx Tattoo
→

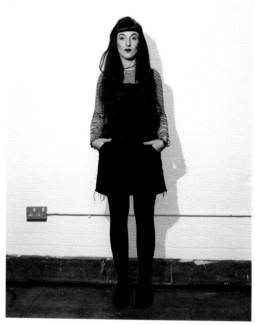

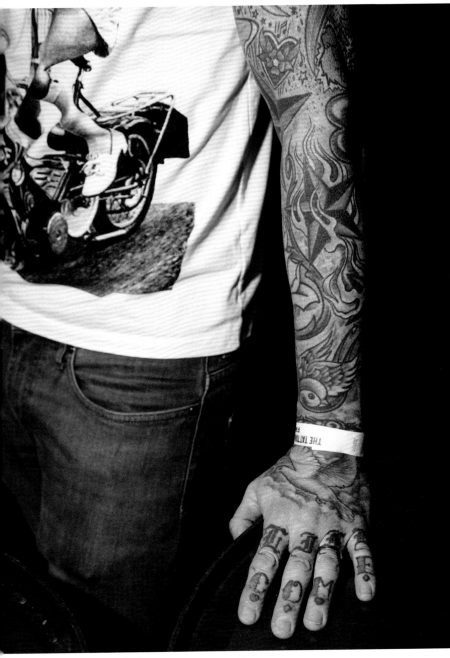

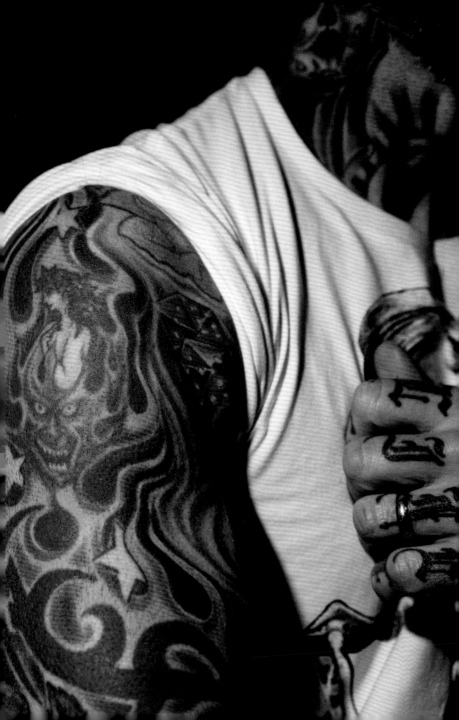

London's best parlours

Black Garden
183 Drury Lane
London WC2B 5QF
blackgardentattoo.com

The Blue Tattoo London
2 Studland Street
London W6 0JS
thebluetattoo.co.uk

Briar Rose
172 Manor Lane
London SE12 8LP
briarrosetattoo.com

The Circle
21 Noel Street
London W1F 8GP
thecirclelondon.com

Cloak and Dagger
34 Cheshire Street
London E2 6EH
cloakanddaggerlondon.co.uk

Diamond Jacks
5 Walker's Court
London W1F 0BT
diamondjacks.co.uk

Divine Canvas
179 Caledonian Road
London N1 0SL
divine-canvas.com

Evil From the Needle
232 Camden High Street
London NW1 8QS
evilfromtheneedle.co.uk

Flamin' Eight
2 Castle Road
London NW1 8PP
flamineight.co.uk

The Family Business
58 Exmouth Market
London EC1R 4QE
thefamilybusinesstattoo.com

Frith Street
18 Frith Street
London W1D 4RQ
frithstreettattoo.co.uk

Good Times
147 Curtain Road
London EC2A 3QE
goodtimestattoo.co.uk

Haunted Tattoos
159 Holloway Road
London N7 8LX
hauntedtattoos.tumblr.com

Hell to Pay
188 Camden High Street
London NW1 8QP
helltopaytattoos.com

Old Habits Tattoo
364 Kingsland Road
London E8 4DA
oldhabitstattoo.com

One by One
70 Berwick Street
London W1F 8TA
onebyoneldn.com

Jolie Rouge
364 Caledonian Road
London N1 1DU
jolierougetattoo.co.uk

Kids Love Ink
138 Deptford High Street
London SE8 3PQ
kidsloveinkdeptford.com

King's Cross Tattoo Parlour
185 King's Cross Road
London WC1X 9DB
kingscrosstattooparlour.com

King of Hearts
137 New Cross Road
London SE14 5DJ
kingofheartslondon.co.uk

Love Hate Social Club
5 Blenheim Crescent
London W11 2EE
lovehatesocialclub.com

Lowrider
311 Bethnal Green Road
London E2 6AH
lowridertattoostudio.com

New Wave Tattoo
157 Sydney Road
London N10 2NL
newwavetattoo.co.uk

Nine Tails
17 Hackney Road
London N1 6HB
ninetailstattoo.com

Sang Bleu
29b Dalston Lane
London E8 3DF
sangbleu.com

Scratchline
245 Kentish Town Road
London NW5 2JT
scratchlinetattoo.com

Seven Doors
55 Fashion Street
London E1 6PX
sevendoorstattoo.com

Shall Adore
11a Kingsland Road
London E2 8AA
shalladoretattoo.com

Vagabond
471 Hackney Road
London E2 9ED
lowridertattoostudio.com

Bohemian, hedonistic, colourful; Brighton may be compact, but its winding streets are filled with curiosity shops, buzzing bars and, as one might expect in a free-spirited city by the sea, boutique tattoo shops. It is the city I was drawn to when I got my first tattoo back in 2009, at 1770 (formerly Into You), in the heart of this hub of creativity. Each year, Brighton Tattoo Convention – one of the world's most prestigious tattoo gatherings – pops up at the start of summer, attracting throngs of tattoo artists, ink covering every inch of their skin, each with their own unique portfolio of work. There is no stand-out trend – styles are eclectic. There's a vibe of 'I don't give a damn' in the sea air, and people are free to experiment with their dress sense. This has influenced tattoo styles. You can be whoever you want to be. Imagine a glamorous woman in a classic mac standing next to a vibrantly made-up drag queen, and that's Brighton. Enjoy our selection of tattoo street style in this wonderful seaside city.

Brighton

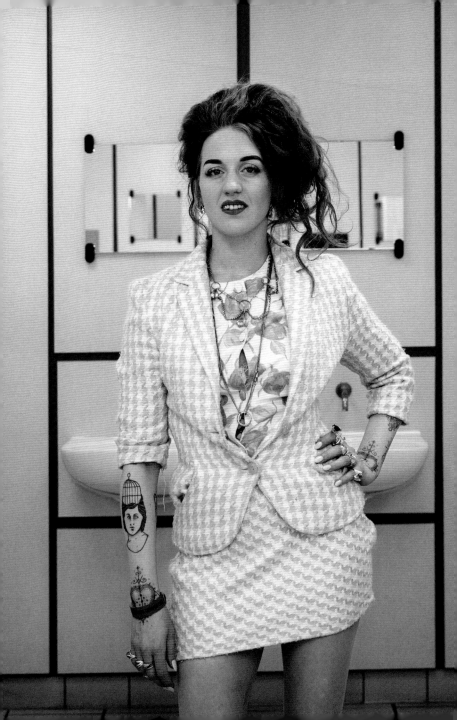

Tessa Metcalfe
Jeweller
Spotted: Brighton Tattoo
Convention
Style: Blackwork/Illustrative
Tattoo by Ryan Jessiman,
Old Habits Tattoo

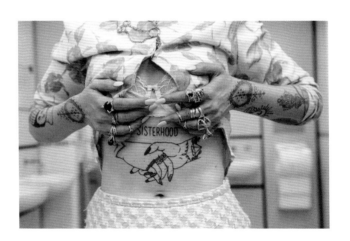

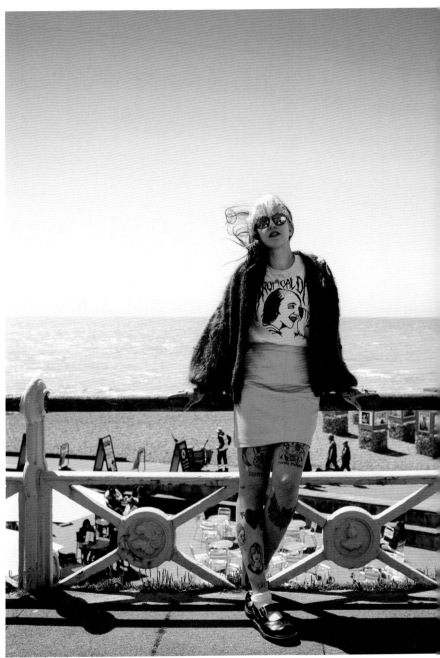

Brighton

Georgina Langford-Biss
Tattooist
Spotted: Seafront
Style: Blackwork/Illustrative

Derryth Ridge
Museum Curator
Spotted: Brighton Tattoo
Convention
Style: Neo-Traditional
Tattoo by Matt Houston

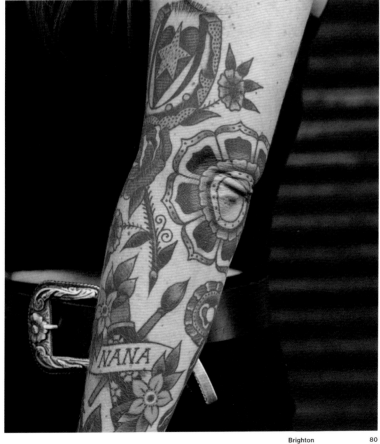

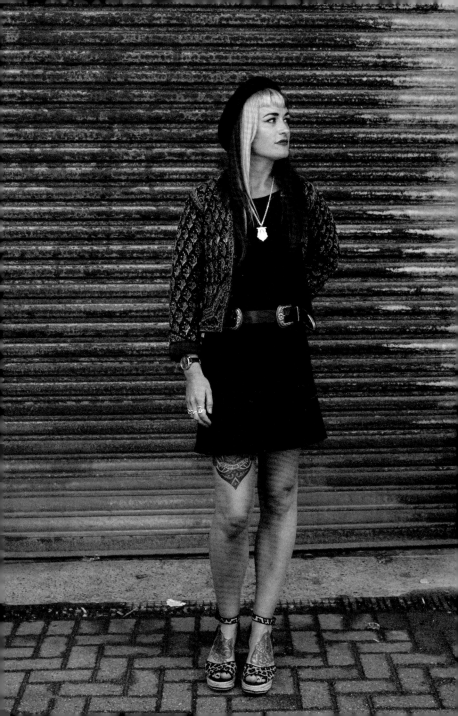

↓ Hollie Shannon
Tattooist
Spotted: Seafront
Style: Black and Grey
Realism/Portrait

→ Chris Leigh Richards
Aircraft Fitter
Style: Traditional

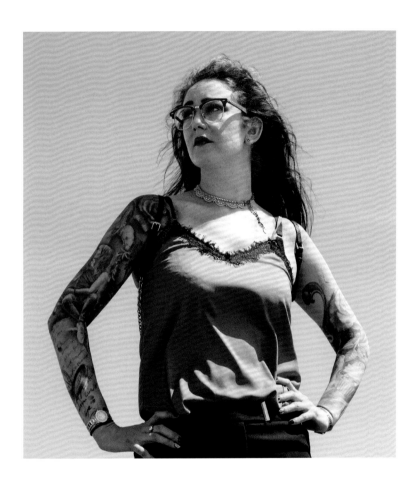

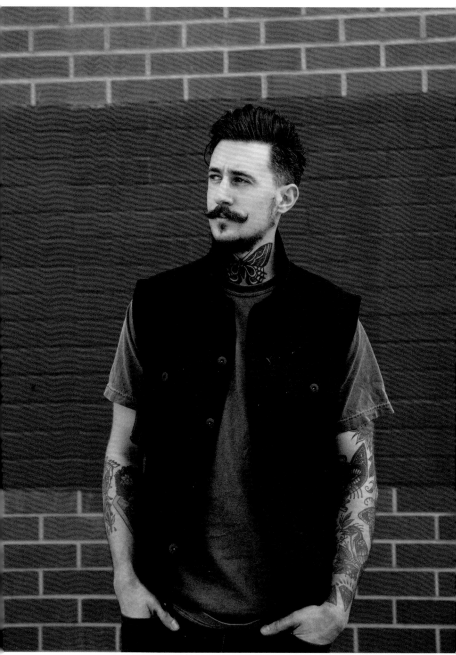

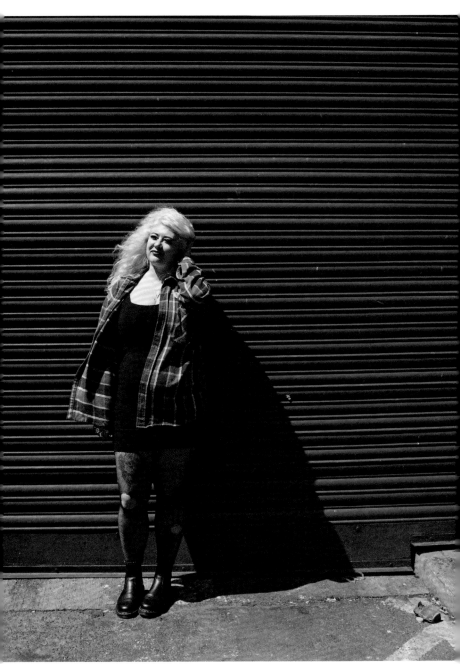

Maisie Manning
Photographer/Aid Worker
Spotted: City Centre
Style: Blackwork
Tattoo by Luke Oakman,
The Interbellum Tattoo
Lounge

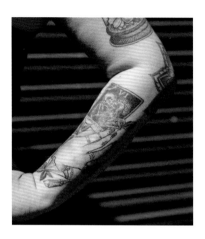

Aimée Cornwell
Tattooist
Spotted: Brighton Tattoo
Convention
Style: Neo-Traditional/
Neo-Classical
Tattoo by Lars Uwe,
Loxodrom

'I wanted something
pretty near my
vagina – it turned
into this.'

– Aimée Cornwell

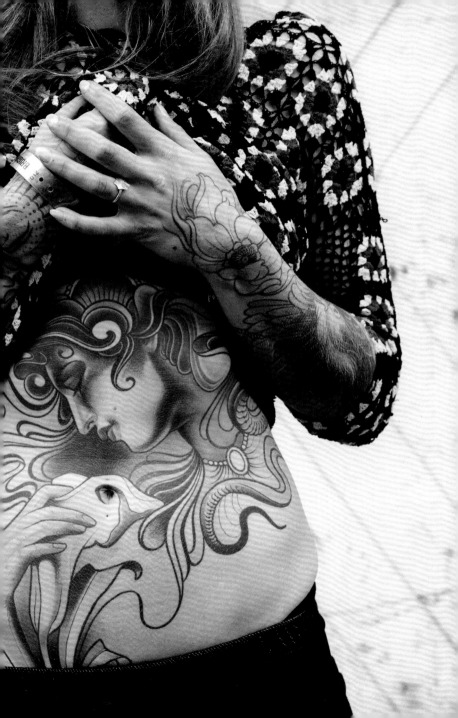

Zoe Binnie ↙
Tattooist
Style: Neo-Traditional

Alex Binnie ↘
Tattooist
Style: Blastover/Blackwork
Tattoo by Duncan X

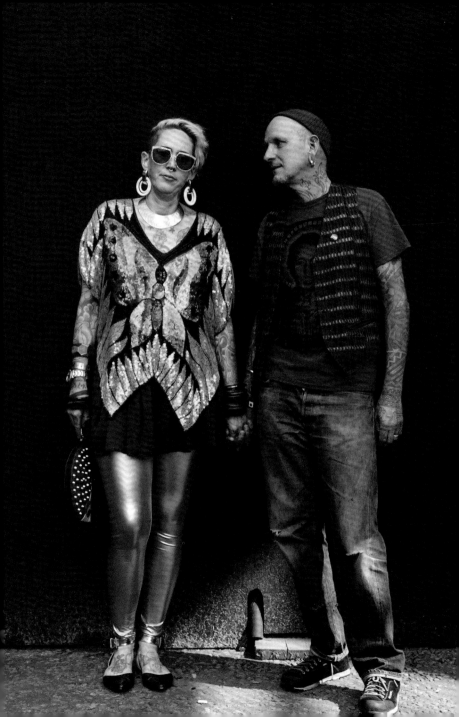

↓ Charlie Paice
Receptionist/PR Marketing
*Spotted: Brighton Tattoo
Convention*
Style: Japanese
Tattoo by Dan Arietti

→ Dan Hayes
Body Modifier
Style: Blackwork
Tattoos by Pedro Mendonca

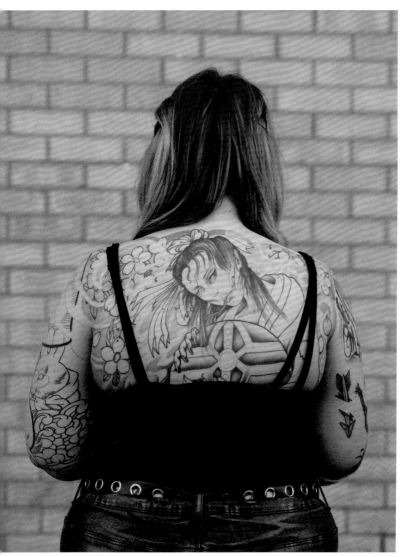

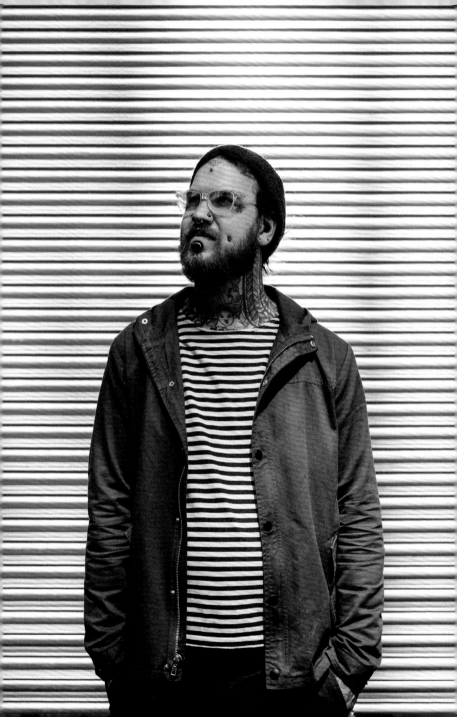

Abbie Williams
Tattooist
Spotted: Brighton Tattoo
Convention
Style: Neo-Traditional
Tattoo by Annie Frenzel

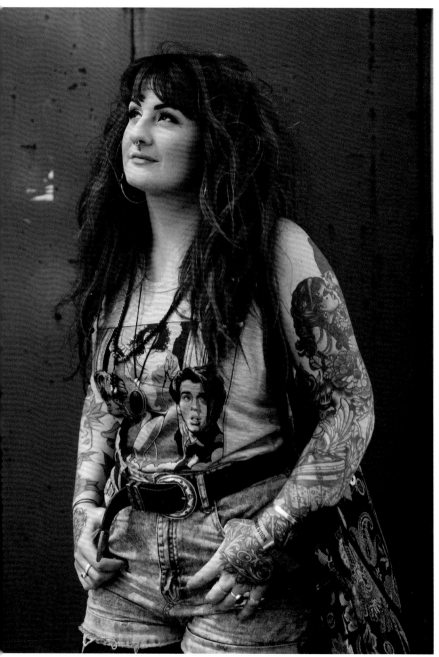

Brighton

Cally-Jo
Tattooist
Spotted: Seafront
Style: Script
Tattoo by Em Scott

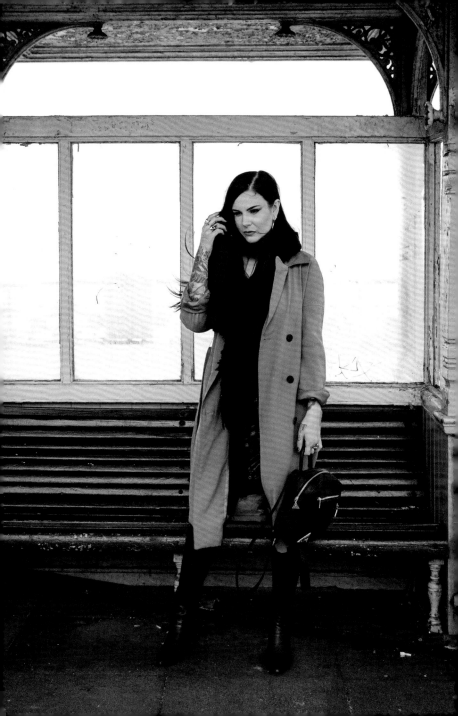

Ashley White
Barber/Model
Spotted: The Lanes
Style: Traditional

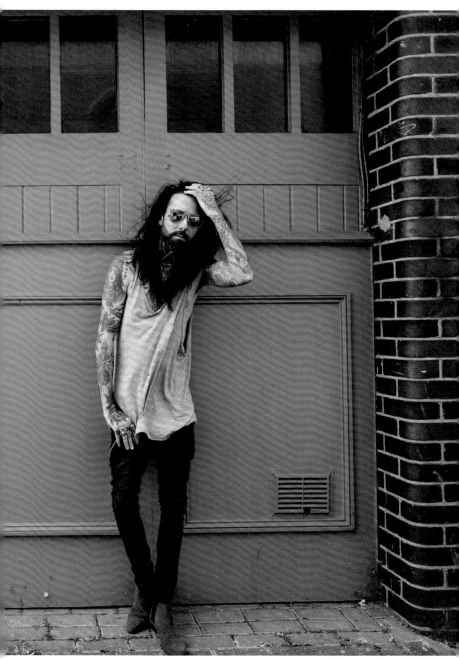

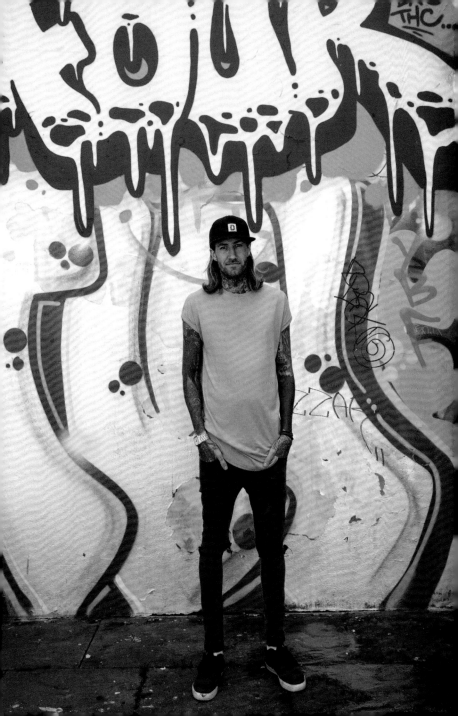

← Sean Bewey
Office Administrator
Spotted: The Lanes
Style: Blackwork

↓ Alice Carter
Barber/Model
Spotted: The Lanes
Style: Neo-Traditional

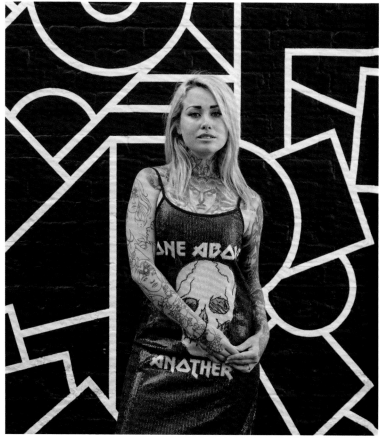

Clare Goldilox
Tattooist

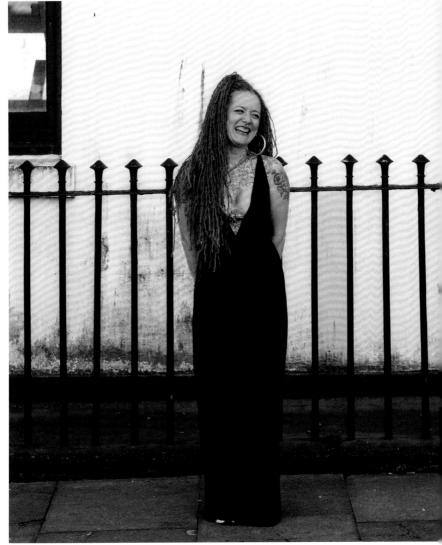

Brighton

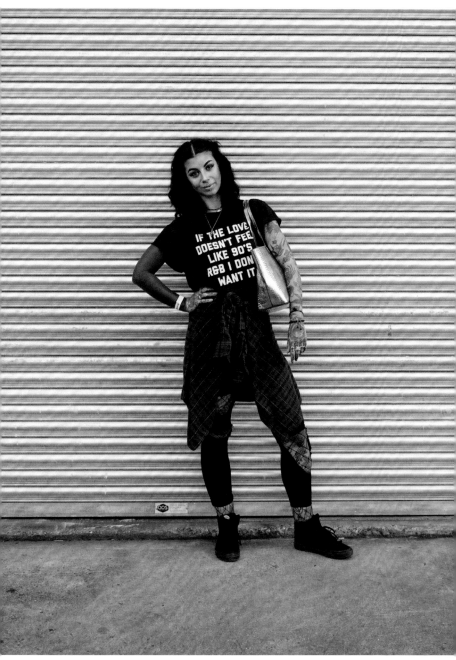

Dolly Plunkett
Tattooist
Style: Script (on hands)
Tattoo by Nipper Tattoo

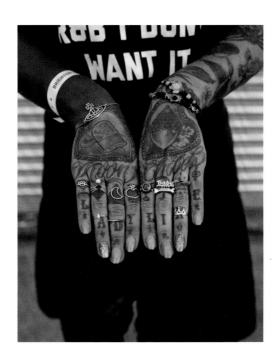

Laurence Sessou,
AKA Moniasse
Artist's Muse
Style: Blackwork

A friend from my childhood recently reminded me that the first time I decided I wanted a tattoo was because my wrists were too small. Apparently, I said I wanted to tattoo them to make them look fuller and more beautiful. I must have been 12 years old at the time.

My body is now covered with tattoos and scarification. Tattoos are applied with a needle and ink; in contrast, scarification is a straightforward cut with a scalpel. First of all, the design is drawn on with a pen, then it is cut into the skin. The cut is done without anaesthetic: you must transcend the pain, you must feel it and go through it. Then there is a very painful, long journey to the healing of the wound and the formation of keloid scarring. And when the keloids form, they are intensely itchy. In total, the process of scarification can take from eight months to a year. Tattoos can be lasered off but scarification is far more permanent – it cannot be removed.

I believe that [with scarification] we are carrying a piece of the artist in our body forever. All the body art I've got means something to me, but scarification has a much deeper meaning as it is my direct link to my ancestry, my tribal African roots and also my spiritual practice.

My tattoo journey is beautiful because everything relates to something about myself that I feel very proud of – a celebration of my understanding of life, spirituality and transformation. Anything could happen in my journey going forwards. I am a woman, therefore a changing creature. Let's see how life unfolds.

Being tattooed makes me feel awesome. It is painful but, because I understand why I do it, it is always rewarding in the end. It means my story is written on my body. Tattoo art is so much bigger than 'style'; it is a reflection of my inner world.

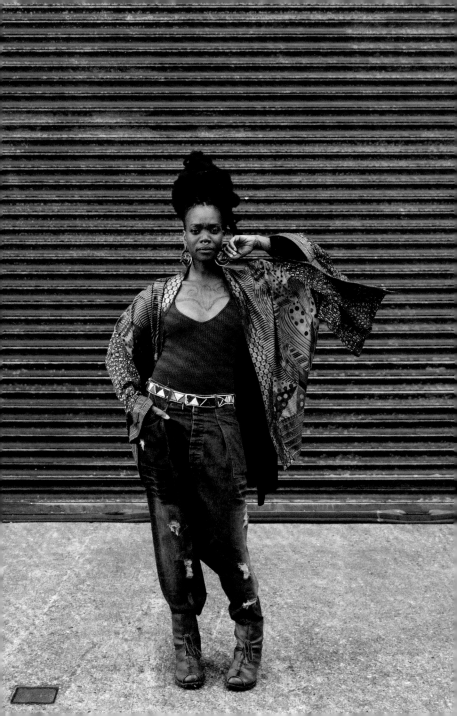

Rosalie Woodward
Copywriter
Style: Neo-Traditional

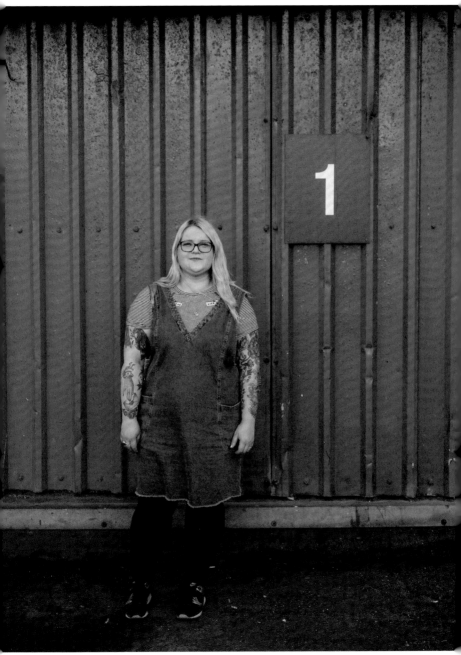

Brighton

Alexandra Tomlin
Freelance Tattooist
Style: Blackwork/
Neo-Traditional

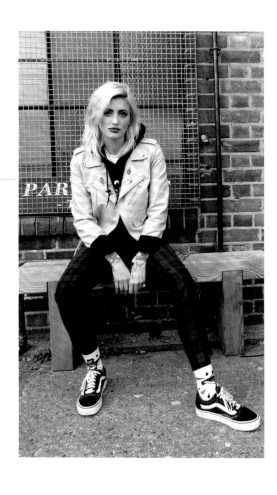

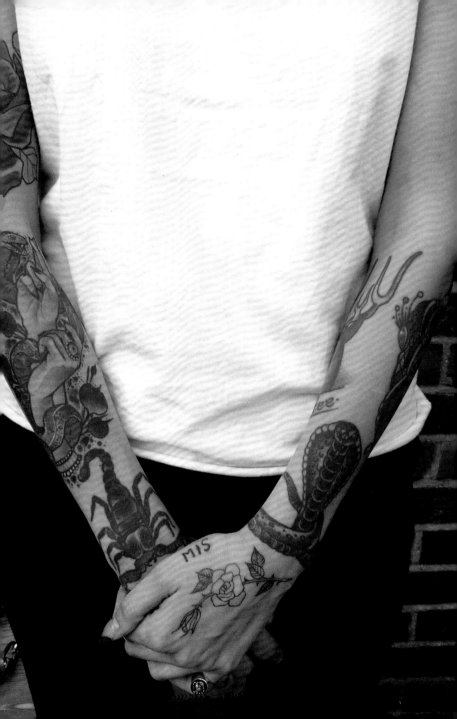

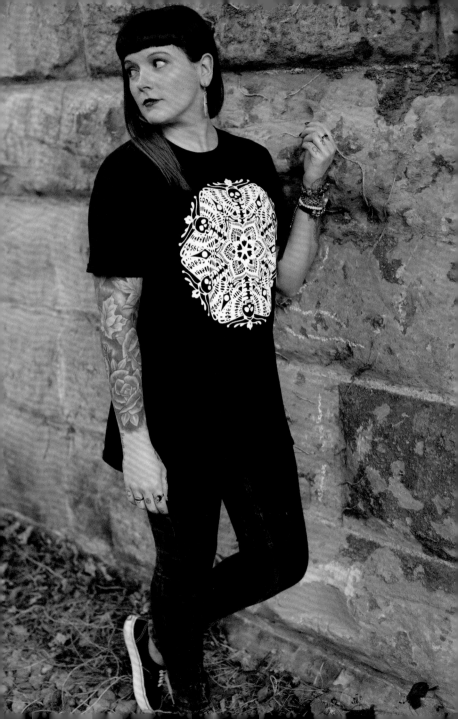

Beccy Rimmer
Freelance Writer
and Marketer

'You start to really notice
those blank spaces as you get
more tattooed and for some
weird reason feel desperate
to fill them!'

– Beccy Rimmer

↓ Holly Ashby
Tattooist
Spotted: Seafront
Style: Black Illustrative

→ Bwale Nkowane
Tattooist
Spotted: Brighton Tattoo Convention
Style: Marquesan

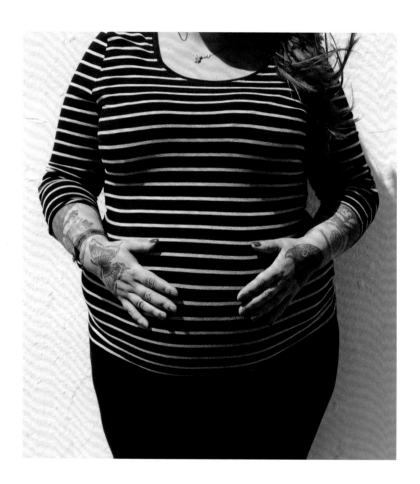

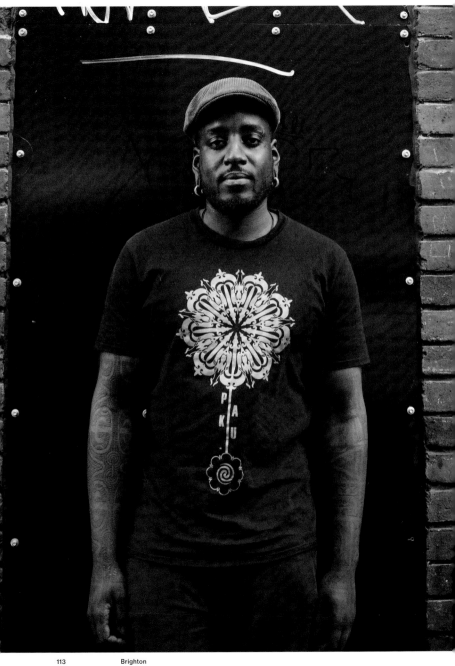

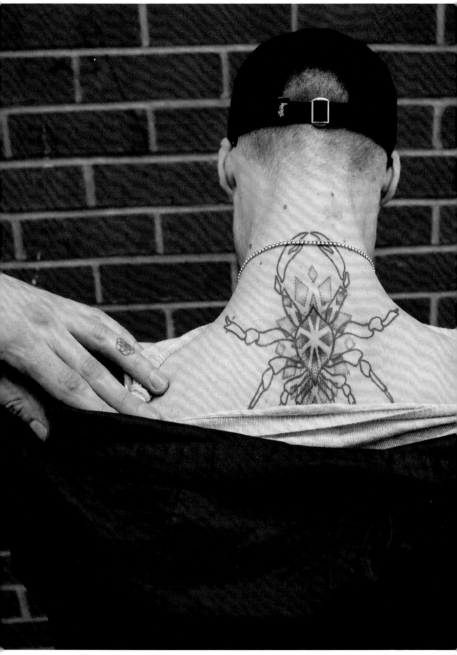

Francis Doody
Artist
Spotted: City Centre
Style: Dotwork/Illustrative
Tattoos by (back)
Alicia Cardenas and
(cat) Shall Adore
→

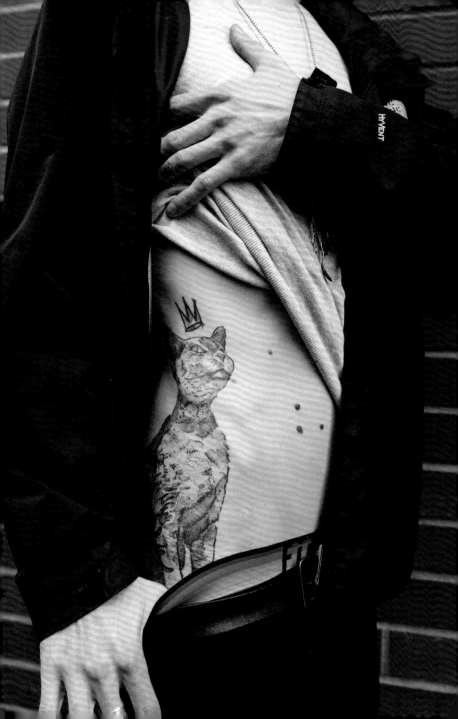

Brighton's best parlours

1770 Tattoo
4 Little East Street
Brighton BN1 1HT
1770tattoo.com

Angelic Hell
2 North Road
Brighton BN1 1YA
angelichelltattoo.com

Black Sails
1 St James's Street
Brighton BN2 1RE
blacksailstattoo.co.uk

Blue Dragon Tattoo
94 North Road
Brighton BN1 1YE
bluedragontattoo.co.uk

Chapter XIII
11–12 Pool Valley
Brighton BN1 1NJ
chapter13.co.uk

Dead Slow
9 Boyce's Street
Brighton BN1 1AN
deadslowco.com

Death's Door Tattoo
13–16 Vine Street
Brighton BN1 4AG
louhoppertattoo.com

Gilded Cage
106 St James's Street
Brighton BN2 1TP
gildedcagetattoostudio.com

Gold Irons Tattoo Club
41 Preston Street
Brighton BN1 2HP
goldironstattoo.com

Inka Tattoos
80c St James's Street
Brighton BN2 1PA
inkatattoos.co.uk

Magnum Opus
33 Upper North Street,
Brighton BN1 3FG
magnumopustattoo.com

North Road Tattoo
71 North Road
Brighton BN1 1YD
northroadtattoo.co.uk

Skin Candy
18 Baker Street
Brighton BN1 4JN
instagram.com/skincandyuk

Stay Much Better Tattoo
Beaconsfield Parade
Beaconsfield Road
Brighton BN1 6DN
smbtattoo.com

Tattoo Workshop
42a Providence Place
Brighton BN1 4GE
tattooworkshop.co.uk

Parisians adorn themselves with tattoos that speak to the city's reputation for cool sophistication while slyly hinting at rebellious undercurrents. Tattoos are bold, yet understated, and rooted in inspiration from history, art and culture. Important styles to note are the stained-glass-window tattoos made famous by Mikael de Poissy, and FUZI's Ignorant Style, which was born in the Paris graffiti scene. Every year, tattoo convention Mondial du Tatouage attracts elite tattooists from across the globe and, with it, serious tattoo collectors who are dedicated to their own tattoo journey, thriving not only on the aesthetic but also on how it alters their sense of self. During that weekend, the city is awash with interesting characters, and this chapter merely scratches the surface of what Paris has to offer the tattoo world.

Paris

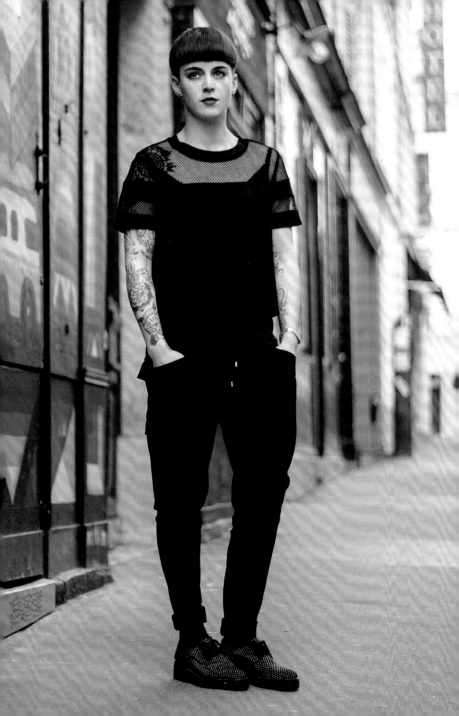

Violette Chabanon
Tattooist
Spotted: Bleu Noir
Style: Blackwork

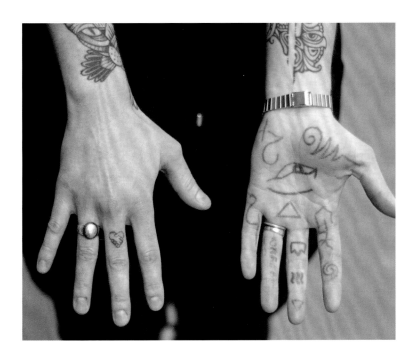

Emilie Henaut
Job Hunting
Style: Neo-Traditional
Tattoo by Tsul, Savage Tattoo
and Sali Ink

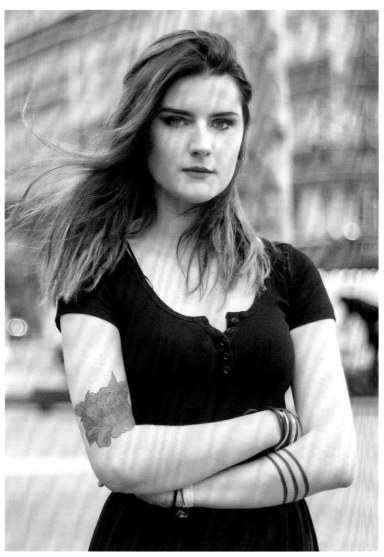

Jackee Sandelands-Strom
Artist
Spotted: Mondial du Tatouage
Tattoos by Tom Strom,
Semper Tattoo

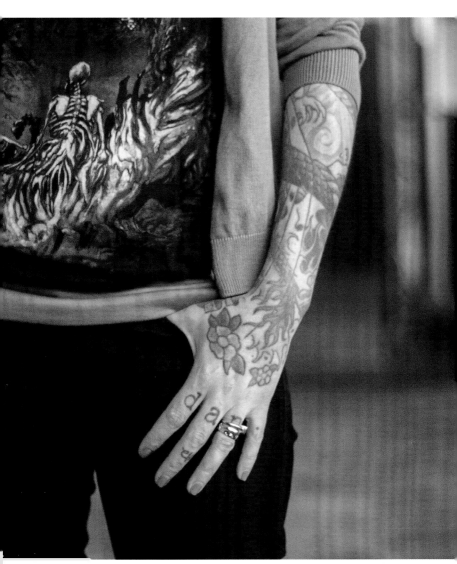

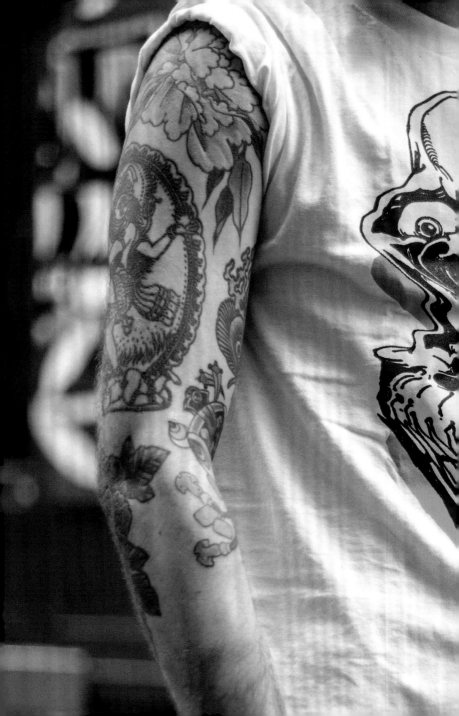

Steve Taniou
Tattooist at Bleu Noir
Spotted: Bleu Noir
Style: Japanese/
Blackwork

'I have an arm reserved
for the artists in the shop
that I work in.'

– *Steve Taniou*

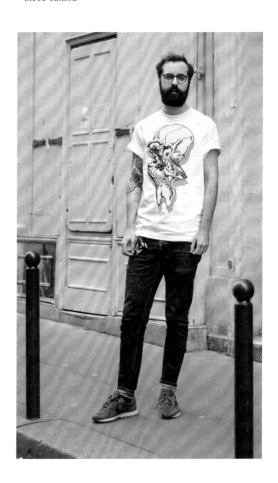

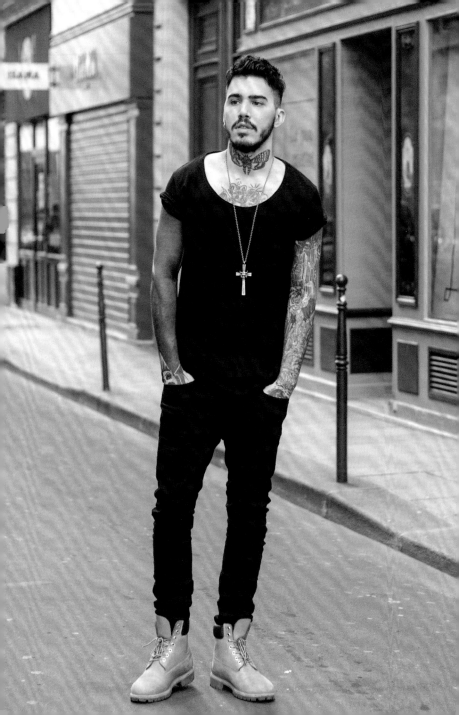

← Judicial Bedabury
Model
Style: Neo-Gothic

↓ Isis Lago
Packaging Engineer
*Style: Blackwork/Traditional/
Ignorant Style*
→

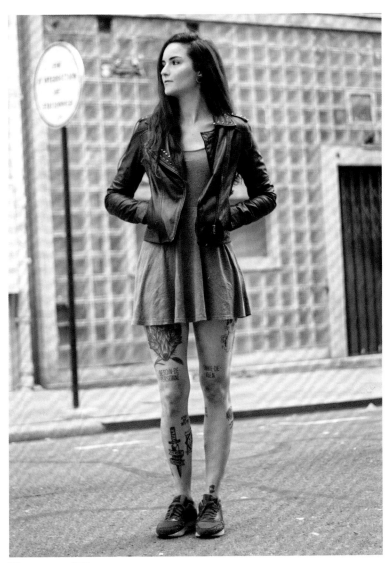

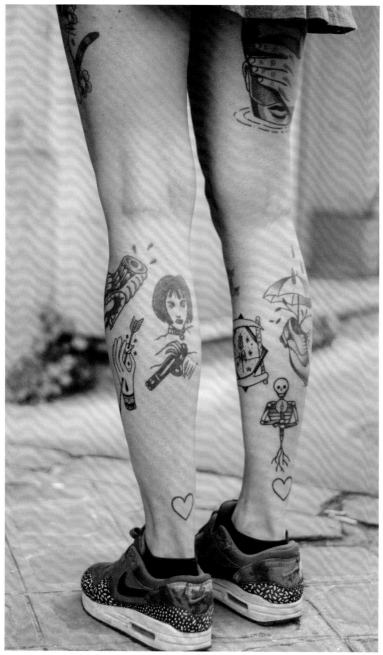

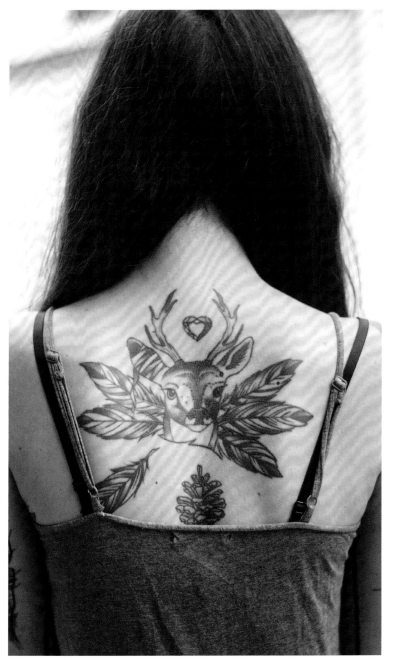

Tamara Abou Habib
Business Student
Style: Old School/
Neo-Traditional

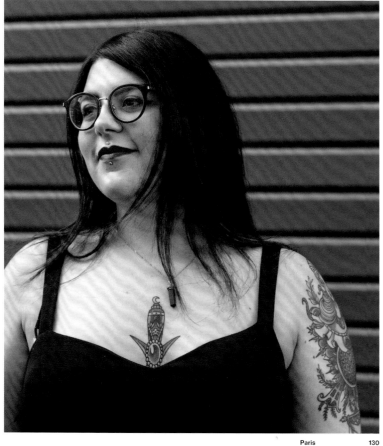

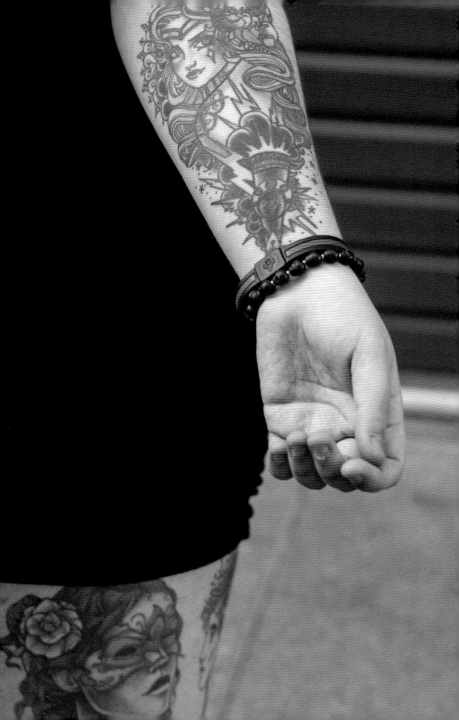

Isabelle Bernhard
Real Estate
Spotted: Mondial du Tatouage
Style: American Traditional

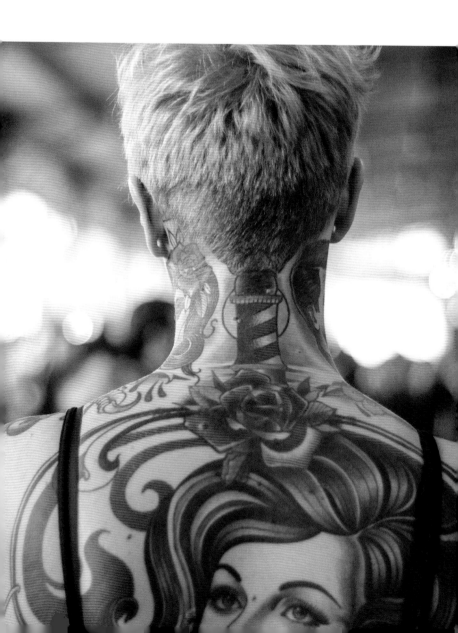

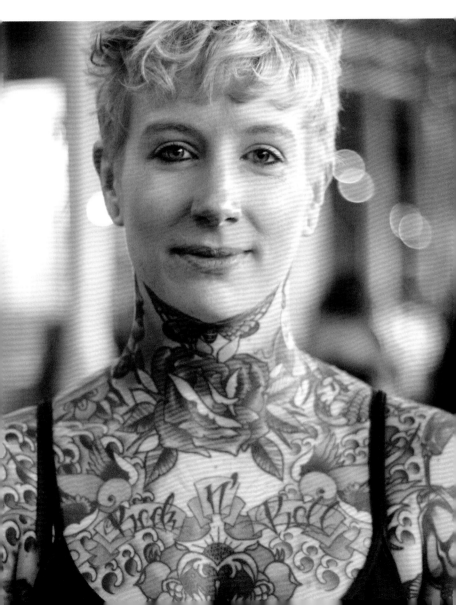

↓ Pino Cafaro
Tattooist
Spotted: Mondial du Tatouage
Style: Script

→ Lee Dongkyu
Tattooist
Spotted: Mondial du Tatouage
Style: Realism

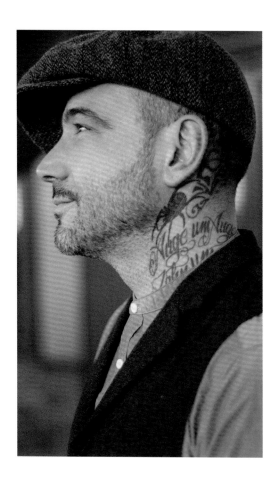

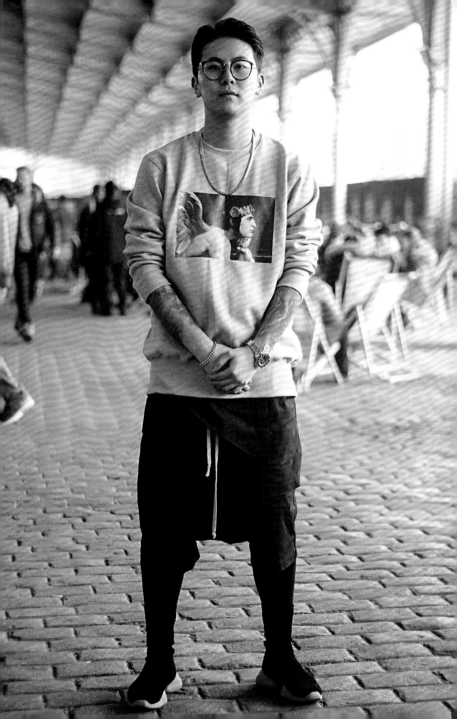

David Meireles
Director
Spotted: Bar Chambre Noire
*Style: Old School/American
Traditional*
Tattoos by Joel Soos
and Florian Santus

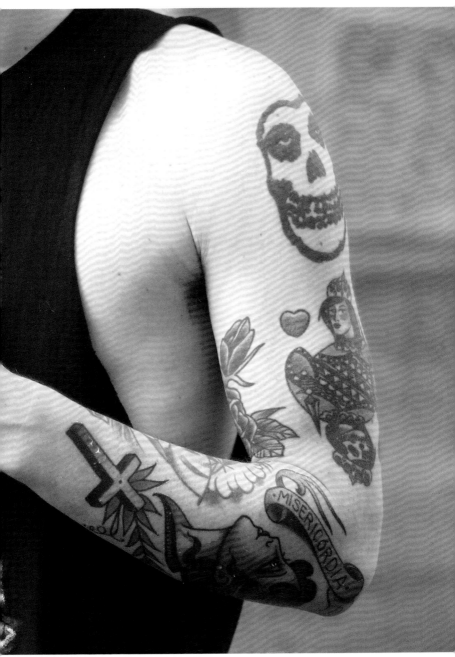

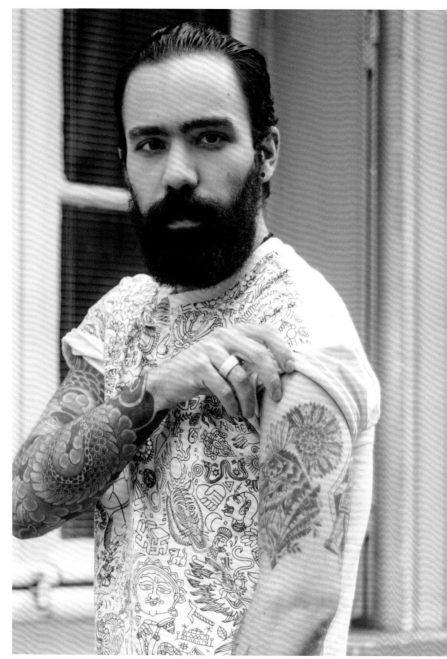

← Gael Beullier
Tattooist
Spotted: Bleu Noir
Style: Traditional

↓ Emilie 'Fenrir' Bedart
Tattooist
Spotted: Tattoo Shop
Style: Neo-Traditional/
Ornamental
Tattoos by Jaxa Tattoo,
Tribal Act; Guy Le Tattooer
and Alexandre, La Main Bleue

'I don't really have a story behind
my tattoos; for me, it's the story
of a collection.'
– Emilie 'Fenrir' Bedart

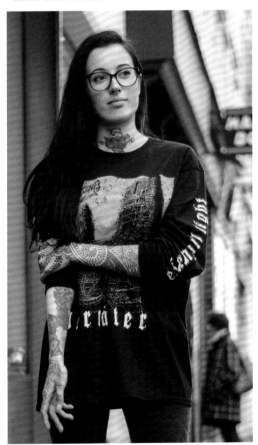

Hélaine Sylvain
School Teacher
Style: Japanese/Old School/
New School/Geometric
→

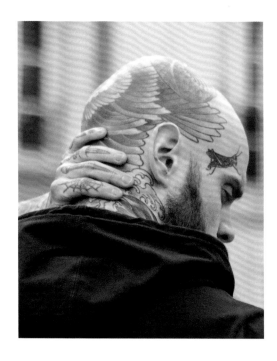

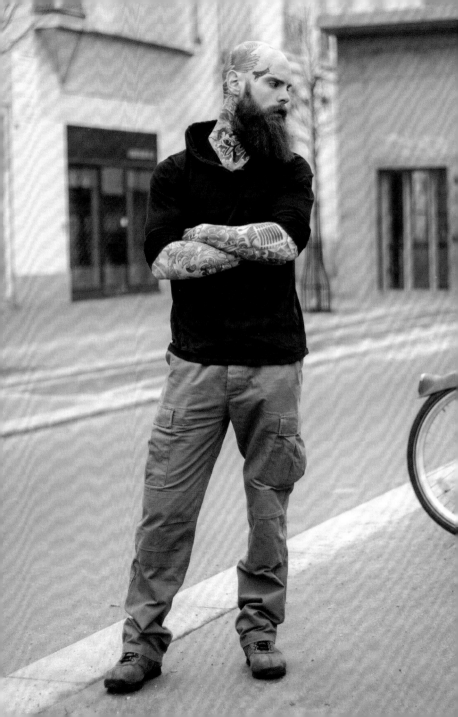

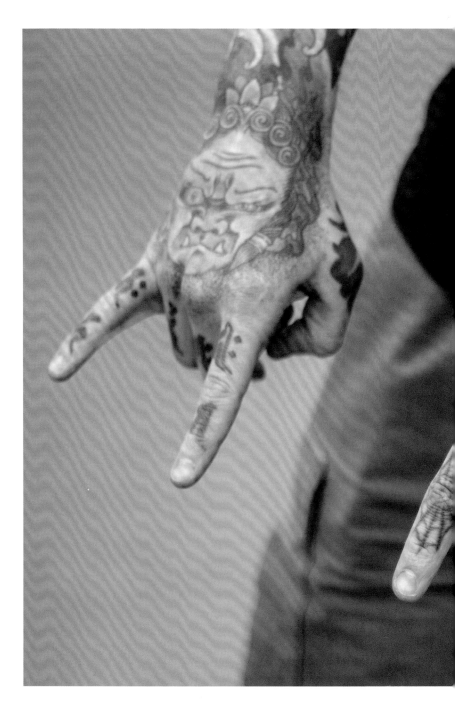

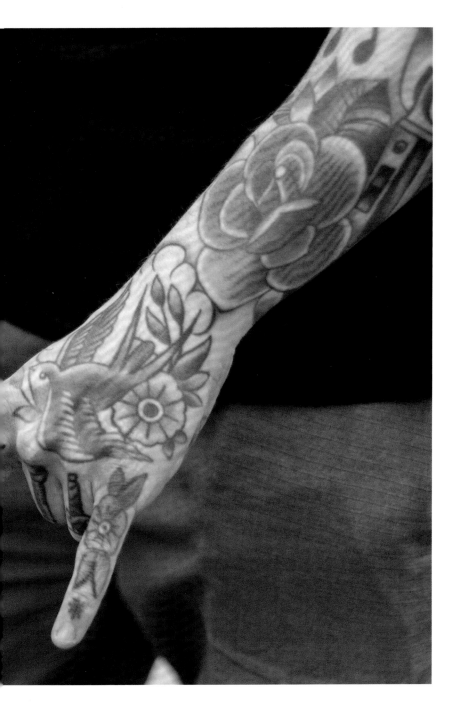

Magaña Christian
Chef
Spotted: Republic of Coffee
Style: Day of the Dead/
Japanese
Tattoos by Barnaby Williams,
Abraxas Tattoo Co.

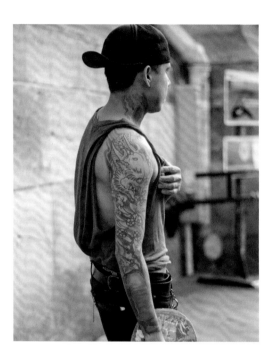

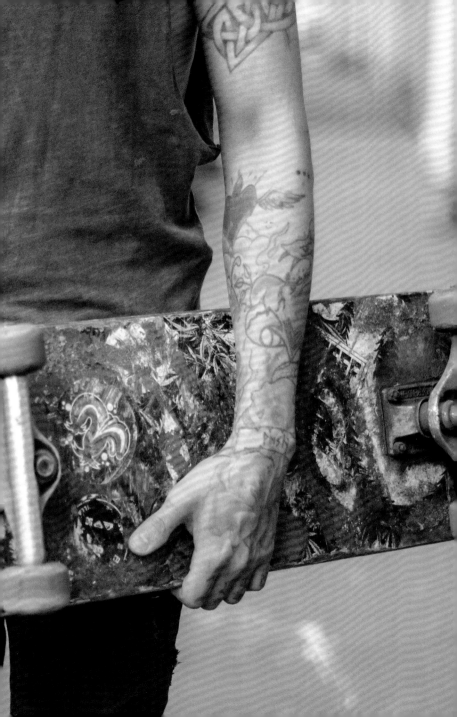

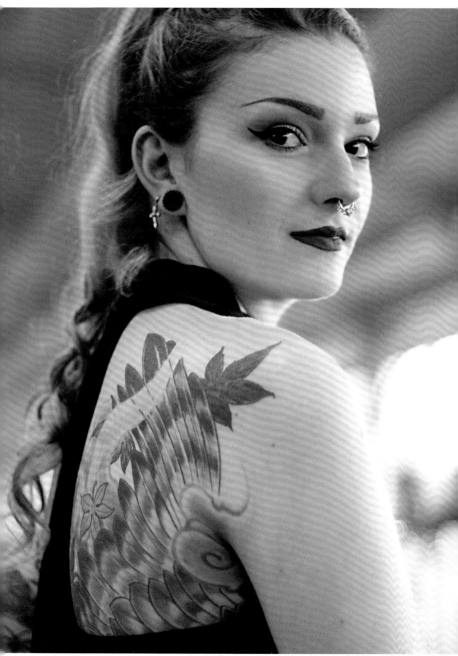

Virginie Lecesne
Artisan
Style: Japanese/
Neo-Traditional

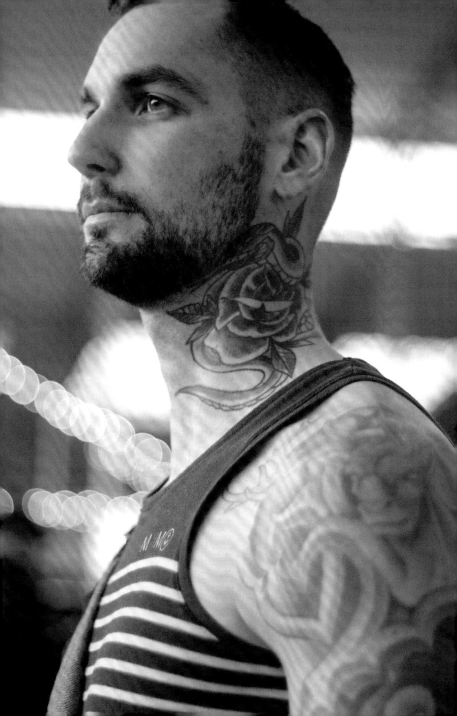

Jeremy Kerhoas
Dog Handler
Spotted: Mondial du Tatouage
Style: Old School

When I was a teenager, I used to hang out with a bunch of friends in my working-class neighbourhood. They were like a second family to me. Most of my friends had tattoos and I was convinced I could create something better, more beautiful and more artistic.

I was 17 when my dad bought me my first tattoo kit. He wanted to be the first person I tattooed, so he asked me to draw a woman whose face transformed into a lion. It was on his shoulder. It wasn't easy and it's not my best piece of art – clearly not – but my dad, Jean-Luc, is very proud of it and still shows it off.

Tattoos are not just a part of me. I've dedicated my entire life to tattoo culture. I love every aspect of it – its aesthetics, its history, its ability to let people become who they truly are. Almost all of my best friends are tattoo artists. Furthermore, I am a collector. I collect everything related to tattoo culture in France, from the first [tattoo] magazine ever printed to video archives of tattoo conventions.

I am an expert at stained-glass tattoos. I was the first one who dared to draw big, bold black lines across my tattoos to reproduce what you see on stained-glass windows.

It's a style I've developed throughout my career. I feel blessed to have the privilege of only tattooing clients who love my art and who come to me for it. They know that I'll create a unique piece of art inspired by French medieval iconography. I have clients from pretty much everywhere. I'm always amazed when certain people are ready to travel miles to visit me in France.

I can choose my clients according to the kinds of projects they want. I like to take time to talk with them, see if they are at least as passionate as me about their future tattoo. Most of my clients give me carte blanche to create something special. I only do big pieces: backs, sleeves and even full bodies. I work with only one client per day for a long session of between five and six hours.

My advice for anybody who wants to get tattooed is this: check the work of the person you want to get tattooed by on social media, discuss your project with them, check how serious they are and the cleanliness of their shop. As soon as you trust your tattoo artist, then just go for it. As with any relationship, it's all about respect. The tattoo world is no longer underground or secret – we're just as crazy or just as normal as anyone else.

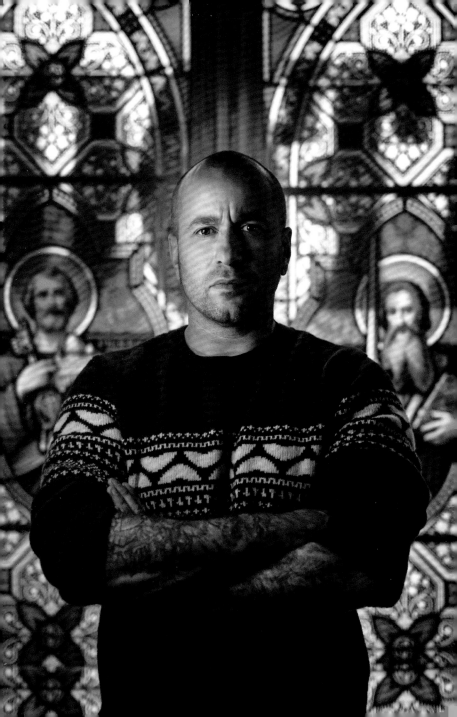

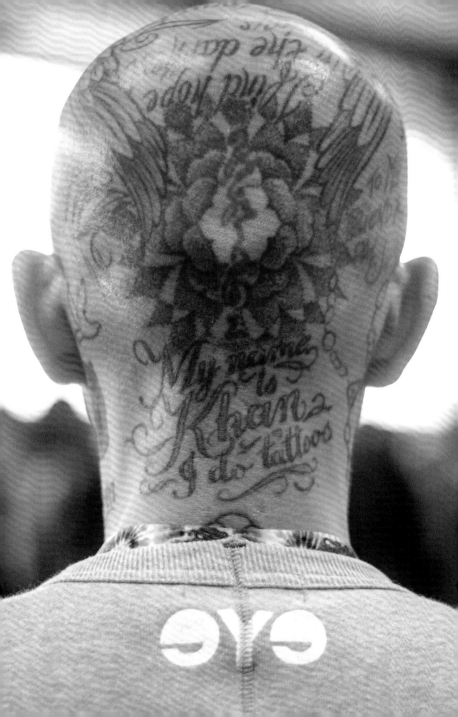

↓ Rogerio Monteiro
Tattooist at Dragao Tattoo
*Style: Portrait/Script/
Japanese*
→

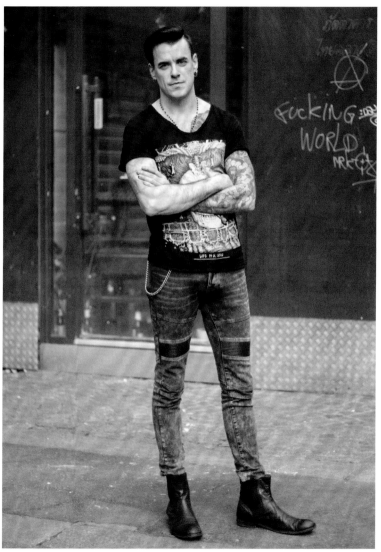

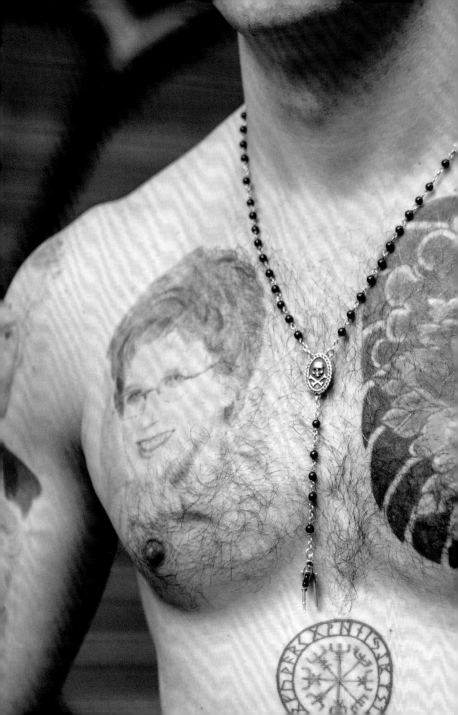

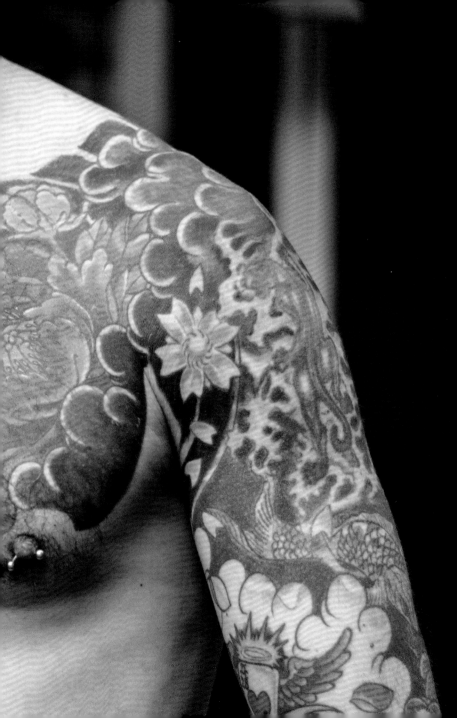

Quentin Grichois
Tattooist
Spotted: Mondial du Tatouage
Style: Blackwork/Dotwork/
Neo-Traditional

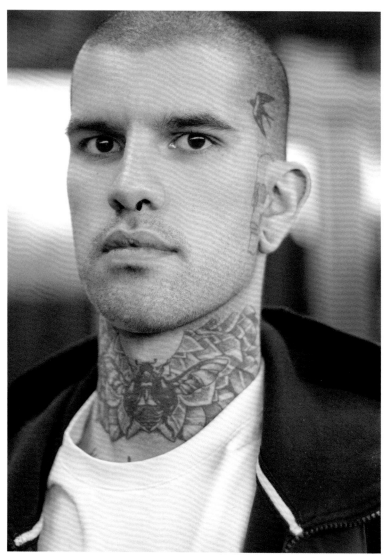

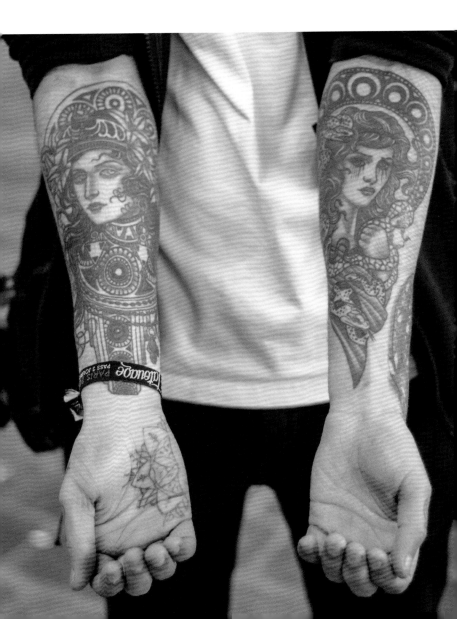

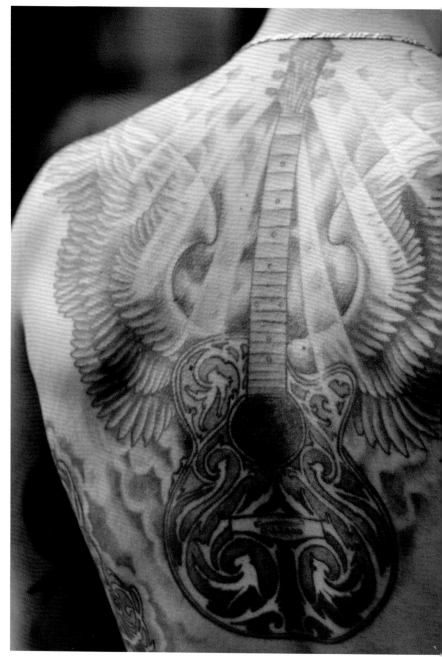

Alexandre Tavukciyan
Tattoo Apprentice
Style: Black and Grey
Tattoos by Mistericol
→

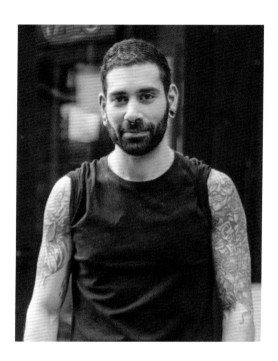

↓ Noëlle Schonenberger
Spotted: Mondial du Tatouage
Style: Japanese

Julio Cesar Martinez Rojas
Artist
Spotted: Chilango Café
Style: Blackwork

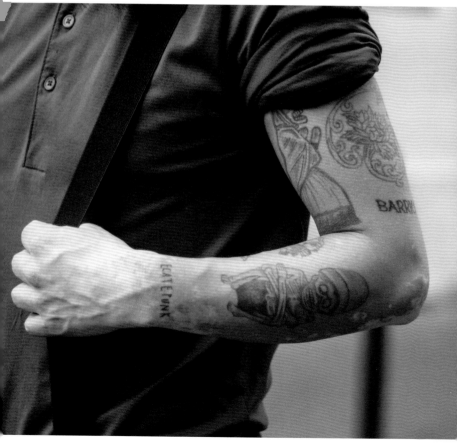

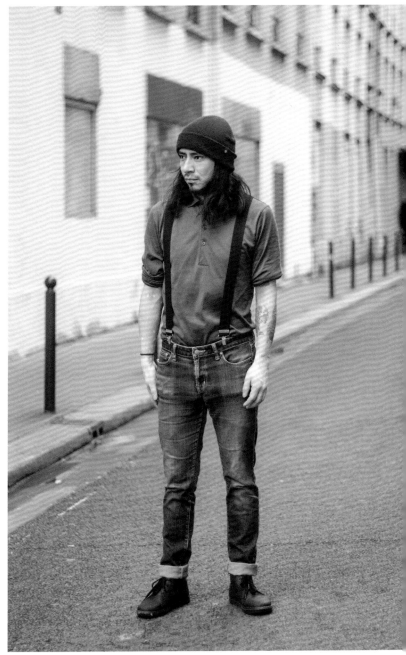

Céline Aieta
Communications Officer
Style: Ornamental/Neo-Tribal/
Japanese/Black and Grey/
Neo-Traditional

My first tattoo was a matching tattoo; I got it with my best friend when I was 15. I was young and wanted to experience everything so fast. It was years later that I developed a real interest in tattoos, after meeting people with body suits in progress. The visual impact was so powerful; I was instantly hooked.

I think the process of getting a body suit is more interesting than the actual result. Going through everything I have experienced has made me a stronger person and brought me so much more confidence. I don't even feel like I'm tattooed; it's a part of who I am, like a second skin.

As far as my style goes, I'm a mish-mash of so many things. My style of tattoos goes from Ornamental/Neo-Tribal to Japanese, Black and Grey portraits and Neo-Traditional. Elegance is the key point of everything I'm trying to achieve.

After collecting tattoos from many artists over a few years, I started a large-scale project with Guy le Tatooer. Guy tattooed pretty much my entire body. The idea was to create a cohesive body suit, including the existing pieces I collected previously. I worked almost exclusively with him during a two-year period, until this interaction came to an end.

I'm now entering a very interesting phase of my journey as I'm starting to add the details that will make my body suit more intricate and sophisticated. I might need one more year to complete it but, to be honest, I think I might always be a work in progress.

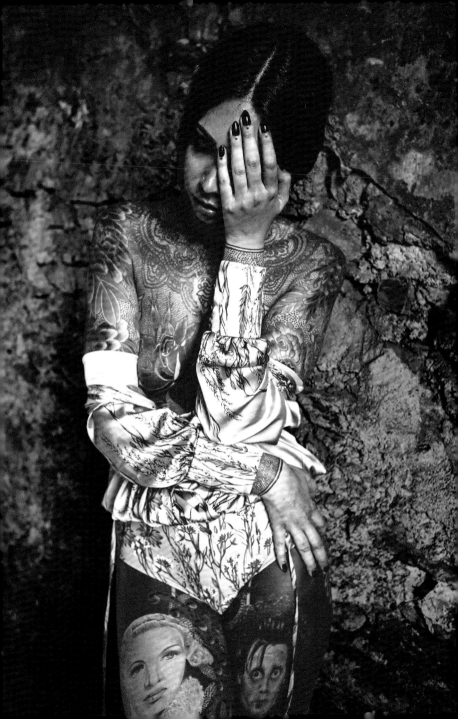

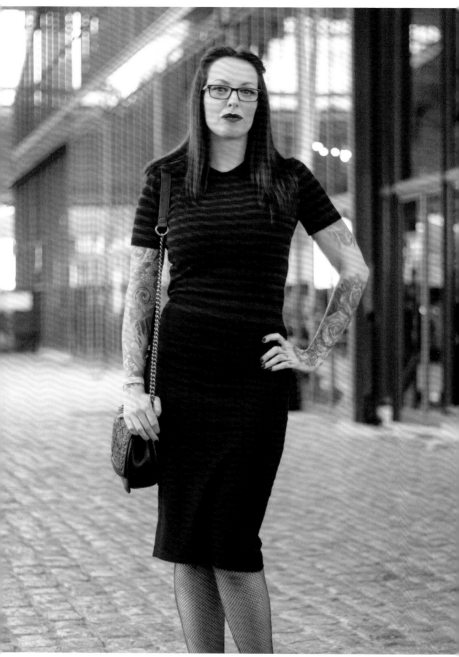

Marie Jose Sarmiento Espejo
Tattooist
Style: Realism
Tattoos by Robert Hernandez
→

Paris's best parlours

American Body Art
24 Boulevard de Sébastopol
75004 Paris
americanbodyarttatouage.com

Art Corpus
49 Rue Greneta
75002 Paris
artcorpus.fr

**La Bête Humaine –
Atelier 168**
7 Rue Geoffroy l'Angevin
75004 Paris
labetehumaine.fr

Bleu Noir
25 Rue Durantin
75018 Paris
bleunoirtattoo.com

Chez Mémé
28 Rue Pétion
75011 Paris
*instagram.com/chez_
meme_paris*

Freaks & Geeks
16 Rue des Envierges
75020 Paris
paristattoo.fr

Hand In Glove
44 Rue Trousseau
75011 Paris
handinglovetattoo.com

23 Keller Tattoo & Piercing
23 Rue Keller
75011 Paris
23keller.tumblr.com

Kustom Tattoo
24 Avenue de la République
75011 Paris
www.kustomtattoo.com

Maud Dardeau Tatouages
21 Cours d'Alsace-et-
Lorraine
33000 Bordeaux
mauddardeautatouages.com

Mikael de Poissy Tatouage
25 Rue du Général de Gaulle
78300 Poissy
www.tattoo.fr

Mystery Tattoo Club
13 Rue de la Grange
aux Belles
75010 Paris
mysterytattooclub.com

Paris Exxxotic Tattoos
233 Rue des Pyrénées
75020 Paris
exxxotic-tattoos.com

Ravenink Tattoo Club
65 Rue d'Amsterdam
75008 Paris
raveninktattooclub.com

Tin-Tin Tatouages
37 Rue Douai
75009 Paris
*instagram.com/tin_
tin_tatouages*

Tribal Act
161 Rue Amelot
75011 Paris
tribalact.com

'You are crazy, my child. You must go to Berlin. Where all the crazy people are.' So said the Austrian composer Franz von Suppé, and he was right. Berlin *is* a crazy, unpredictable place. But that is precisely what makes it so magical. Germany's capital city is a place to let go, party all night and lose your inhibitions. It's a creative hub of innovation – architecture, art, fashion, design, film and publishing are all thriving industries there. So, too, is the tattoo scene. It's somewhere I have visited specially to collect work from the incredible artists at Taiko Gallery. Guen Douglas and Wendy Pham both create technically excellent tattoos in their own distinct styles. Many of the people photographed in this book have also been tattooed by Lars Uwe, who is best known for creating custom pieces worthy of being housed in a museum. Over the following pages, you will get to meet just some of the inhabitants of Berlin's burgeoning tattoo scene.

Berlin

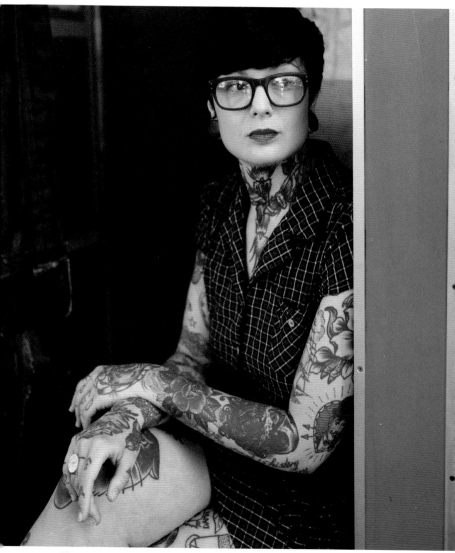

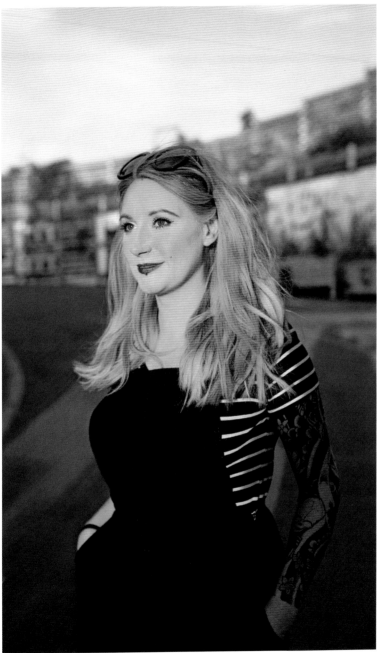

Stephanie Shea
Art Sales
Style: Neo-Japanese

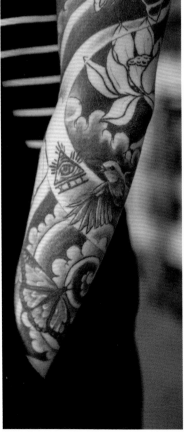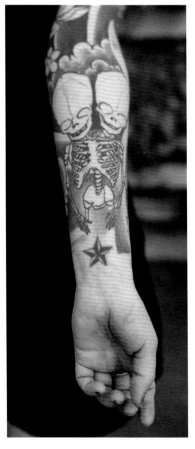

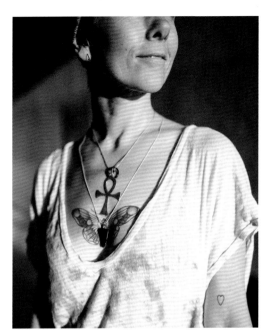

Wendel Tjon Ajong-Meyer
Style: Blackwork

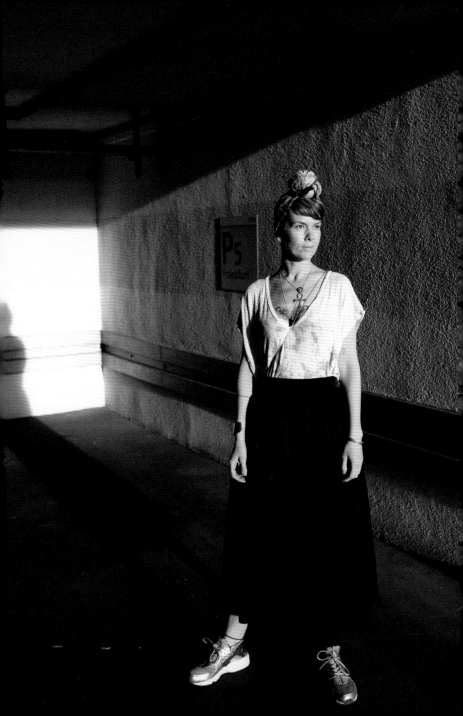

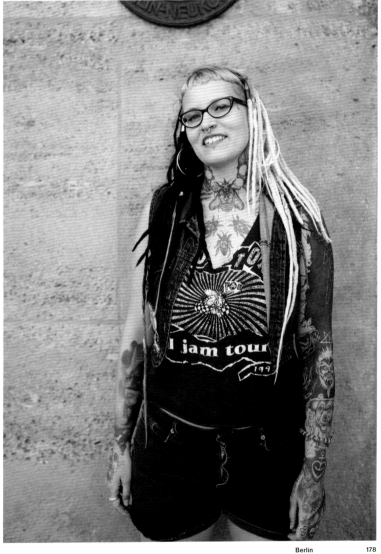

Tinka Samoilova
Social Worker
Spotted: Neukölln
Style: Dotwork/Blackwork/
Lettering

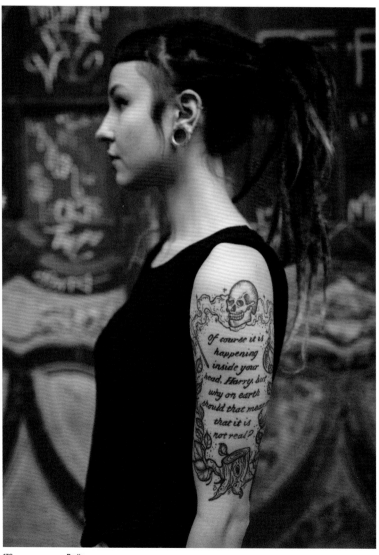

Guen Douglas
Tattooist
Spotted: Taiko Gallery
Style: Japanese
Tattoo by Dave Cummings,
PSC Montreal
→

I like the idea of being part of a group of outsiders. I think this is probably true for most tattooed people: the desire to exclude yourself from one group and solidify your position within another.

Like most things in my life, tattoos are a part of me but do not define me. Tattooed people have a unifying love of tattoos and perhaps share this outsider quality, but I think to assume anything beyond that is false. I have dedicated a huge portion of my adult life to tattoos and obviously love tattoos, but I would hate to be defined solely on this.

My tattoos are generally Illustrative, applied using the principles of American Traditional. They tend to be bold and are mostly neutral or feminine, sometimes colourful and intricate, and sometimes graphic and simple. I think bold is probably the word that applies to the spectrum of styles I create.

I tend to attract lots of collectors who wish to add a piece from me to their collection. I generally attract clients who share the same interests and have the same outlook on life. Lots of creatives, intellectuals and all-round thoughtful people. I hope it stays like this forever. Every day is a fun hangout.

Most of the trends right now don't really affect me, since they are either Blackwork or 'Watercolour'. Heavy Blackwork and Etching is all the rage and, when it's well done, can be really striking. And I'm really looking forward to this trend of hand-poked party tattoos dying out, because it lessens the perceived value of quality work done by professionals. But I've been around long enough to know that trends come and go and tattoos are forever.

There is so much to say about tattoo etiquette. Never ask any tattooed person, 'How far down does that go?' or, 'Are you tattooed ... all over?' Creepy comments are always no-go, no matter what the topic. I'm sure some would argue that tattoos are a form of visual rhetoric, but those people are not the target audience! I think as long as the questions aren't packed full of sexual innuendo and are polite and thoughtful, I'm usually up for answering anything. Also, remember what your mother taught you: look with your eyes and not with your hands.

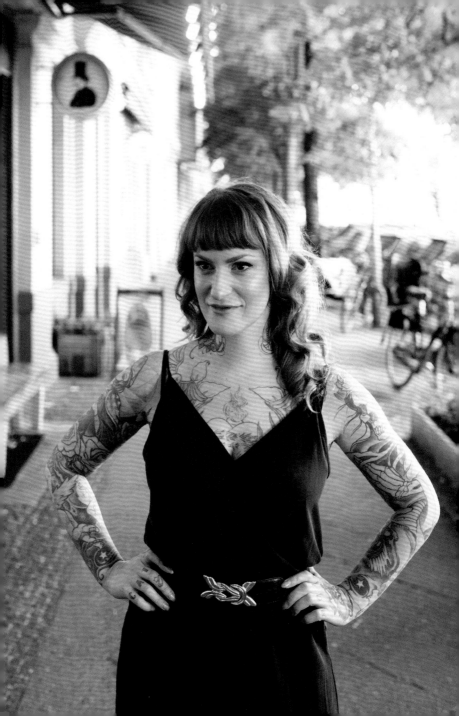

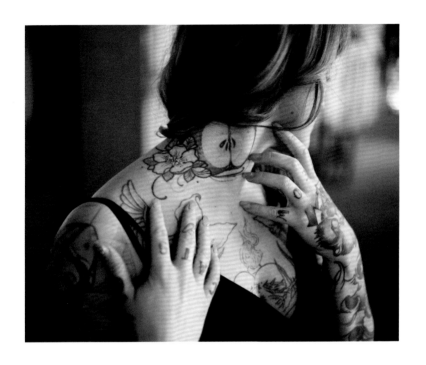

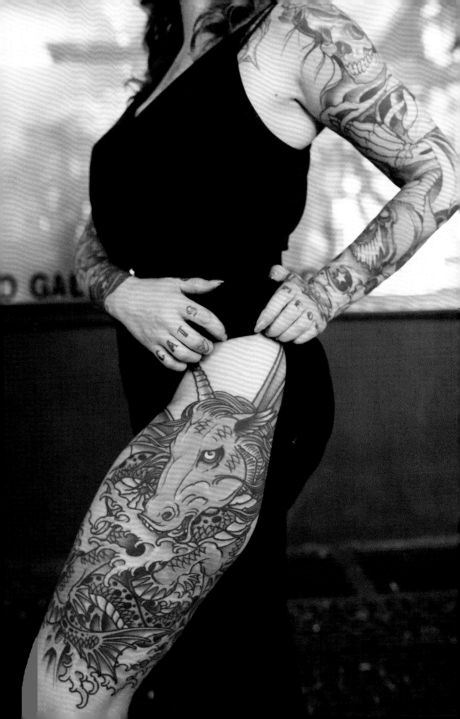

Jared Warmington
Barber
Spotted: Nomad Barber
Style: Traditional
Tattoo by Ethan Jones,
Modern Body Art

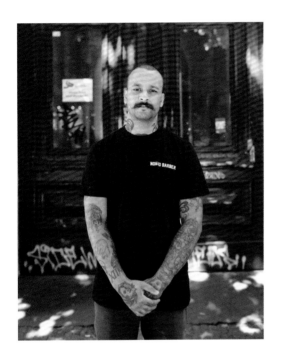

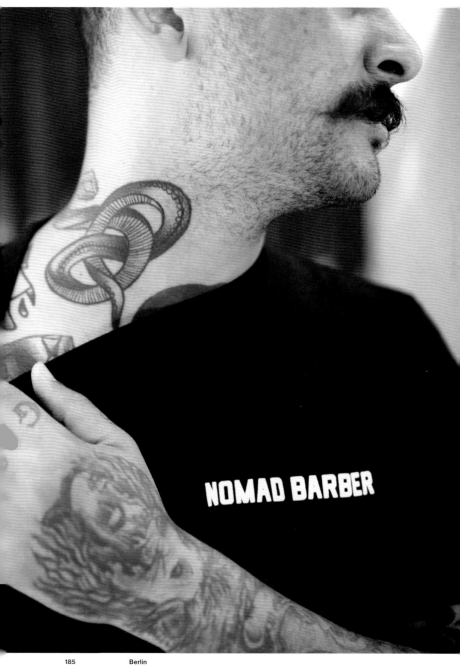

NOMAD BARBER

Mark Bannon
Bike Messenger
Spotted: Neukölln
→

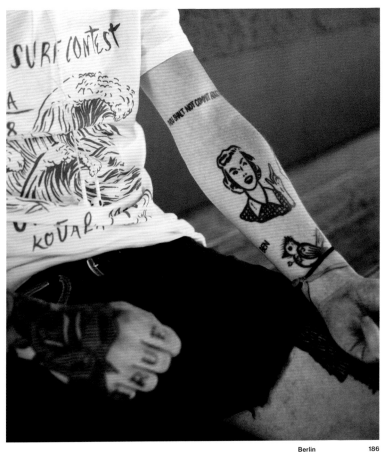

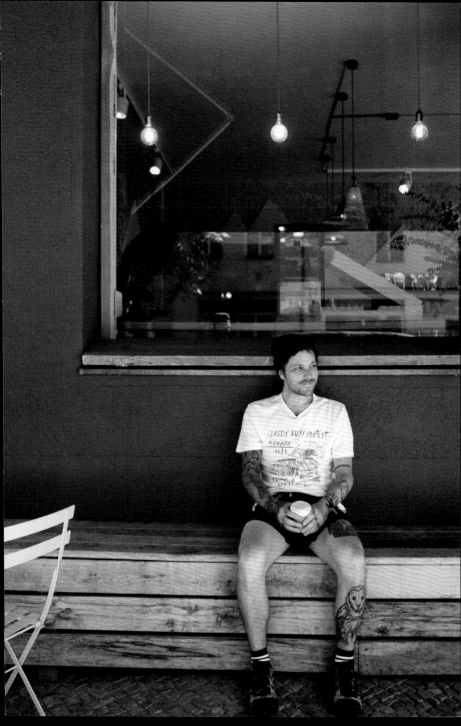

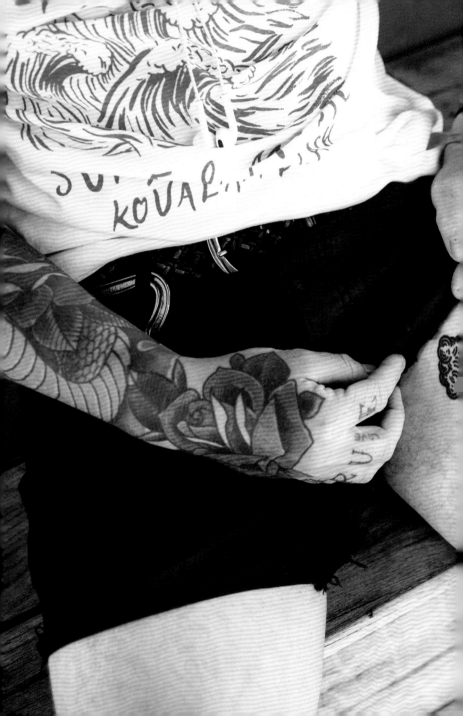

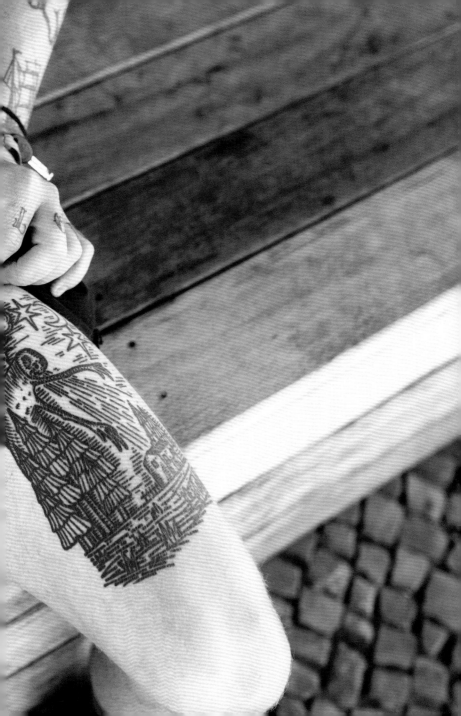

Vanessa Zolg
Architect
Style: Linework
Tattoos by Stefan Halbwachs,
Blut & Eisen

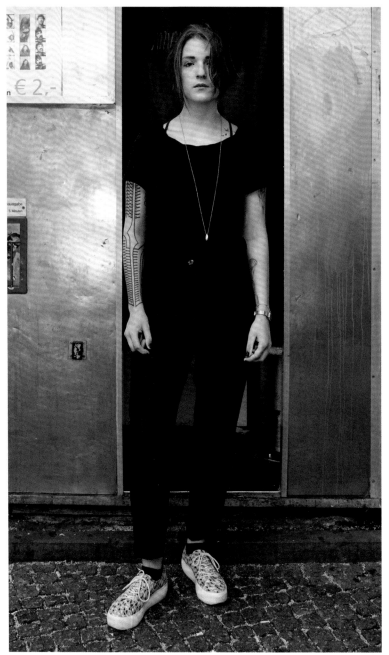

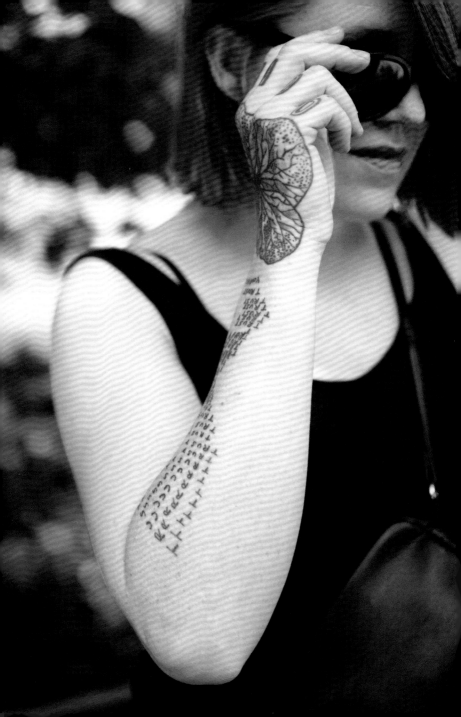

← Laurie De Kok

↓ Laura Shea
Musician
*Spotted: Klunkerkranich,
Karl-Marx Straße*
Style: Modern

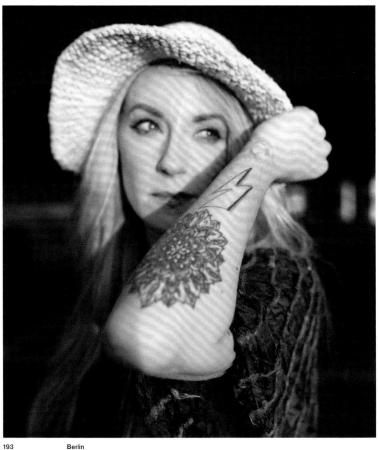

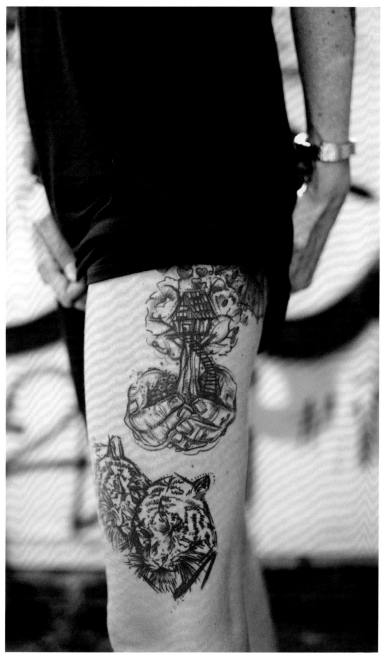

Carolin Weinert
Assistant to a Heart
Specialist
↙→

Sandra Höferer
Waitress
Friendship tattoos by
Stefanie Hübscher
↘→

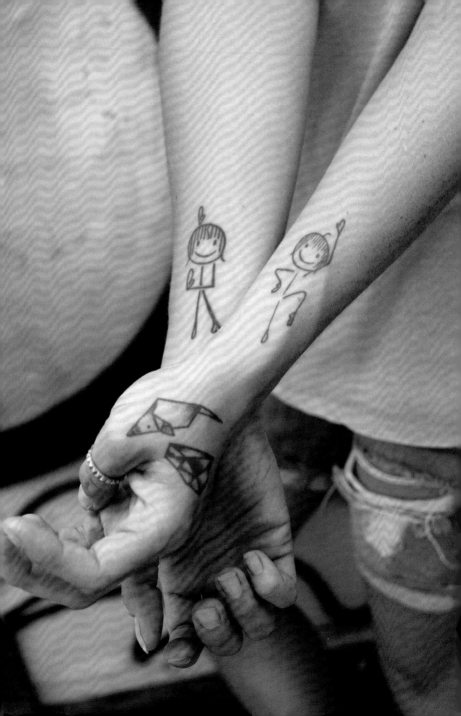

'Friendship tattoos are about best friends
always looking out for each other.'

– Sandra Höferer

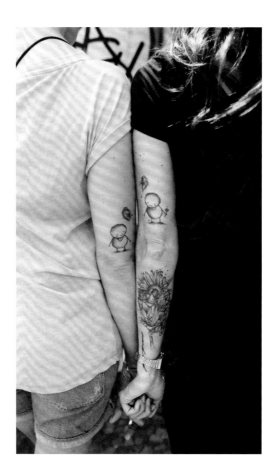

Georgie Harrison
Tattooist
Spotted: AKA Berlin
Style: Blackwork
Tattoos by Thomas
Burkhardt; Rafael Silveira

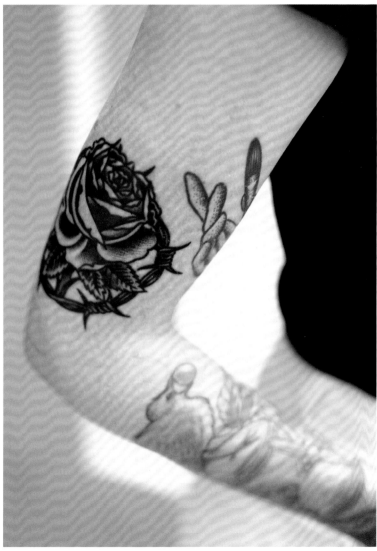

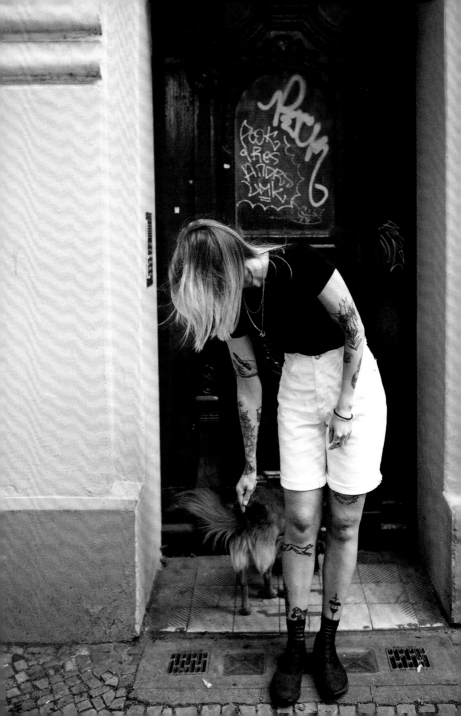

Diana Gnaude

'Tattoos are my lifestyle,
my story in skin.'
— *Diana Gnaude*

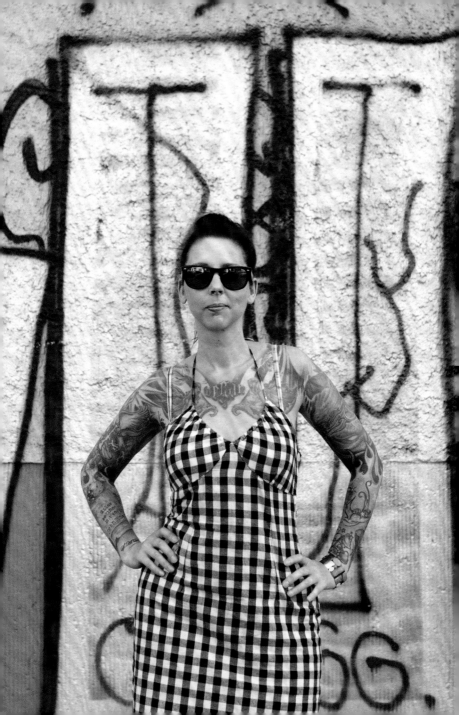

Wendy Pham
Tattooist
Spotted: Taiko Gallery
Style: Japanese
Tattoo by Shige,
Yellow Blaze

The first time I noticed tattoos was on Chester Bennington, who was the lead singer of Linkin Park, in a music video. Then I started to notice tattoos a lot more on TV. I didn't know anyone with tattoos; my parents are fairly conservative Vietnamese immigrants.

Tattoos are my passion, my hobby and my job. Tattoos are also decorative and can represent meaningful things, but they don't define who a person is inside.

My style of tattooing is a mix of Japanese, Illustrative, horror and cute stuff. I usually cover my tattoos in public because I don't like drawing attention to myself, plus it protects them from the sun.

I enjoy it when there is a bit of humour or a story behind a tattoo. It makes it more personal for the client and more fun for me to design.

My advice to anyone who wants to get tattooed is this: choose an artist based on their style – not the price. Know that tattoos age and aren't perfect. Be prepared for possible regret.

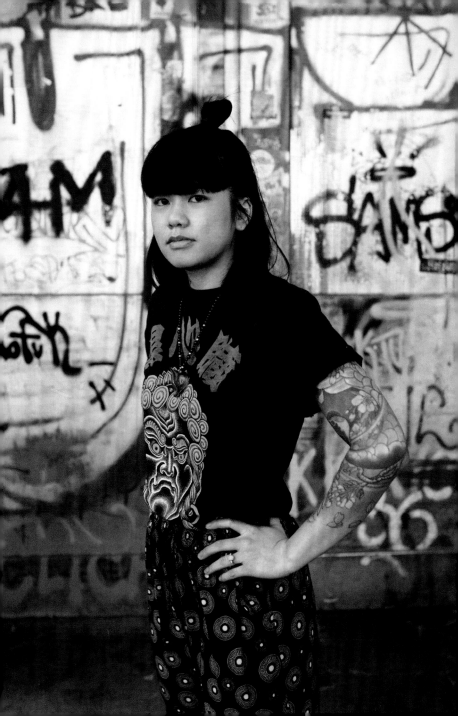

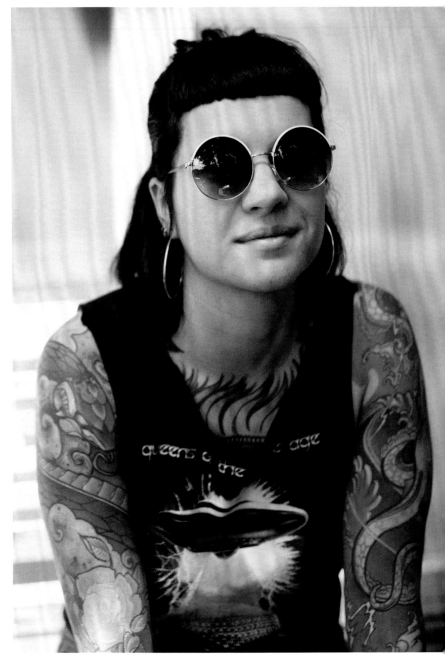

Tanja Schulze
Tattooist
Spotted: Treptow
Style: Traditional
Tattoos by Wendy Pham,
Taiko Gallery; Annie Frenzel,
Lowbrow
→

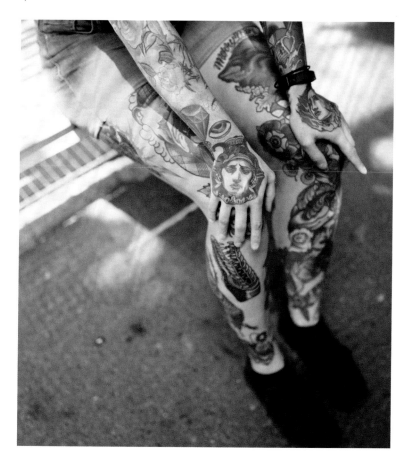

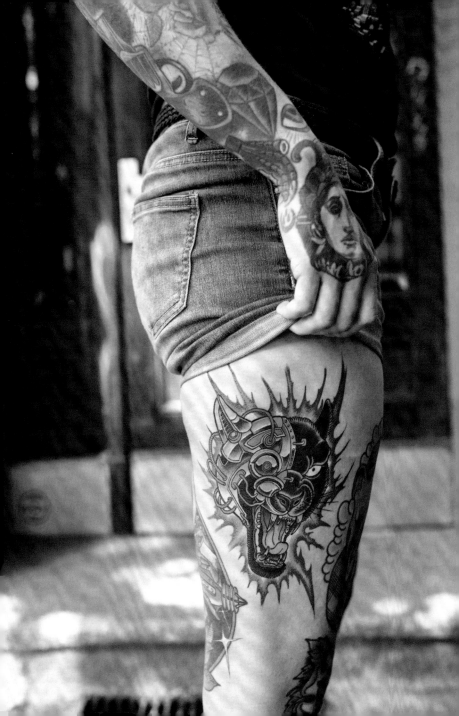

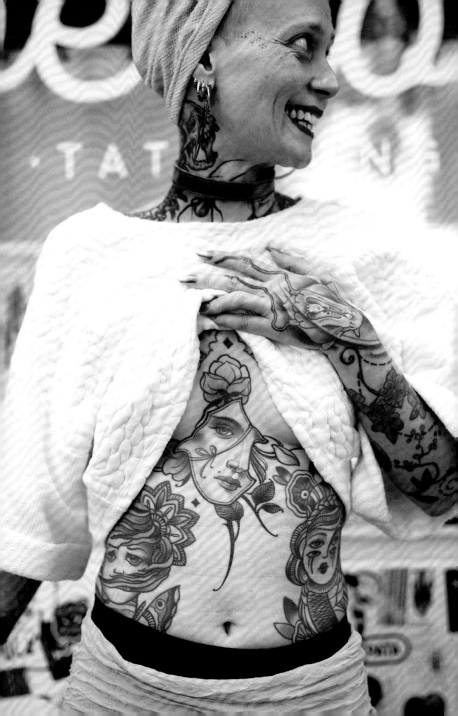

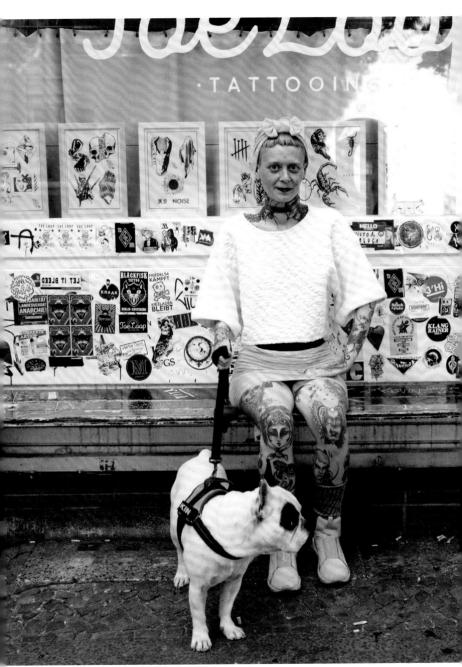

Macha Romaniuk
Tattoo Shop Manager
Spotted: Toe Loop Tattooing
Style: Neo-Traditional
Tattoos by Victor Zabuga,
Toe Loop Tattooing;
Lars Uwe, Loxodrom
←

Theres Smith
→

Flora Amelie Pedersen
Stylist/Blogger
Style: Japanese
Tattoos by Wendy Pham,
Taiko Gallery; Shige,
Yellow Blaze
→

'People tend to think I'm cooler
than I actually am because of
my tattoos. There are still days
where I question my choice to be
this heavily and visibly tattooed,
or even wish I had completely
different tattoos. But, generally,
I think they're me, and I like
who I am.'

– Flora Amelie Pedersen

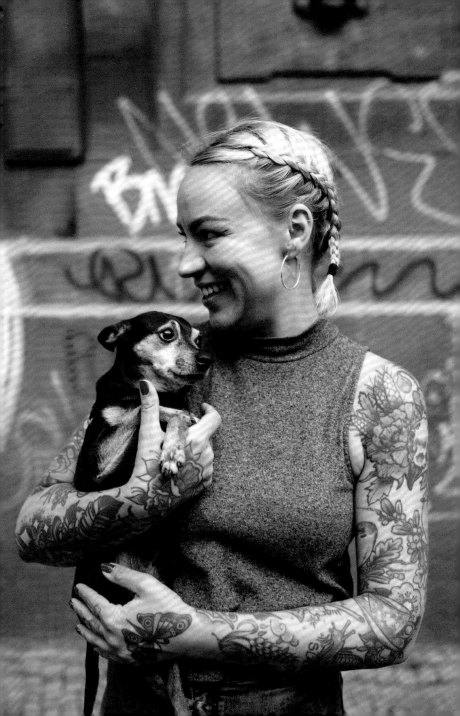

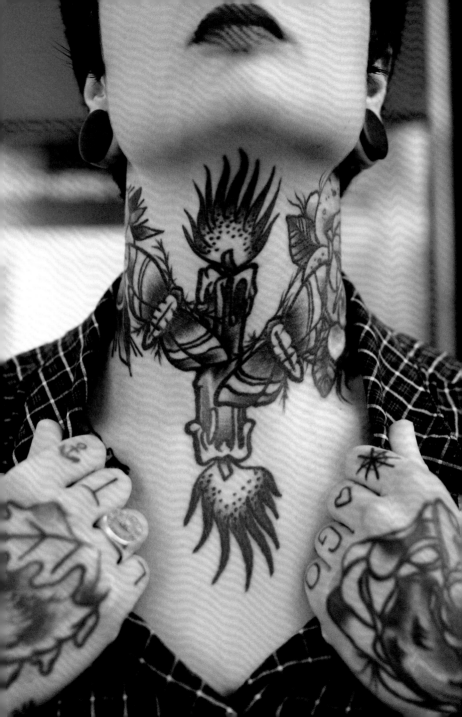

Berlin's best parlours

AKA Berlin
Pflügerstraße 6
12047 Berlin
akaberlin.com

Bitch Wedding
Burgsdorfstraße 4
13353 Berlin
bitch-wedding.de

Black Cat
Wühlischstraße 34
10245 Berlin
blackcattattooberlin.
jimdo.com

Black Mirror Parlor
Fichtestraße 25
10967 Berlin
blackmirrorparlor-blog.
tumblr.com

Bläckfisk Tattoo Co.
Reichenberger Straße 133
10999 Berlin
blackfisktattoo.de

Brust oder Keule
Danziger Straße 134
10407 Berlin
facebook.com/
BrustOderKeuleBerlin

Conspiracy Inc.
Hauptstraße 155
Schöneberg
10827 Berlin
conspiracyinctattoo.
blogspot.co.uk

DotsToLines
by appointment only
www.dotstolines.com

Loxodrom
Kastanienallee 23
10435 Berlin
loxodrom.de

Mirja Fenris Tattoo
Fichtestraße 34
10967 Berlin
mirjafenris.tumblr.com

Nevada Johnny
by appointment only
peteraurisch.com

NOÏA
by appointment only
noiia.com

Out Of Step Tattoo Parlour
Proskauer Straße 8
10247 Berlin
outofstepberlin.tumblr.com

Taiko Gallery
Schönleinstraße 33
10967 Berlin
taikogallery.com

Toe Loop Tattooing
Weserstraße 38
12045 Berlin
toe-loop-berlin.de

The city may be tiny, but it is full to the brim with culture; there is a myriad of museums – more per capita than any other city in the world. Add to that Holland's long history with tattoos, thanks to the Dutch merchant navy whose members returned home with ink from around the world, and it's little wonder that its tattoo scene is unique. Holland's capital was home to a legendary tattoo museum, opened by Henk Schiffmacher (also known as Hanky Panky, the King of Amsterdam Tattoos) in 2011. Unfortunately it recently closed, but the quality of the work created in the city is exceptional. Welcome to The Dam, just with a little more ink that you're used to.

Amsterdam

Gillian Bendanon
Style: Egyptian Tribal
Tattoos by Black Ink

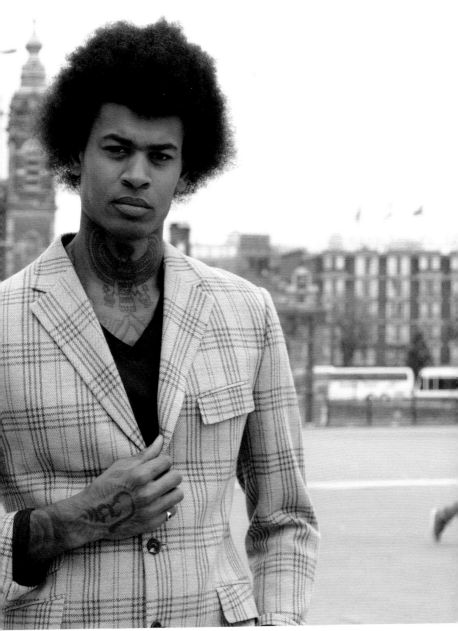

Amsterdam

Richie Hendo
Art Director
Spotted: Derde
Weteringdwarsstraat
Style: Black and Grey
Penitentiary Fineline
Tattoos by Mister Cartoon;
Jose Lopez

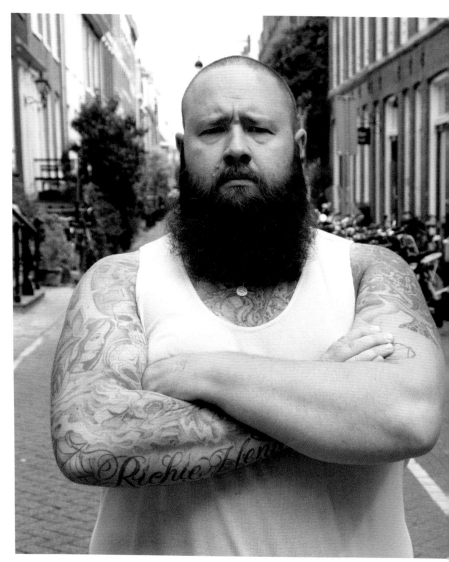

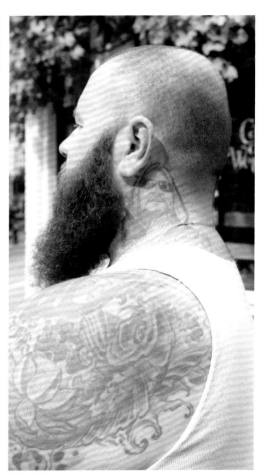

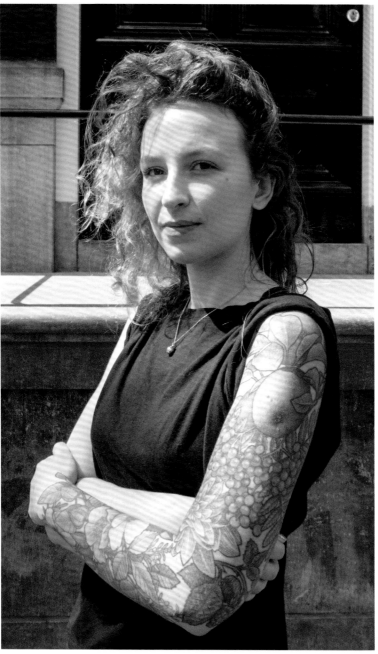

← **Maria Kociszewska**
Style: Dotwork/Blackwork
Tattoos by David Rudziński,
Theatrum Symbolica

↓ **Giverny Deenik**
Art Student
Style: Traditional Realism
Tattoos by Sander,
Inkredible Tattoos
→

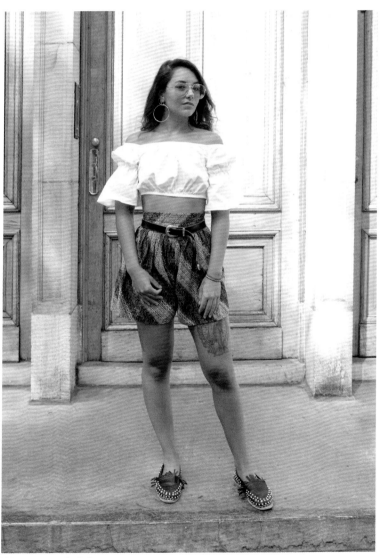

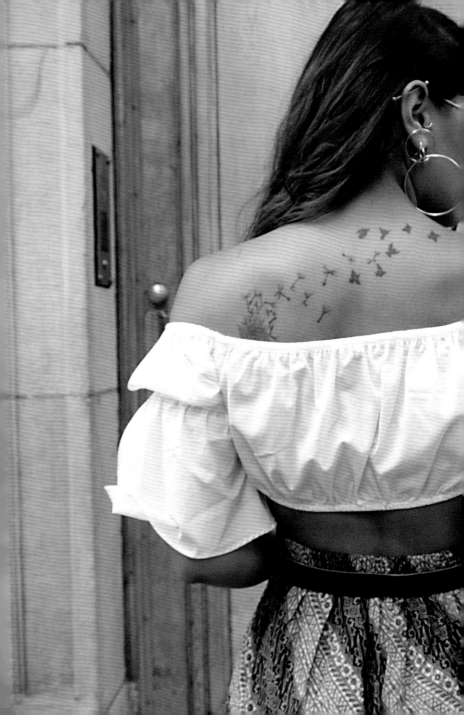

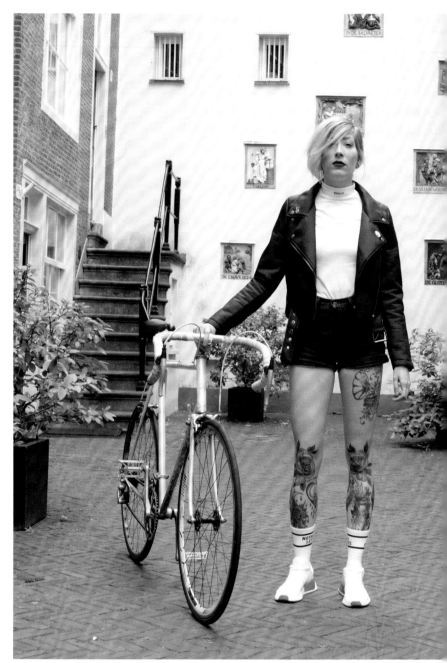

Nula Steinfort
Rehab Nurse
Style: New School/Traditional

Jesler Amarins
Project Manager, Music
and Creative Industries

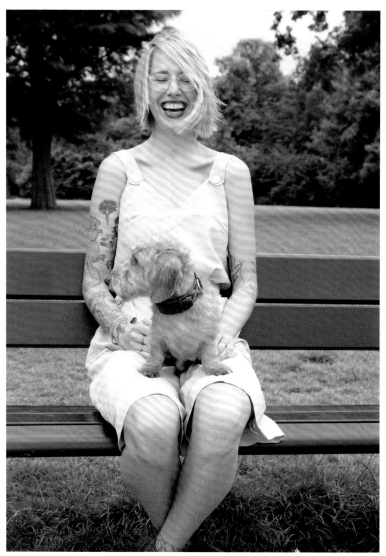

Tjeerd Braat
Creative Director
Spotted: Canals
Style: Old School/Japanese

'I am actually trans and tattoos
are a way for me to get the
power over my own body back.'

– *Loena Maas*

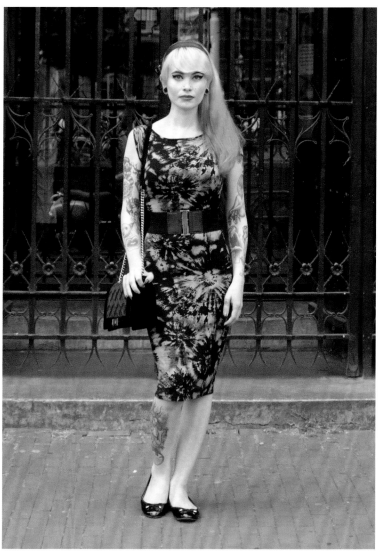

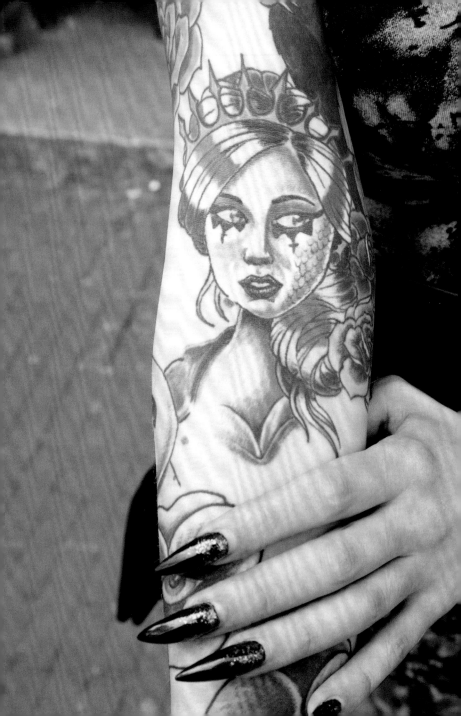

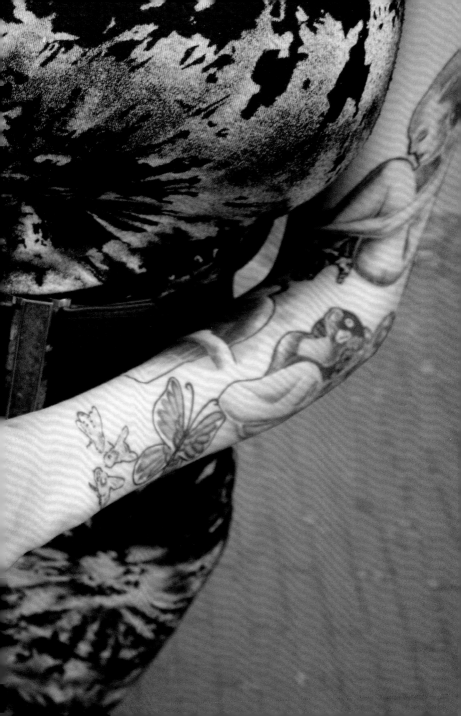

↓ Valentina Corongiu
Waitress
Style: Dotwork/Mandala

→ Pascal Ummels
Menswear Tailoring
Spotted: Barber Birdman
Tattoo by Nikita

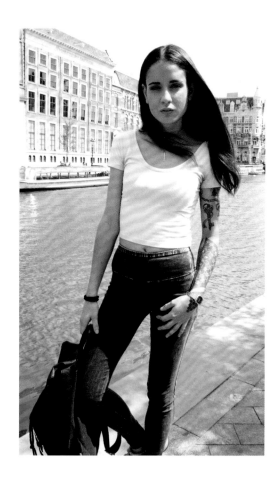

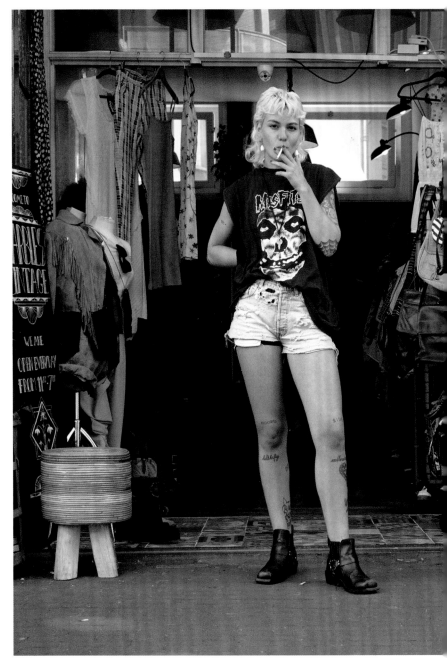

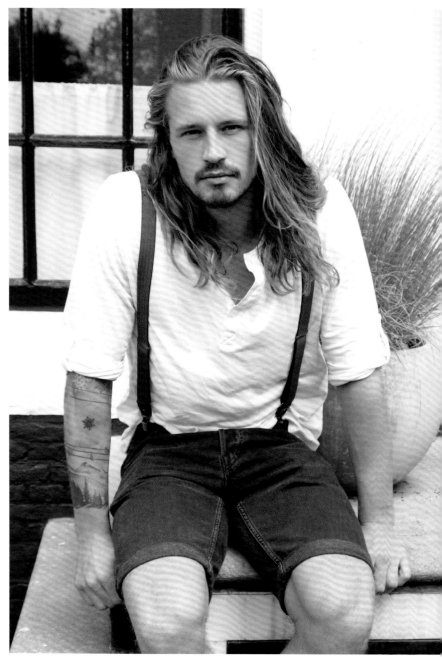

Bram van Adrichem
Style: Trash Polka
Tattoos by Hankey Jee,
Sanctus Deus,
Syndicat du Tatouage

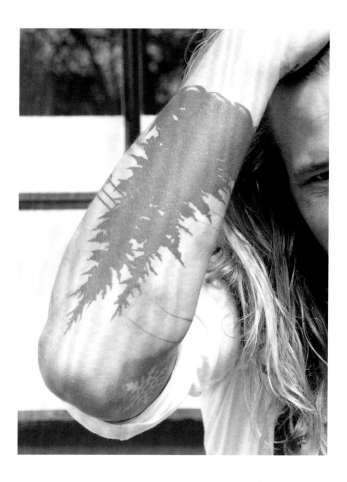

Angelique Houtkamp
Tattooist
Spotted: Salon Serpent
Tattoo Parlour

When I was a pre-teen, my auntie dated a really cool fella with a beautiful snake and dagger tattoo on his lower arm. I think I fell in love with tattoos then.

I haven't always loved art, however. My parents would take me and my sister to museums a lot, but I don't remember really liking them. I was always keen to do crafts, though, with anything I could get my hands on.

Tattoos are a part of me and a huge part of my life. As a wearer of tattoos, you absorb the tattoos into your daily life – it's as if they've always been there. As a tattooist, though, you are more conscious of them and what people would like to express with them. I think they help us deal with our basic emotions: love, loss, power, anger or fear.

Nowadays, it is almost impossible to know all the tattooers in your area; and I actually don't think the scene differs that much from city to city, country to country. With social media, everybody knows what everybody is up to instantly. Which is really cool, but also a bit of a bummer in that everything gets so generic that there are no more regional specialities. I am pretty lucky, as are my co-workers, in that our shop is well known inside and outside of the Netherlands, so we get a lot of Dutch customers with good taste and a lot of travellers, who usually bring really great design ideas.

As an artist, I also trust other artists completely with my own tattoos. In my opinion, customers who don't trust the artist usually don't trust their own taste or judgement. I know a great tattoo artist when I see one, and know they will produce their best work if the client doesn't try to control the details too much. Usually I give them a few subjects to pick from, just so they can choose what suits them best, and then leave it all to them.

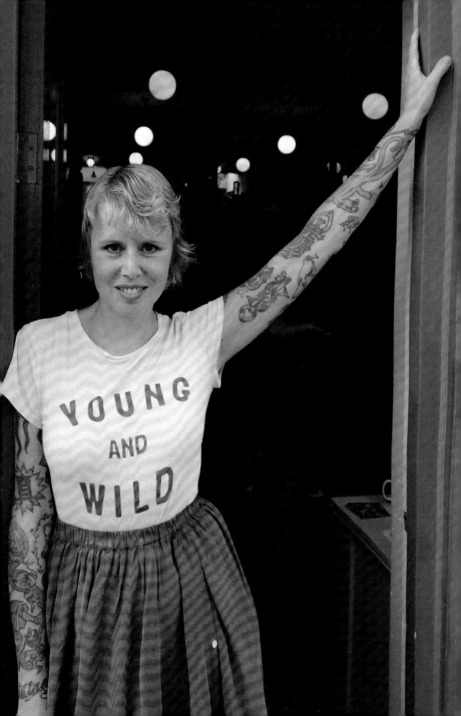

Josje van Hagen
Entrepreneur
Tattoos (mostly)
by Jay Freestyle

'I just love tattoos! I love looking different from the rest. My tattoos don't have a special story. When I think it's awesome, I want it!'

– *Josje van Hagen*

Dayana Isadora Drillich
Bar Worker
Spotted: Koffie Academie
Style: Original/American

Sven Borst
Style: Polynesian/Haida/
Old School/Japanese
Tattoos by Ivar Verheij

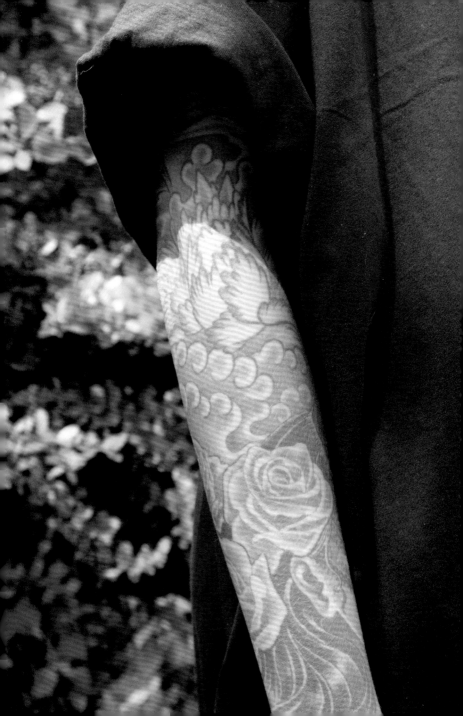

Nikita Verberner
Tattooist
Spotted: Nikita Beaux Ink
Style: Dotwork/
Sacred Pattern

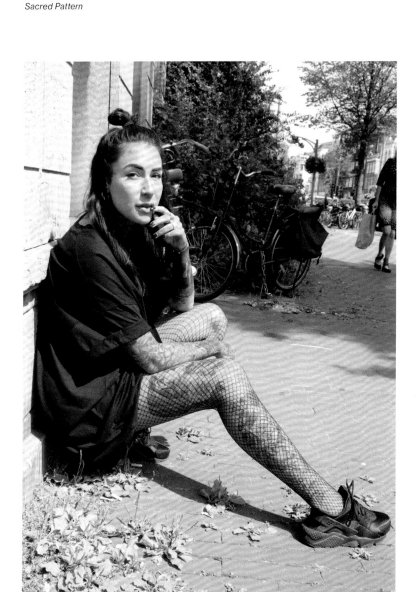

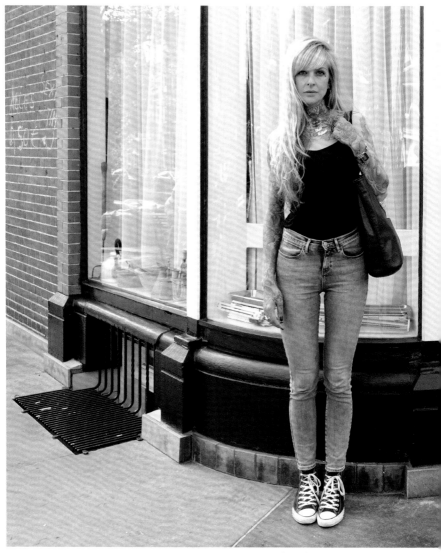

Sabina Dik
Creative Processes
Coordinator
*Spotted: Amsterdam
Wiechmann Hotel*
→

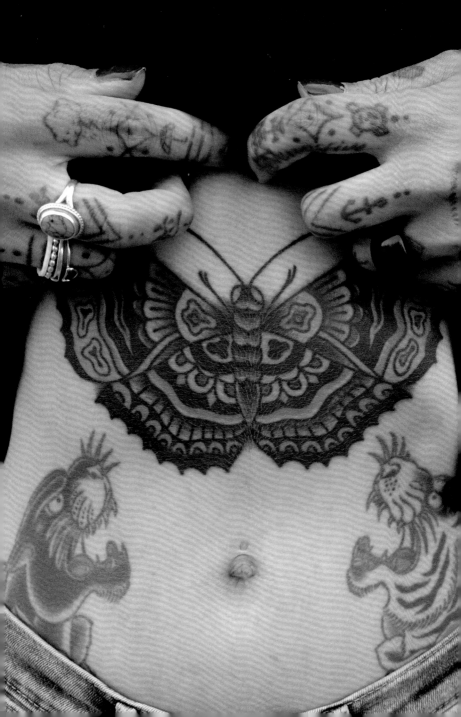

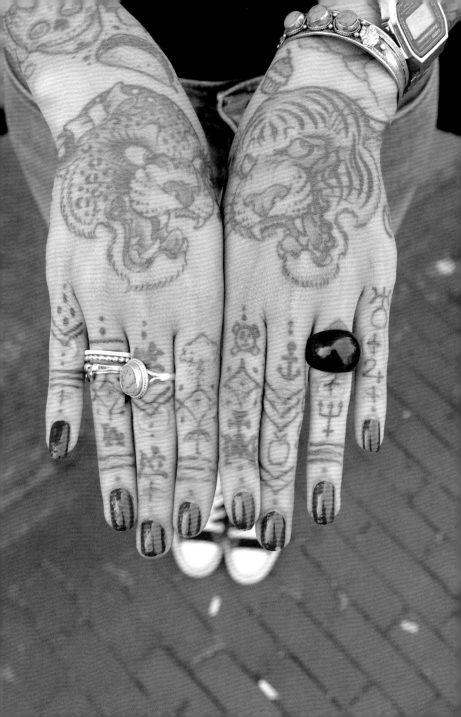

Emiel van Rijn
Model
Style: Old School

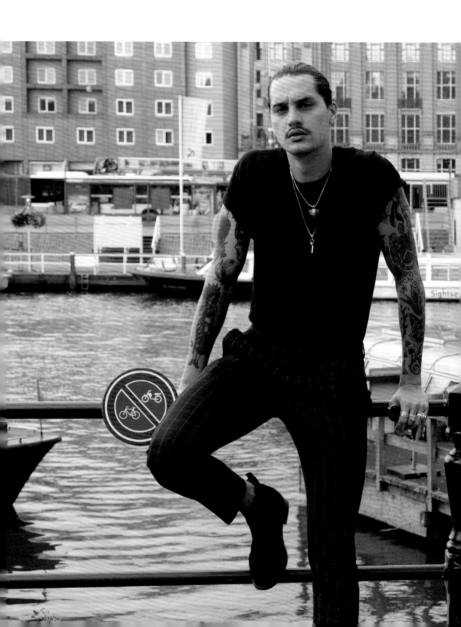

↓ Justin Emot
Chef

→ Cristel Ball
Jewellery Designer
Spotted: Central Station
Style: Traditional Realism

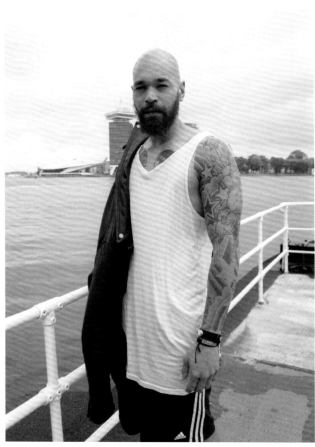

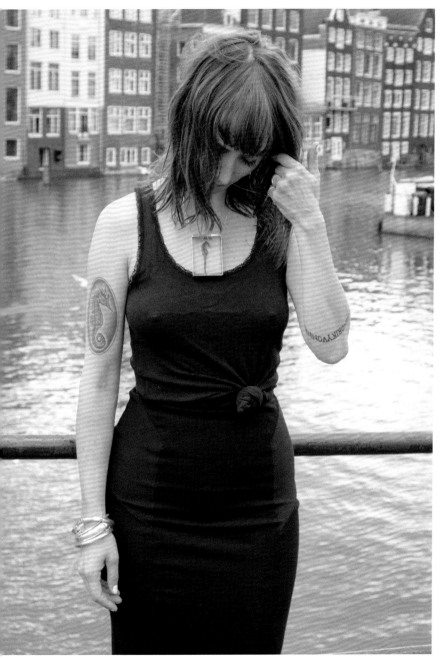

257 Amsterdam

Boudewijn Jurriaans
Barber
Style: Neo-Traditional
Tattoos by Toby Gawler,
Salon Serpent Tattoo Parlour

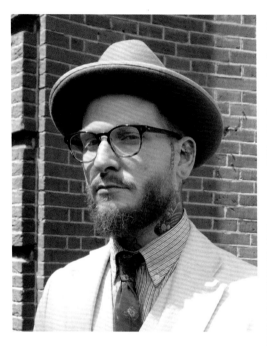

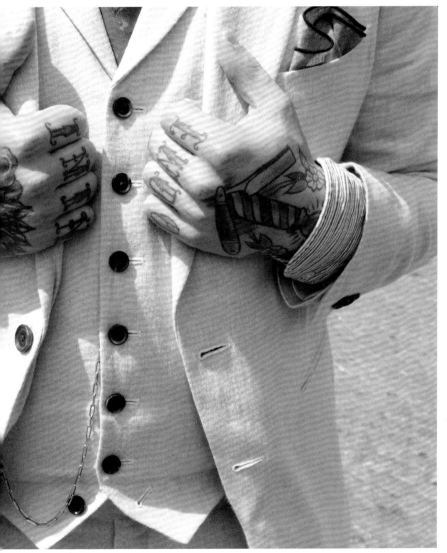

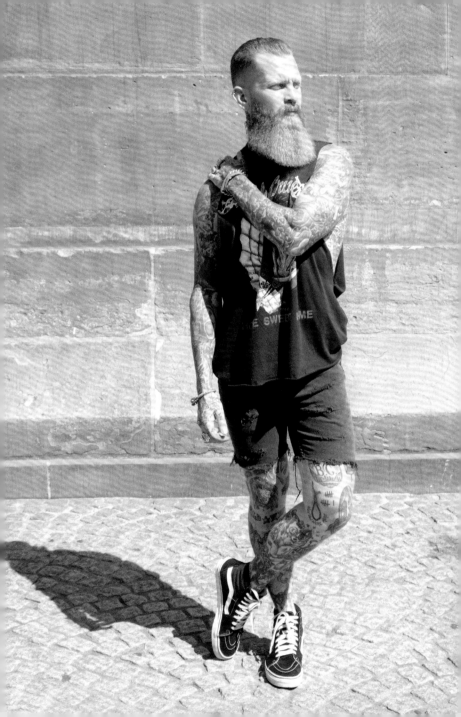

Jake Lewis-Hurn
Barber
Style: Old-School/Traditional
Tattoos by Tom Kelly,
Cherry Blossom

↓ Danny Roumimpel
Event Director
Style: Old School

→ Katie-Rose Petley
Copywriter
Style: Traditional
Tattoos by Matt Houston

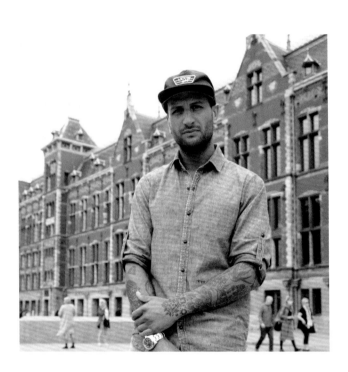

'People always ask if my husband's name is Frank. I laugh and say I love my husband way too much to get his name tattooed on my body!'

– Katie-Rose Petley

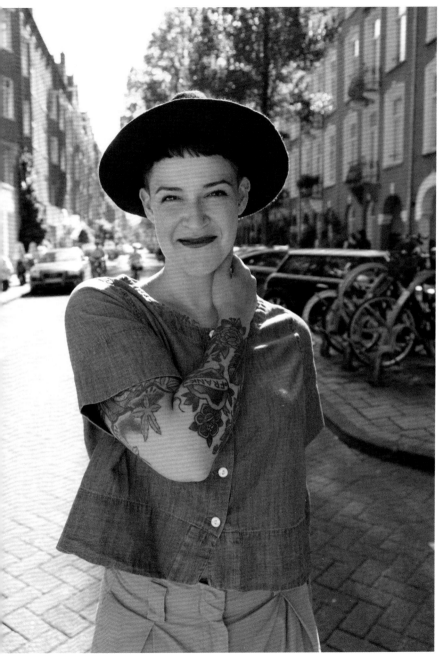

Joëlle 'Space Kitty' van der Vegte
Student
Style: Neo-Traditional
Tattoos by Berend-Jan Luft,
MIA'S Tattoo Vision

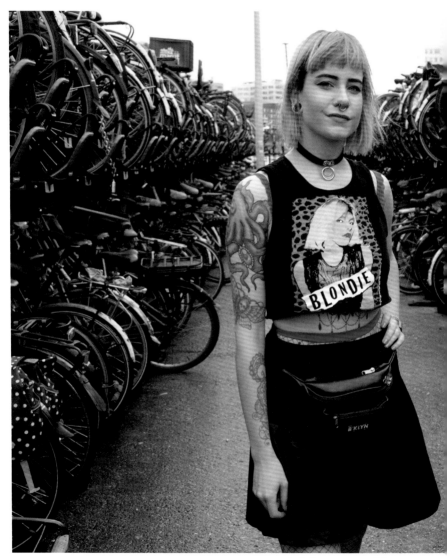

Amsterdam

Amsterdam's best parlours

The Blue Blood Studios
Kinkerstraat 14
1053 DV Amsterdam
thebluebloodstudios.com

Hanky Panky
Oudezijds Voorburgwal 141
1012 ES Amsterdam
hankypankytattoo.nl

House of Tattoos
Haarlemmerdijk 130 C
1013 JJ Amsterdam
houseoftattoos.nl

Motorink Finest Tattooing
Jonge Roelensteeg 4A
1012 PL Amsterdam
facebook.com/Motorink

The Preacher's Son
Utrechtsestraat 23
1017 VH Amsterdam
thepreachersson.nl

Salon Serpent Tattoo Parlour
Jacob van Lennepstraat 58
1053 HL Amsterdam
salonserpent.com

Wise Kid Tattoo
Dirk van Hasseltssteeg 47
1012 NE Amsterdam
wisekidproductions.com

New York City has had a somewhat tumultuous relationship with tattooing.

Banned for 35 years, tattooing finally became legal in 1997, bringing the art form out from the dingy, poorly lit backrooms and into the well-maintained and professional studios people have come to expect today. Tattooists have gone from being law-breakers to fine artists and celebrities in their own right. The city is now home to almost 300 tattoo shops; some are boutique havens attracting tattoo collectors the world over. One of these, Saved Tattoo, is co-owned by tattooist Scott Campbell, whose roots are in the fashion industry – he tattooed Marc Jacobs – and who was also famously part of an art installation in 2015 at the Milk Gallery. Titled *Whole Glory*, visitors to the installation stuck an arm through a hole to receive a free tattoo – which they weren't allowed to see until it was finished. The diverse crowd of people featured over the following pages are as varied as the city itself, from tattooed mothers and lawyers to high-end tattooists. NYC tattoo culture is bustling, exciting and ever-evolving.

New York

Meghan Shadis
Urban Outfitters
Warehouse Associate
Tattoos by Joe Palladino
and John Lemon
→

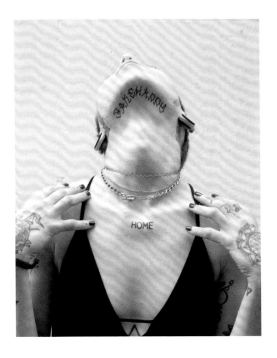

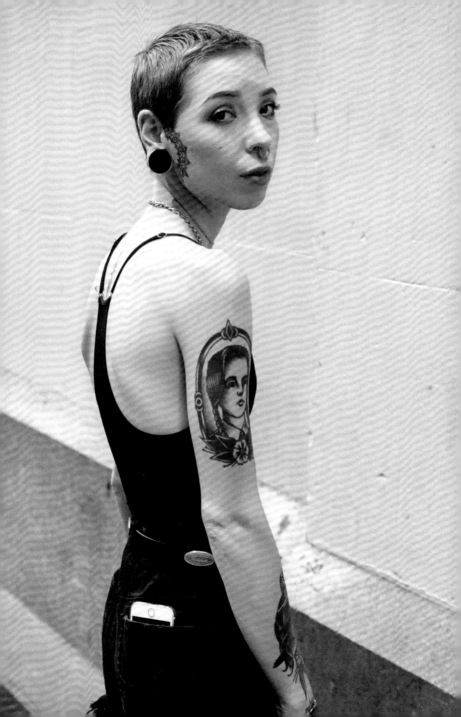

Marisol King
Social Worker
Spotted: Washington
Square Park
Tattoos by Annie Lloyd

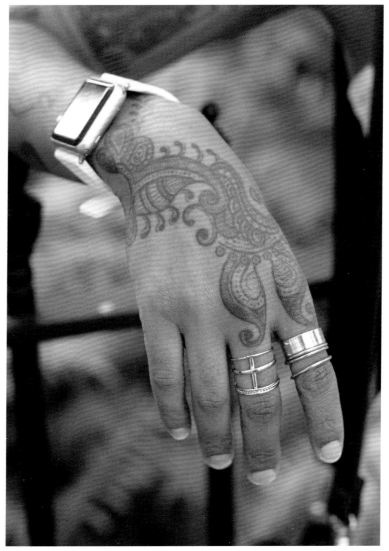

Daniel Singh
TV
Spotted: Bushwick

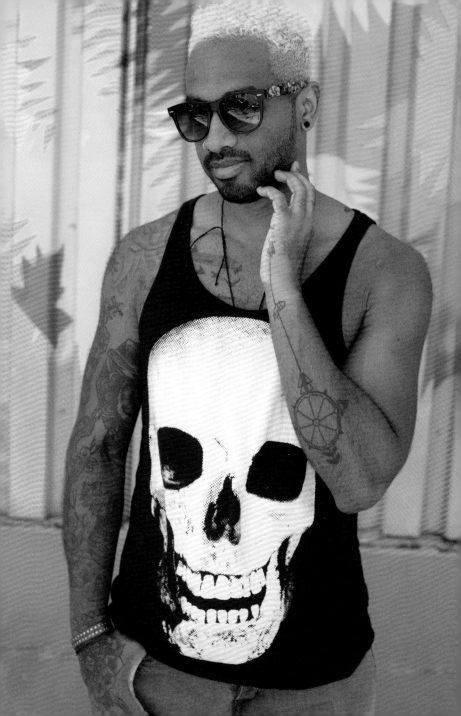

Marcy Cruthirds
Bike Mechanic
Spotted: Greenpoint

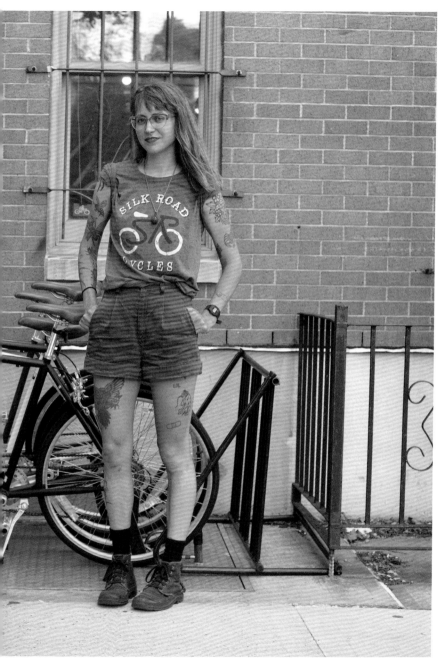

Britni Sweet
Design Business Owner
Spotted: Clinton Hill
Style: Realism
Tattoos by Tamara Santibanez,
Saved Tattoo

'Having permanent art is like
a collectable stamp book.'

– *Britni Sweet*

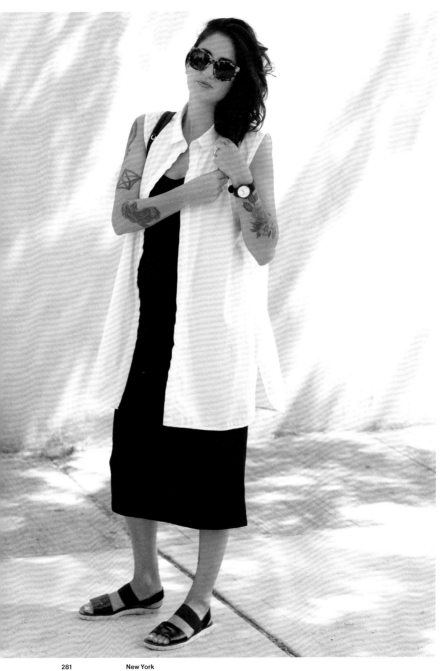

Cris Cleen
Tattooist at Saved Tattoo
Style: Traditional

I started getting tattooed when I turned 18, and fell in love with the flash and the way the designs had so much heart and sentiment. It was a language I understood. They were all powerful symbols of love, lust, faith, devotion. I like tattoos that show thought and narrative, as well as crude and primitive designs. If the work comes from what you love, it will resonate with people and attract people that, in turn, you like.

I take doing tattoos very seriously, but I also want people to feel comfortable. Older generations of tattooers wanted to sell you a tattoo experience that said: 'We're serious, we care, and we know what we're doing.' That attitude always appealed to me. I just want people to know that I've put my heart and soul into all my designs; they are curated and thought-out.

I have a book of flash that customers can pick anything they like from. I do this because that is what tattoos are: they are designs that all people are worthy of wearing. That's the whole appeal for me, ever since I got my first tattoo. Tattoos are ideas that we all relate to. That's what I'm interested in drawing – things that we understand and feel. Getting something just for you – that no one else can have – is elitist, and takes away the sharing experience of wearing something that other people see and think, yeah, I get it, I feel that too.

No tattoo is custom. If you want an image that I haven't done and it goes on the internet, someone else will want it and if I don't do it, they will get it from someone else. So everything becomes flash. I think you can convey any sentiment with a tattoo, using the vocabulary that exists with symbols and images that are universally beautiful.

I know what I'm doing – leave the designs and ideas up to me. If you feel what I'm saying in a piece, get it tattooed – now it's yours, too.

Amelia Kersten
Tattoos by Mike Lucena,
Flyrite Tattoo; John Sultana,
Saved Tattoo; Ron H. Wells

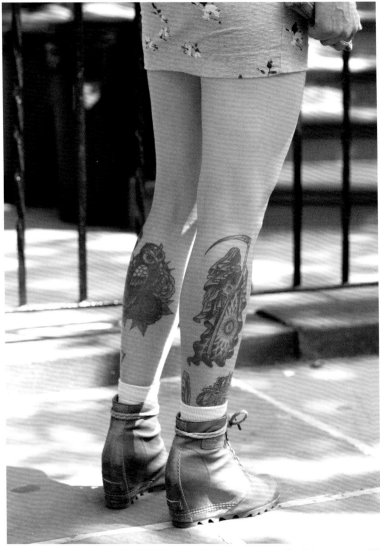

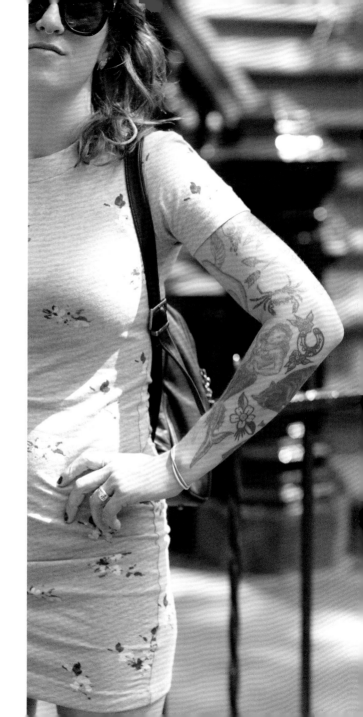

Jonah Rollins
Student/Retail
Spotted: Soho
Style: Blackwork
→

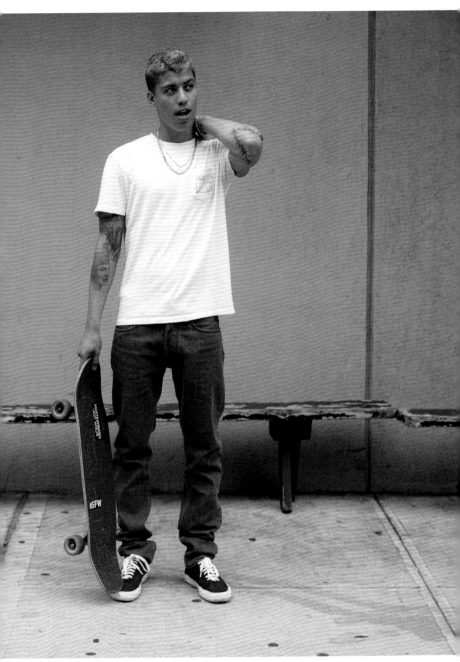

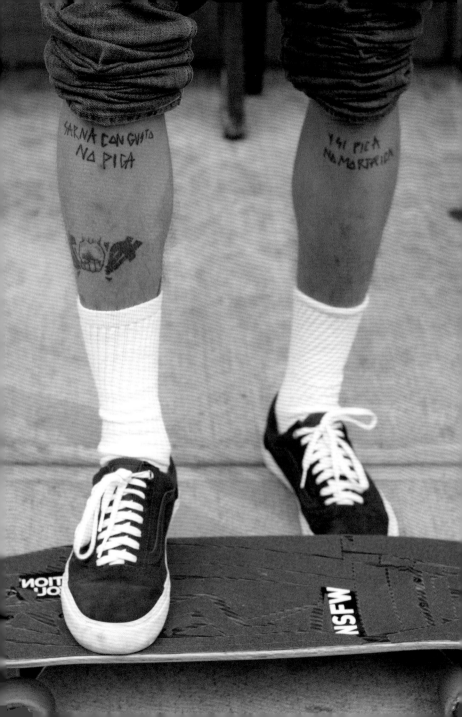

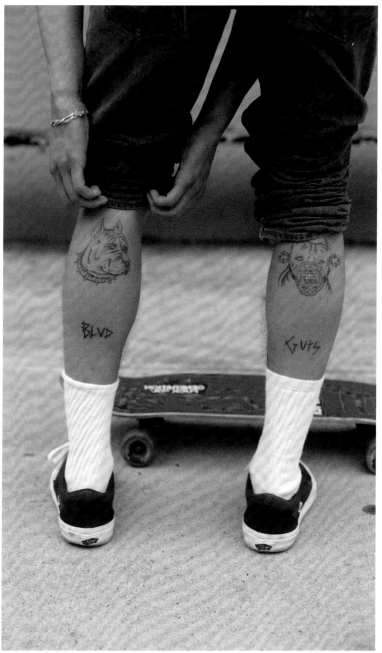

Serenity Smith
Artist
Spotted: Washington
Square Park
Style: Traditional

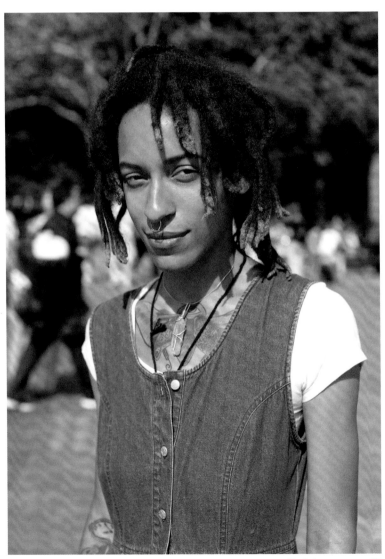

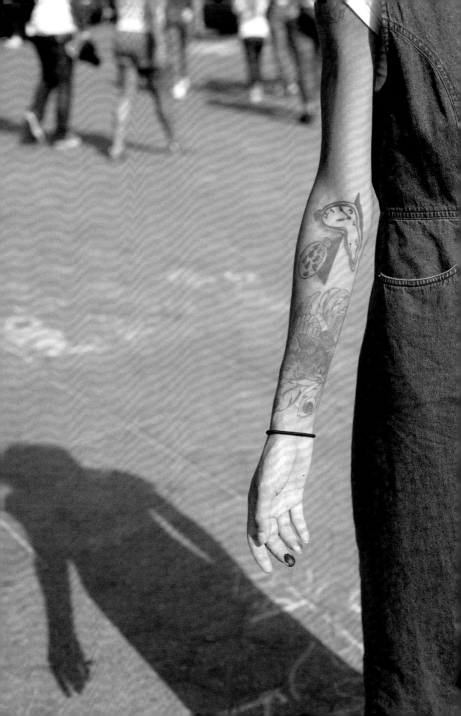

Christopher Hill ↙
Advertising
Spotted: Astor Place
Style: Queer

Rob Aquino ↘
Filmmaker
Spotted: Astor Place
Style: Modern/Queer

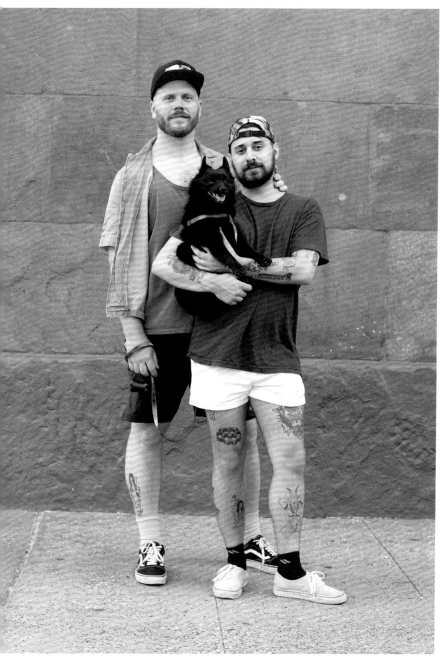

Tashay Gonzalez
Project Manager,
Advertising
Tattoos by Kristi Walls,
Bang Bang NYC

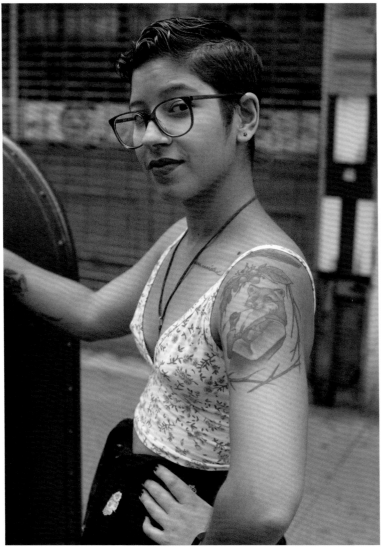

Cellini Kim
Spotted: Cha Cha Matcha, Soho
Style: American Traditional
Tattoos by Dave Halsey

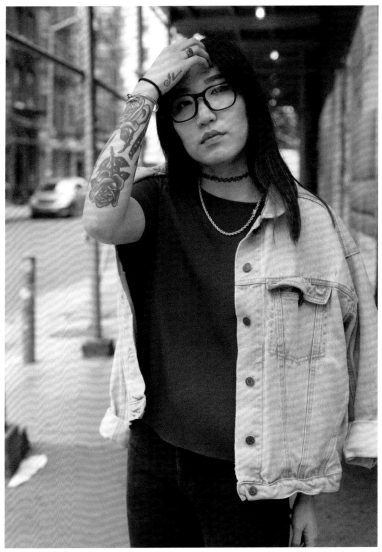

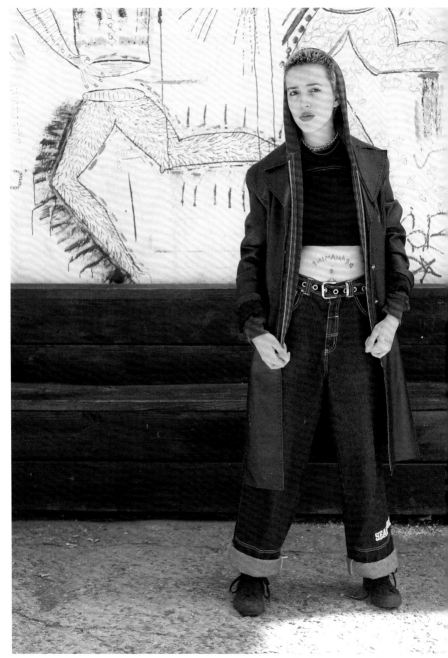

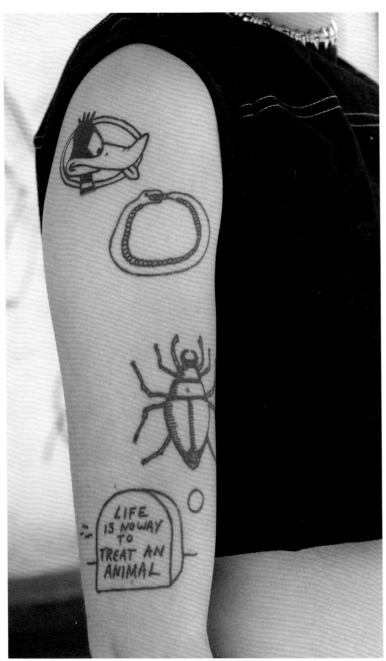

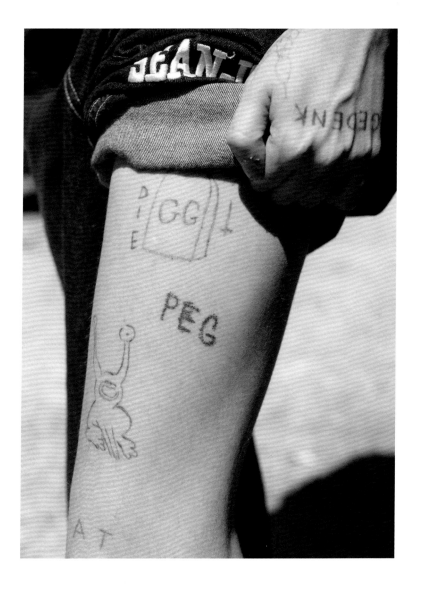

Ivan Kostadinov
Advertising
Spotted: Bushwick
Tattoo by Darren Hall

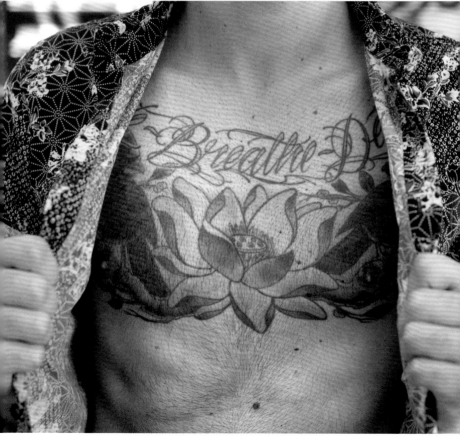

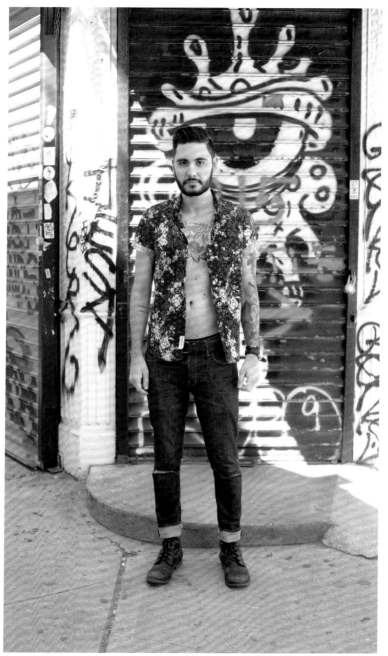

Eddy DeMartino
Furniture Designer
Spotted: Union Square
Style: Traditional
Tattoos by Brandon Swanson

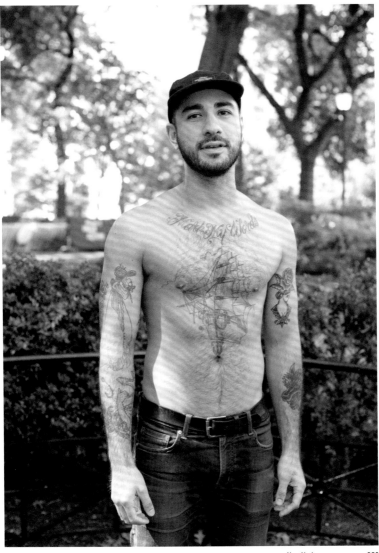

Virginia Elwood
Tattooist
Spotted: Brooklyn
→

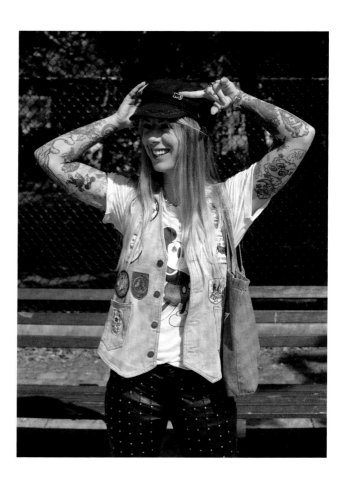

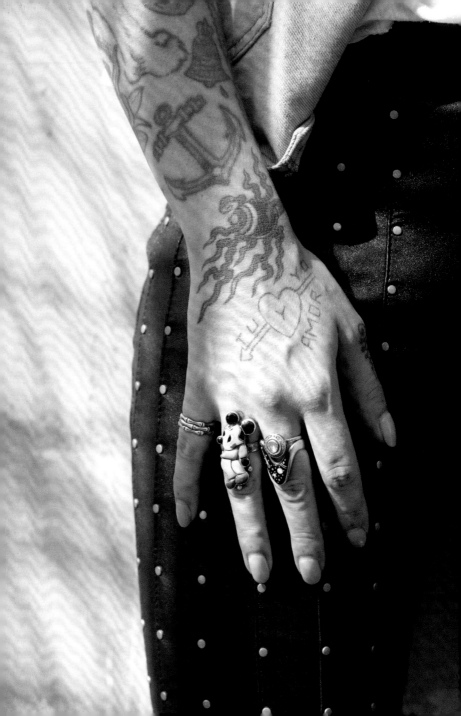

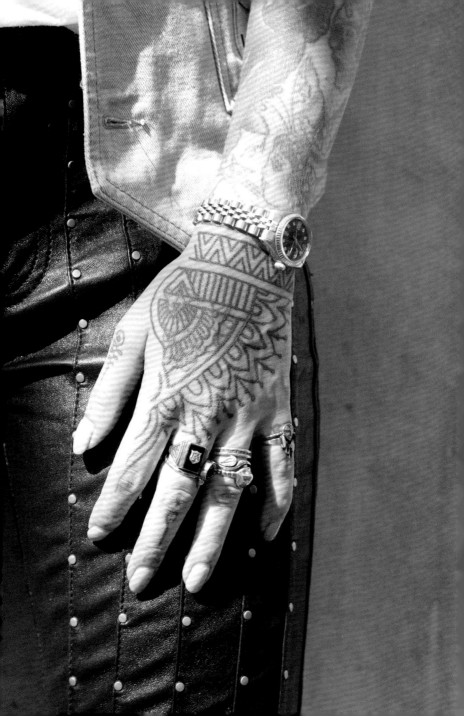

Marisa Kakoulas
Spotted: Athens Square Park
Style: Ornamental/
Blackwork/Dotwork

'I'm no longer seen as badass,
but I also don't have to wear
a turtleneck in the summertime,
so I'll take that trade-off.'

– *Marisa Kakoulas*

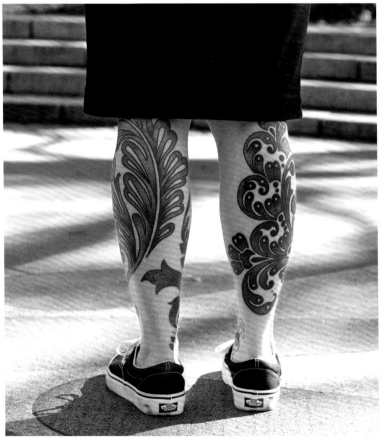

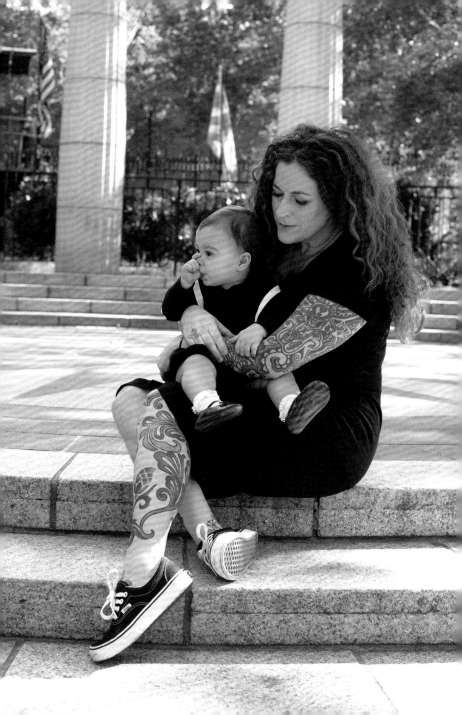

Joseph Merrill
Designer
Spotted: Williamsburg
Style: American Traditional

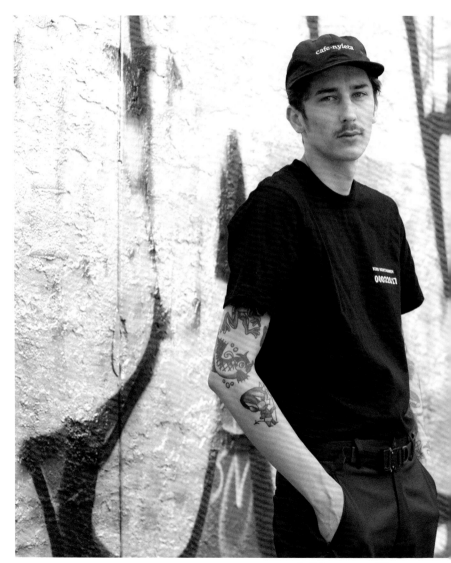

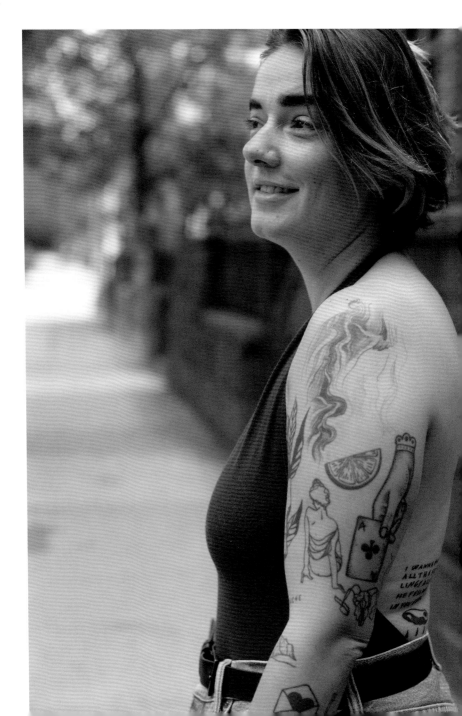

Kristen Chiucarello
Freelancer
Spotted: Bedford-Stuyvesant
Style: Blackwork
Tattoo by Ana and Camille,
Sans Bavures

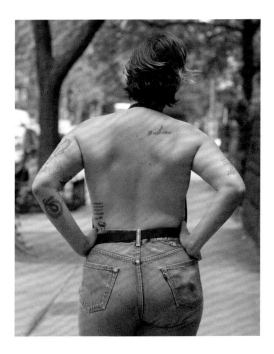

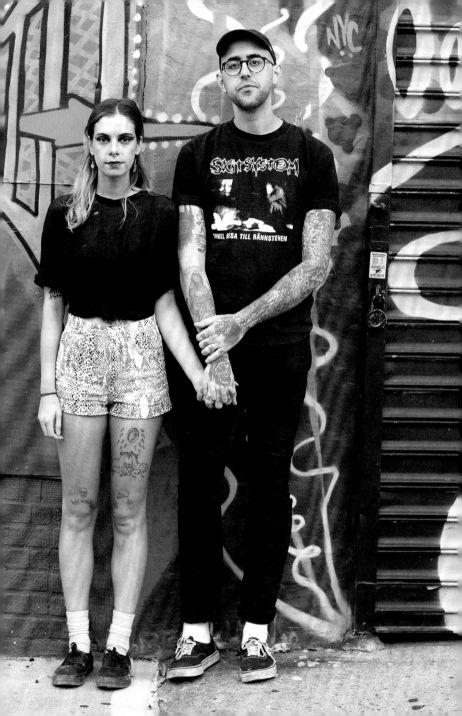

↓ Kendall Borland
Artist
Spotted: Bushwick
Style: Black and White Linework
←

→ Joshua Robinson
Chef
Spotted: Bushwick
Style: Traditional
←

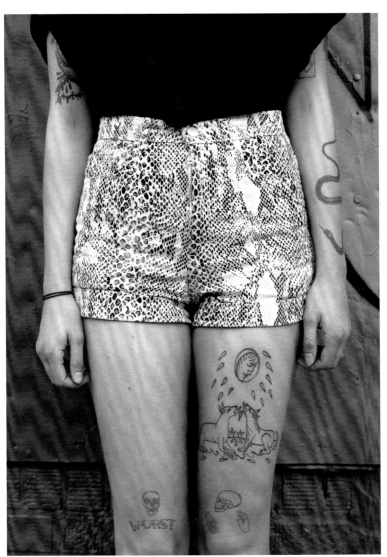

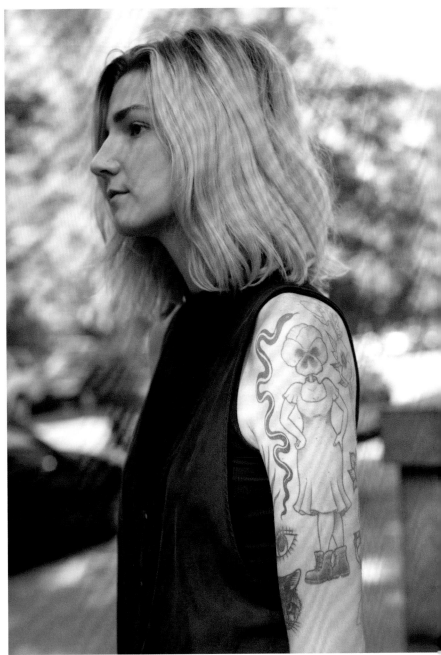

Erika Williams
Florist
Spotted: Sprout Home,
Williamsburg
Style: Neo-Traditional
Tattoos by Gareth Hawkins

Simone Thompson
Photographer
Spotted: Bedford-Stuyvesant
Tattoo by Joseph Bryce

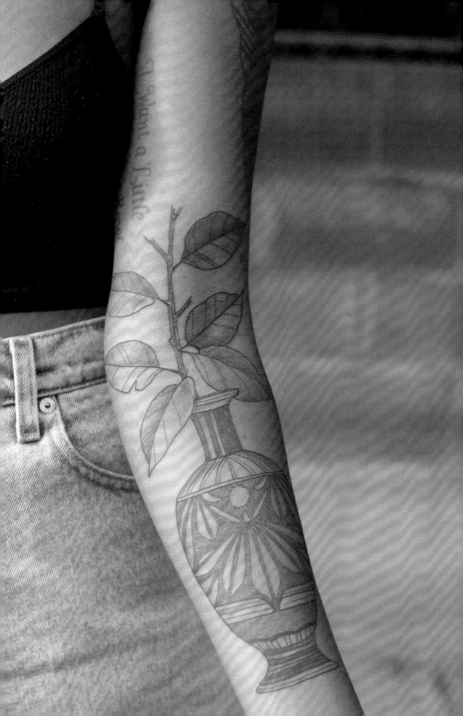

Rose Hardy
Tattooist
Spotted: Kings Avenue Tattoo
→

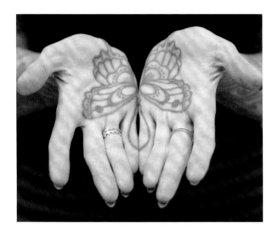

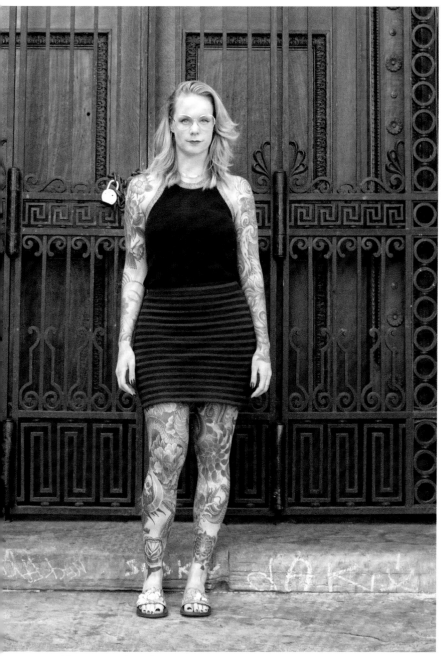

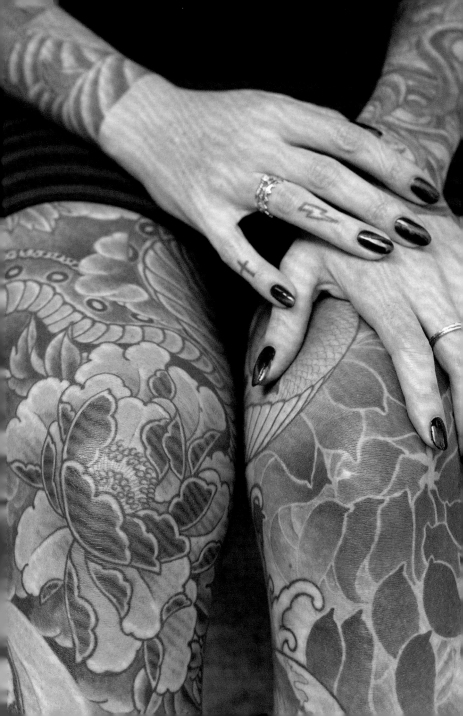

New York's best parlours

Allied Tattoo
48 1/2, Grattan Street
Brooklyn, NY 11237
alliedtattoo.com

Bang Bang NYC
328 Broome Street
New York, NY 10002
bangbangforever.com

Daredevil Tattoo
141 Division Street
New York, NY 10002
daredeviltattoo.com

East River Tattoo
1047 Manhattan Avenue
Brooklyn, NY 11222
eastrivertattoo.com

East Side Ink
95 Avenue B
New York, NY 10009
eastsideinktattoo.com

Smith Street Tattoo Parlour
411 Smith Street
Brooklyn, NY 11231

Electric Anvil Tattoo
721 Franklin Avenue
Brooklyn, NY 11238
electricaniltattoo.com

Fleur Noire Tattoo Parlour
439 Metropolitan Avenue
Brooklyn, NY 11211
fleurnoiretattoo.com

Fun City Tattoo
94 St Mark's Place
New York, NY 10002
funcitytattoo.com

Grit N Glory
186 Orchard Street
New York, NY 10002
gritnglory.com

Invisible Tattoo
148 Orchard Street
New York, NY 10002
invisiblenyc.com

Kings Avenue Tattoo
188 Bowery
New York, NY 10012
kingsavetattoo.com

Last Rites Tattoo Theatre
325 W 38th Street
New York, NY 10018
lastrites.tv

Magic Cobra Tattoo
775 Driggs Avenue
Brooklyn, NY 11211
magiccobratattoo.com

Majestic Tattoo NYC
1086 Broadway
Brooklyn, NY 11221
majestictattoonyc.com

New York Adorned
47 Second Avenue
New York, NY 10003
nyadorned.com

Red Rocket Tattoo
78 W 36th Street
New York, NY 10018
redrockettattoo.com

Rose Tattoo Parlour
382 Graham Avenue
Brooklyn, NY 11211
rosetattoonyc.com

Saved Tattoo
426 Union Avenue
Brooklyn, NY 11211
savedtattoo.com

Three Kings Tattoo
572 Manhattan Avenue
Brooklyn, NY 11222
threekingstattoo.com

Welcome Home Tattoo
by appointment only
welcomehome.studio

West 4 Tattoo
163 West 4th Street
New York, NY 10014
west4tattoo.com

Attracting wannabe actors aplenty, LA is a city of ambition, and not just for the film industry. There are tattoo shops dotted all over the streets – just drive down to Hollywood Boulevard or Melrose, and there's a plethora. Thirty-six per cent of young adults in the US have been under the needle, and that percentage is undoubtedly higher in La La Land – a city full of celebrities, skater punks, surfers and socialites. And, of course, also home to the iconic TV programmes *LA Ink*, which brought Kat Von D to fame, and *Ink Masters*, bringing tattoo culture from subculture to suburbs. If you fancy rubbing shoulders with someone famous, head to Shamrock Social Club – rumour has it that Lady Gaga, David Beckham and Rihanna have all had designs inked onto their skin here. From rockabilly beauties (an LA staple) to tattooed dudes with surfboards (of course), this chapter captures LA's randomness and vastness picture perfectly.

Los Angeles

Michelle Carr
Style: Traditional
Tattoos by Craig Jackman,
American Electric Tattoo

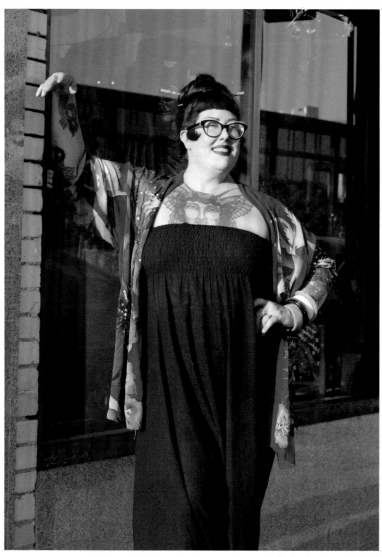

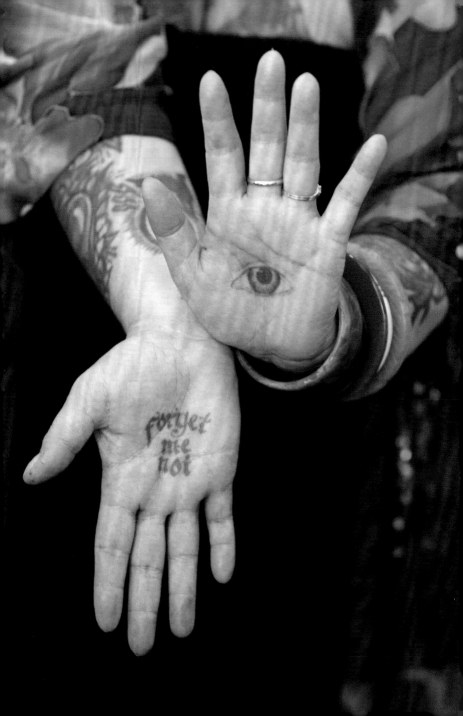

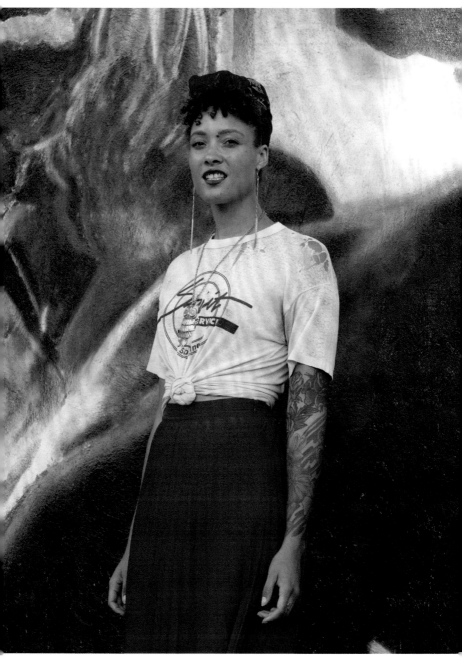

← Elyse Cizek
Poet/Actress/Musician/
Aesthetician
Spotted: Silver Lake

↓ Ally Toal
Interior Designer
Spotted: Silver Lake
→

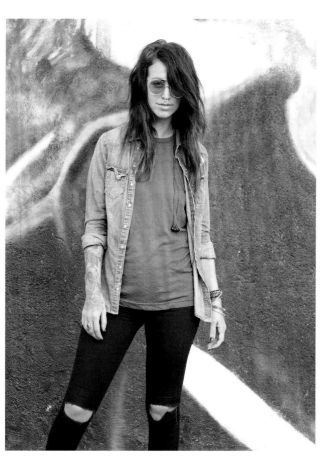

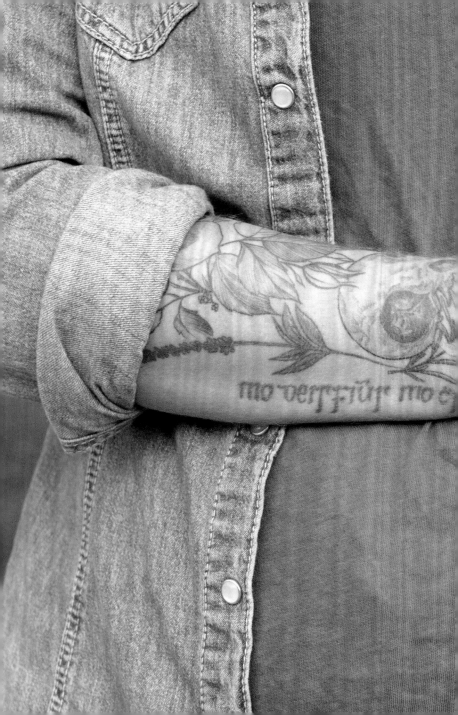

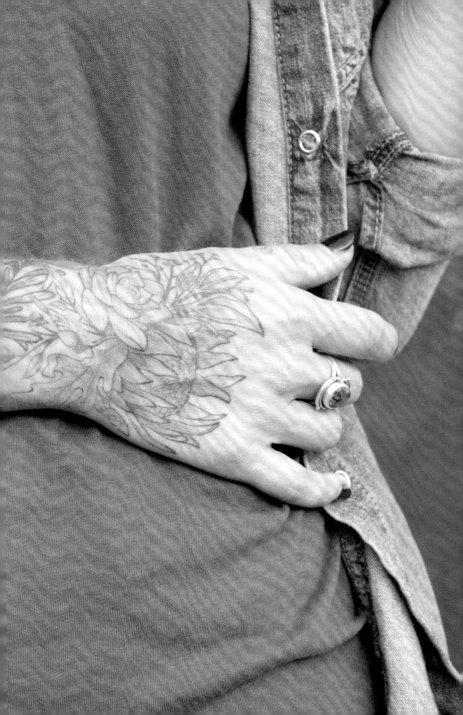

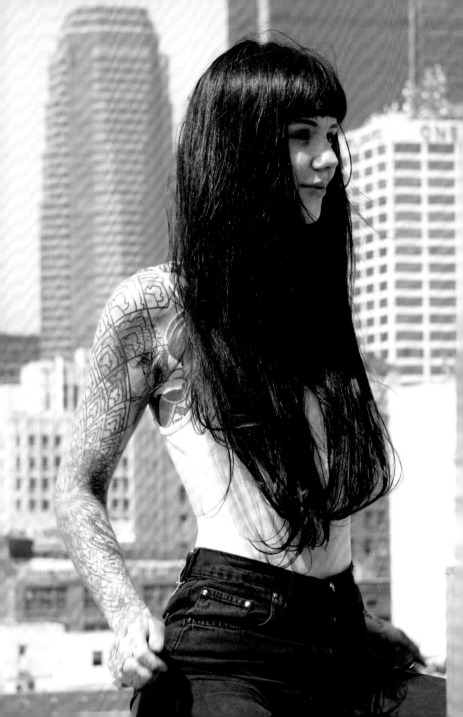

■

'Tattooing is a way for me
to break down all sorts of
barriers and help people
rebuild themselves.'

– Grace Neutral

↓ Ian Gottschalk
Musician
*Spotted: Abbot Kinney
Boulevard*

→ Oren Pius
Tattoos by Sung Song,
Unbreakable Tattoo

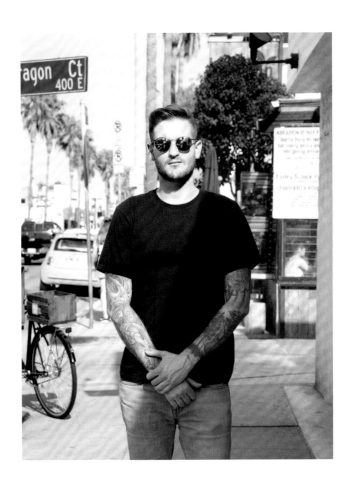

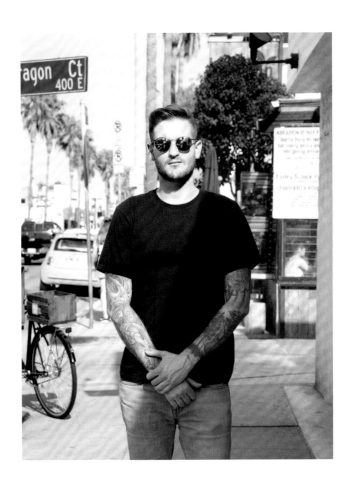

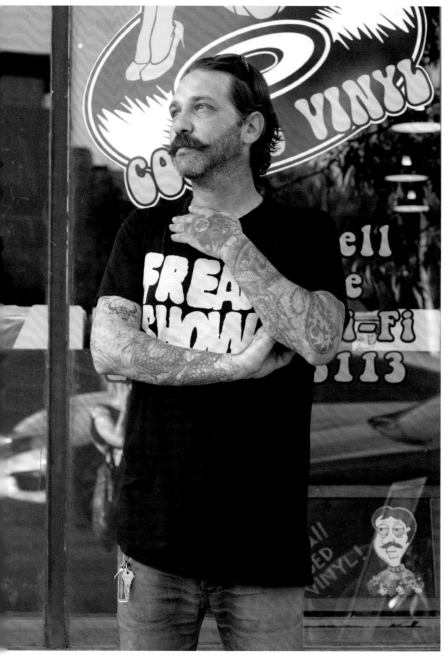

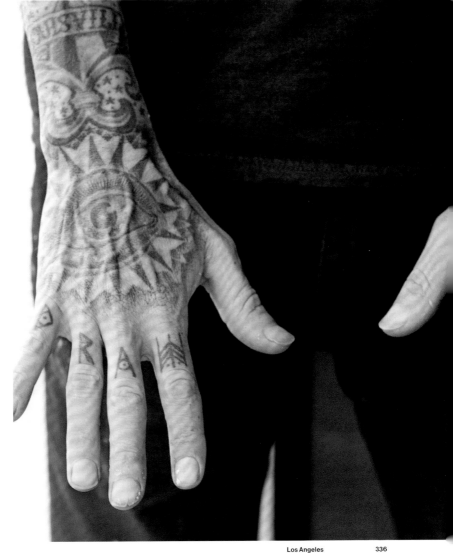

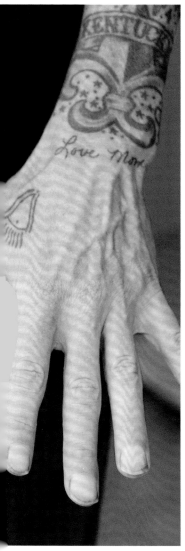

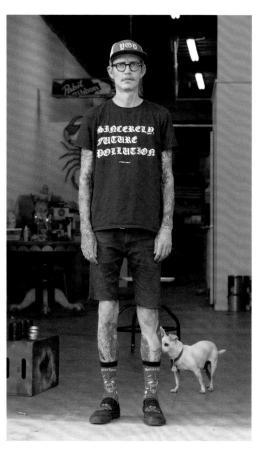

'My grandfather told me he was going to show me
the way out. A gruff construction foreman turned
self-taught artist, he set up two easels outside and
taught me to paint. He said that no matter how hard
life gets, as long as you have a pen and a piece of
paper, that very act of creating is your way to escape.'

– Bret Autrey

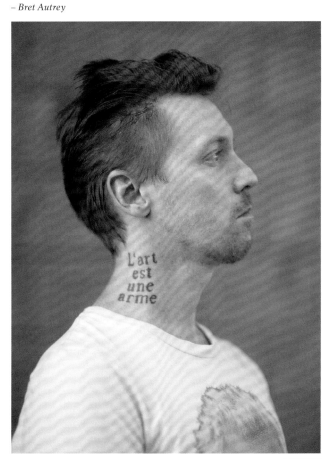

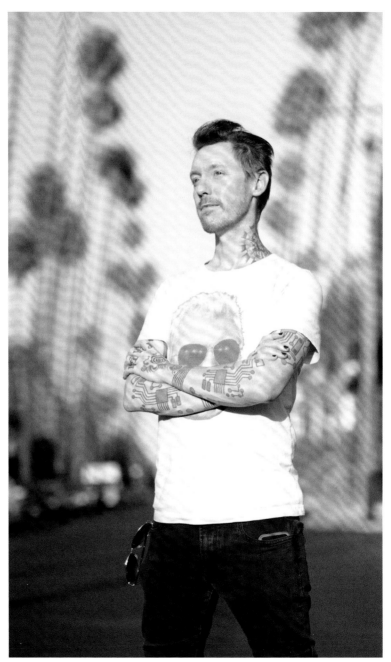

Joe Calixto

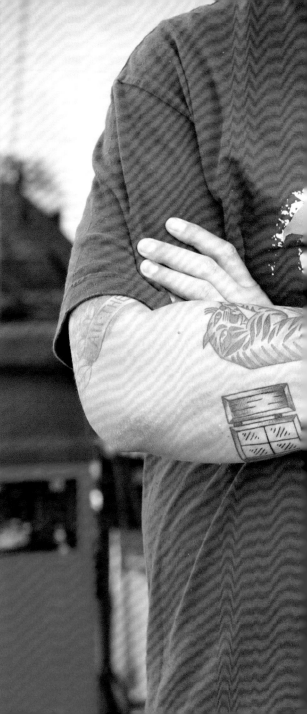

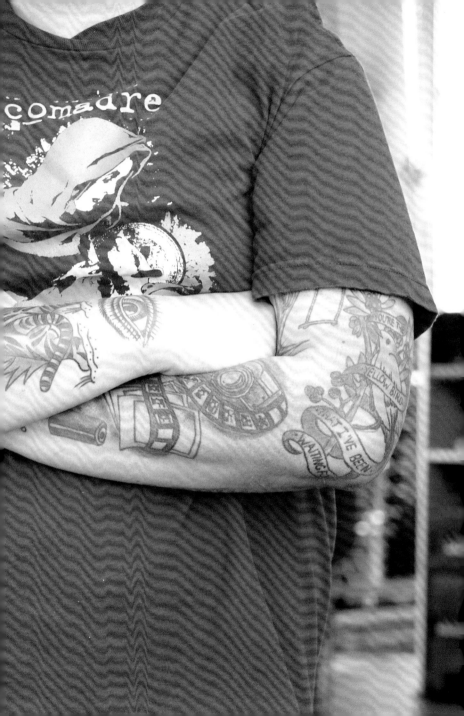

Sarah Otto-Combs
Ayurvedic Practitioner
Spotted: Sunset Boulevard
Style: Intergalactic
Tattoos by Carlos Ransom,
Abraxas Tattoo Co.;
Jon Osiris, Baraka Naga

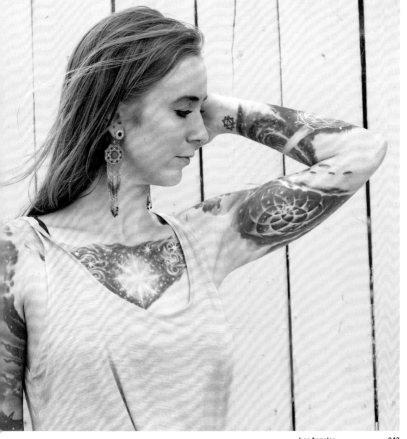

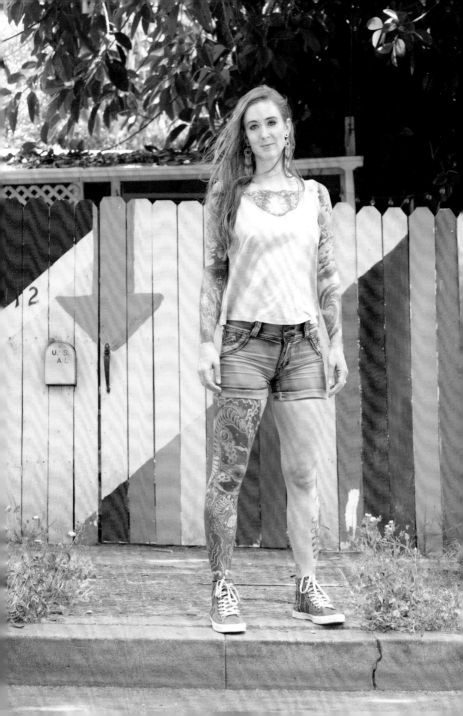

Laura Pardo
Photographer
Spotted: Venice Beach
Style: Traditional/Vintage/
Blackwork
Tattoos by Evie Yapelli,
Isabela Verri, Anka Tompkins,
Danelle Wulc, Andy Madrigal

Jonni Alcantara
Consultant
Spotted: Stories LA,
Echo Park
Style: Black and White/
Traditional
Tattoo by Jeffery Page,
California Gold

'All my tattoos have been inspired by
my upbringing – the places I grew
up, the people who raised me and the
things they passed on to me.'

– *Jonni Alcantara*

Sarah Miller
Apprentice/Piercer
Spotted: House of Ink, Venice Beach
Style: American Traditional
Tattoos by Spencer Harrington,
Harrington Tattoo; Dana Melissa
Dixon, Sea Serpent Saloon

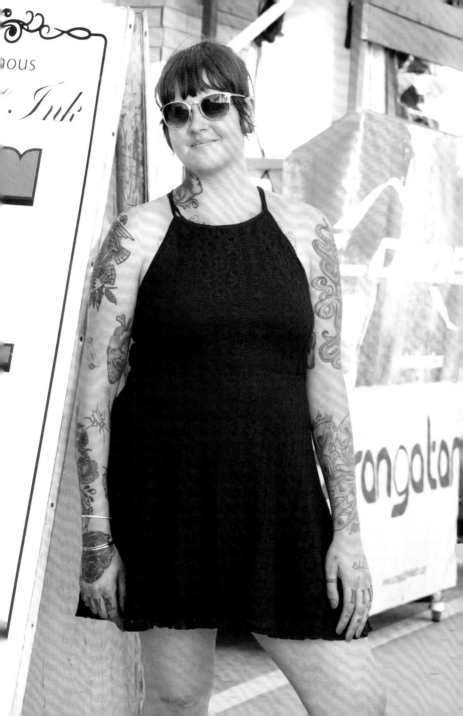

Rebecca Montalvo
Production and Event
Coordination
Spotted: In a women's group
Style: Stick 'n' Poke/Antique
Tattoos (mostly) by
Jason Andrew Smith

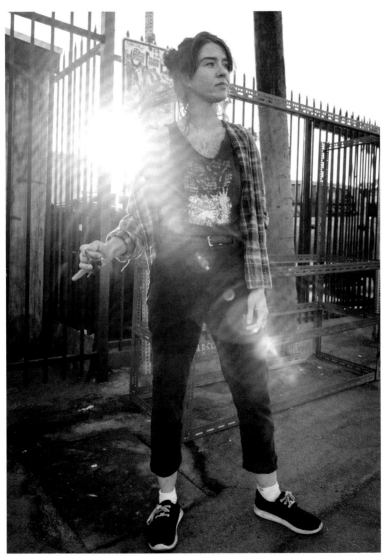

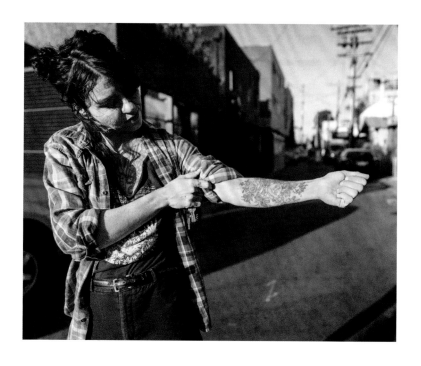

Los Angeles

'The flowers are copied directly off of an antique music box that my mother bought me right when she was released from prison. I was young and it eventually shattered in a move. I saved the pieces until I was grown enough to figure out what to do with them. It was my first tattoo and means a lot to me.'

– *Rebecca Montalvo*

Sid Jones
Piercer at House of Ink

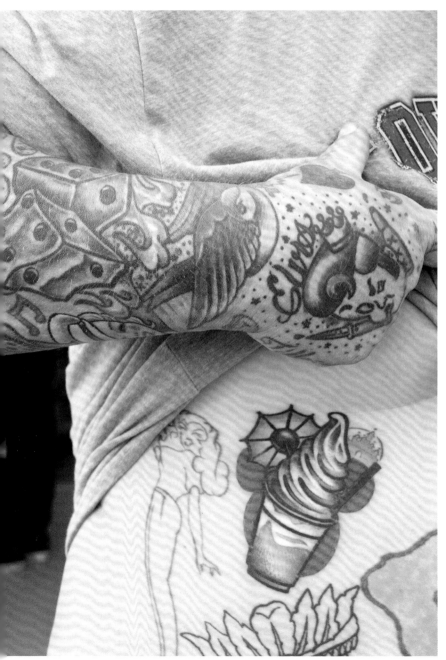

Sofia Lejrin

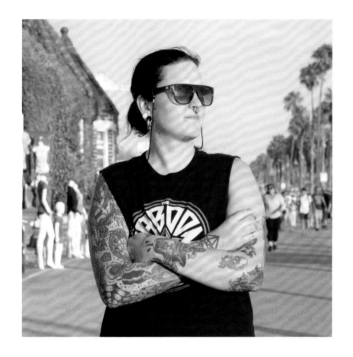

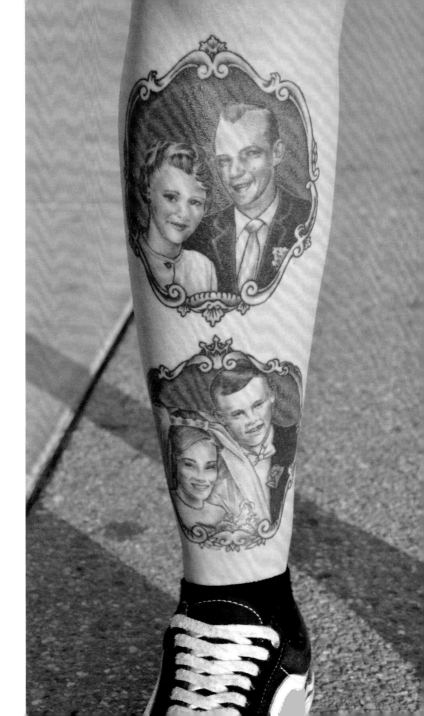

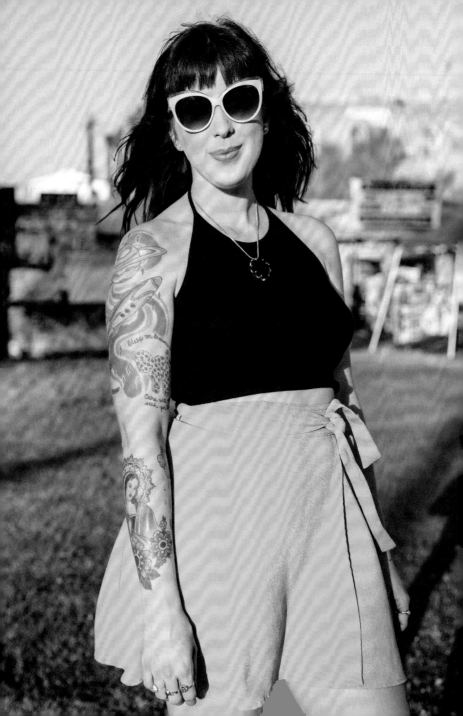

Leigh Scariano
Preschool Teacher
Spotted: Venice Beach

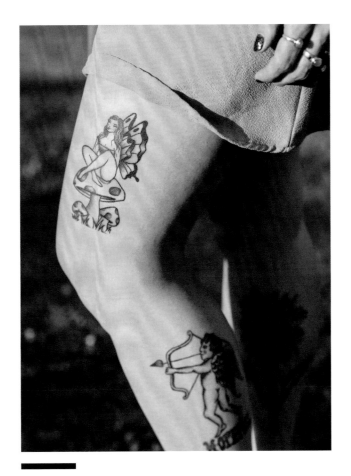

'All of my tattoos have a deep personal
meaning to me, but I often choose to
not share the meaning, and just leave
them for interpretation if people ask.'

– Leigh Scariano

Alexo Wandael
Photography
Tattoos by Paolino,
Rising Dragon

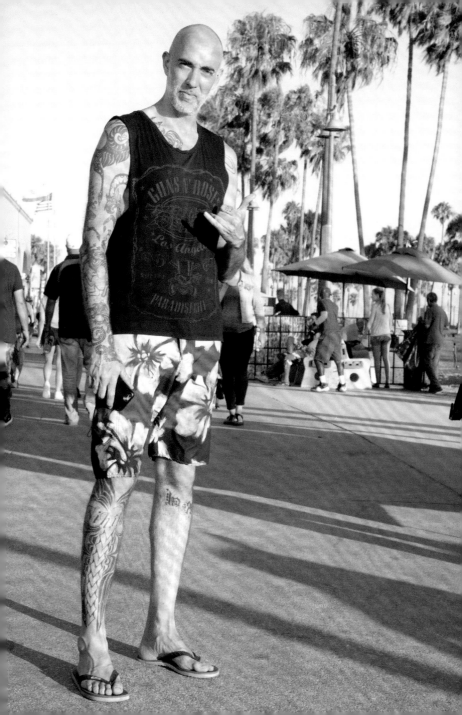

↓ **Justin Paraday**
Spotted: Venice Beach
Tattoos by Alex, House of Ink

→ **Dante Francione**
Recording Artist
→

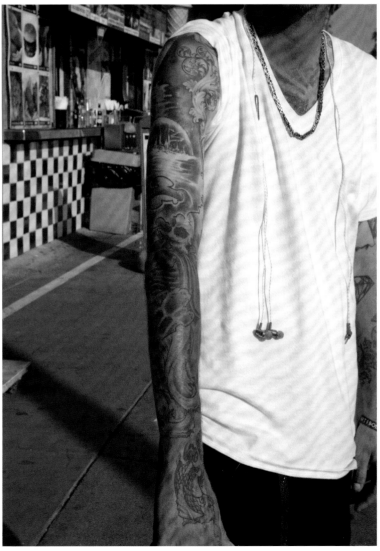

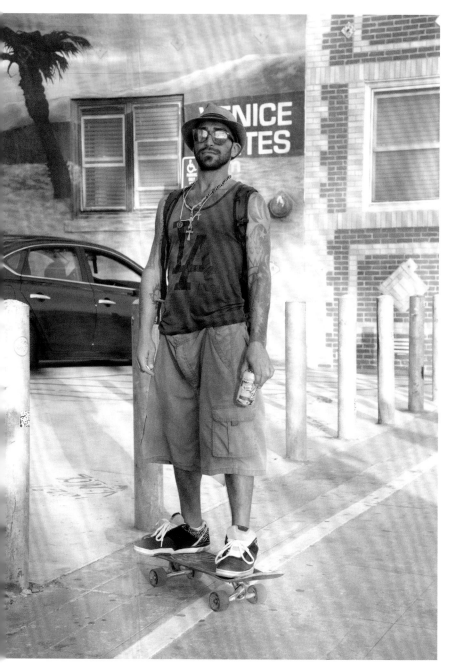

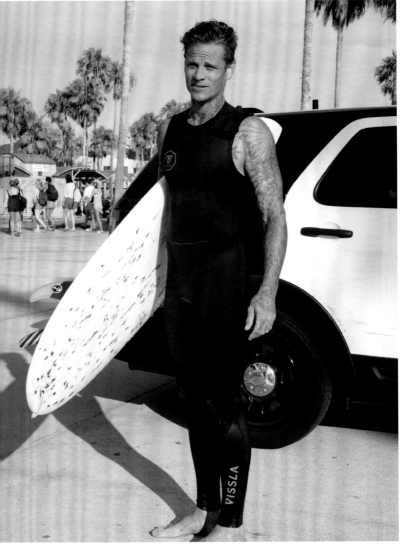

Sebastian Rosell
Spotted: Venice Beach
Style: Realism
Tattoos by Filip Qubic
→

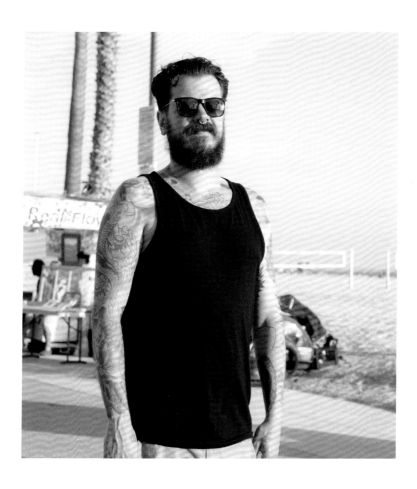

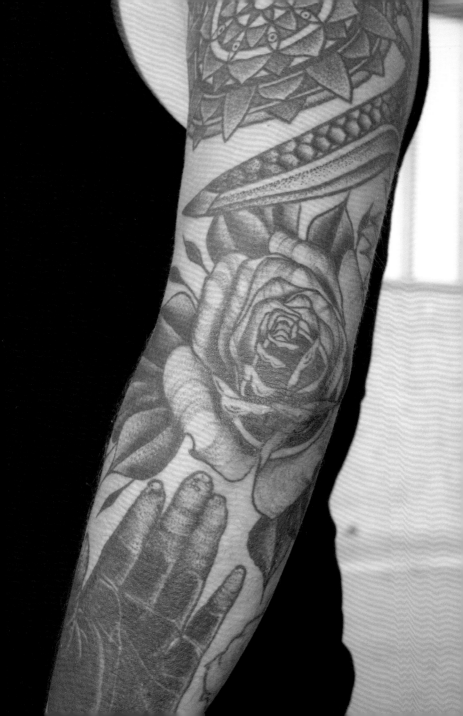

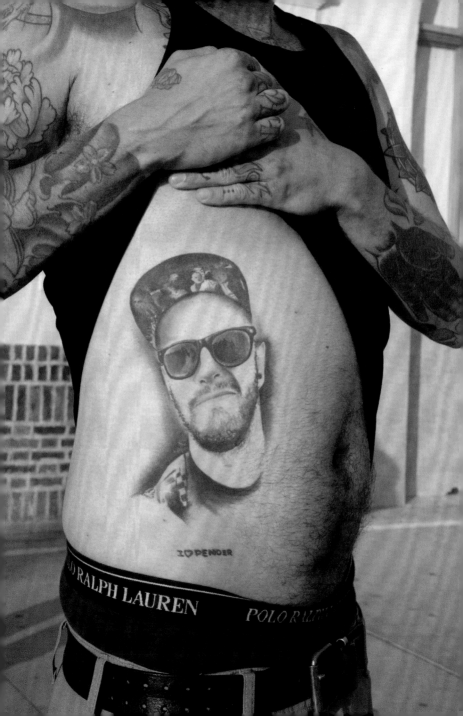

Marcella Kroll
Artist

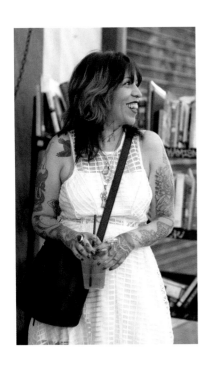

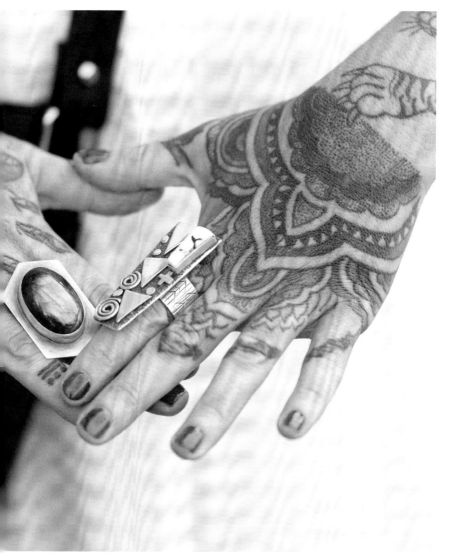

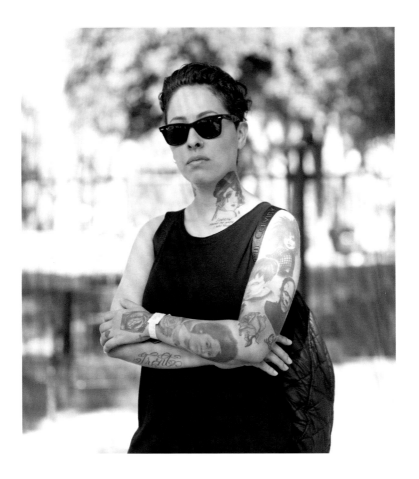

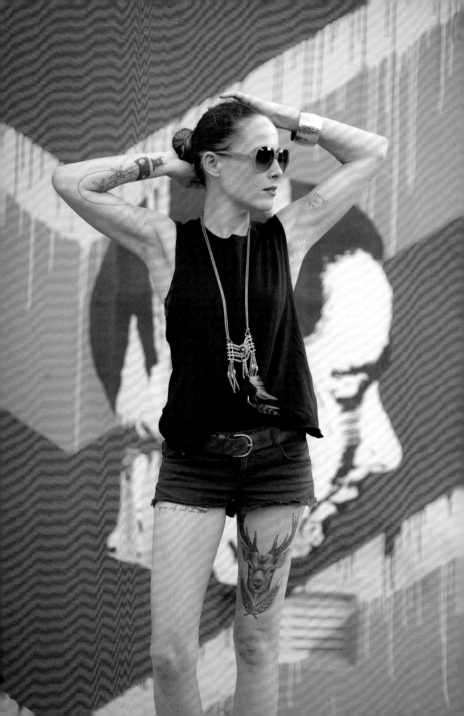

Sara Hilliard

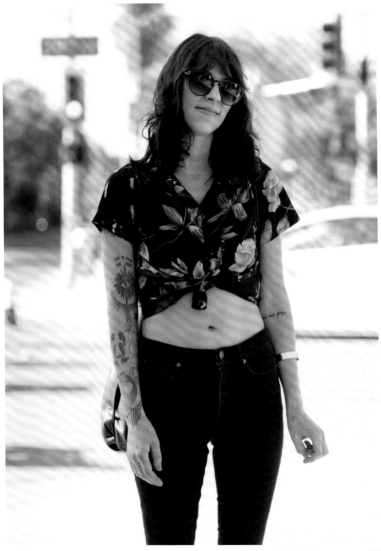

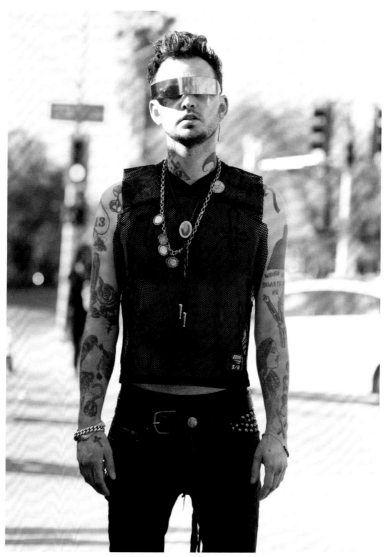

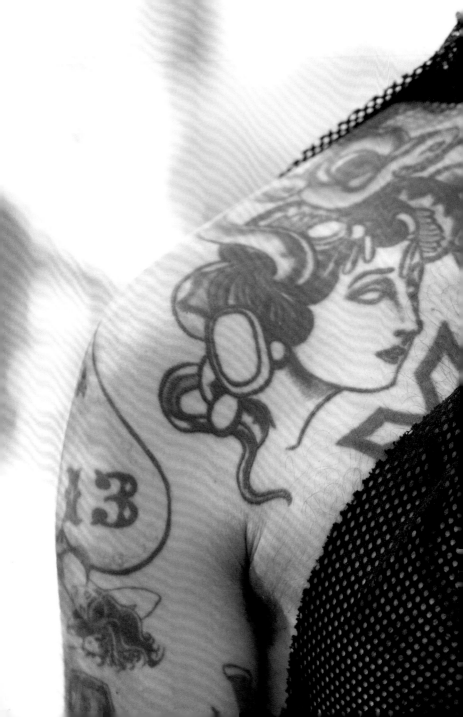

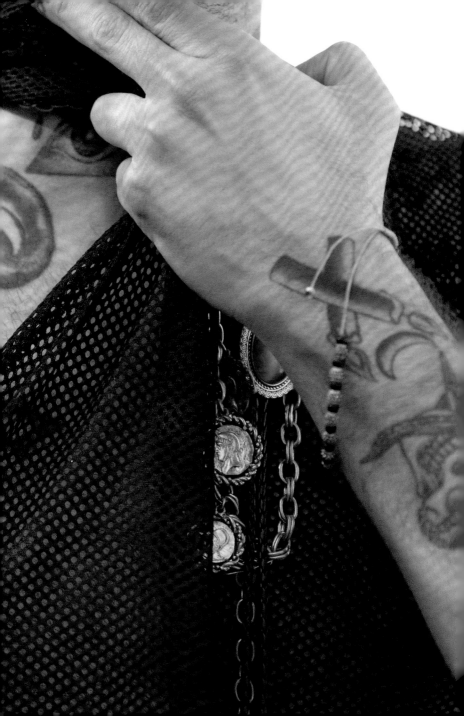

Joseph Inchausti

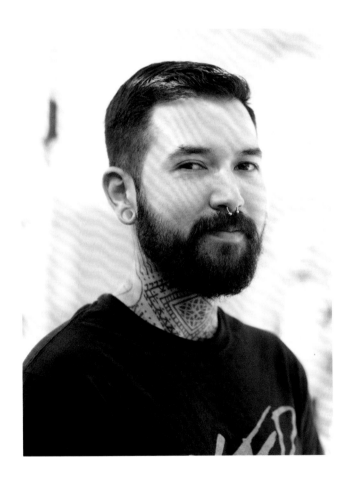

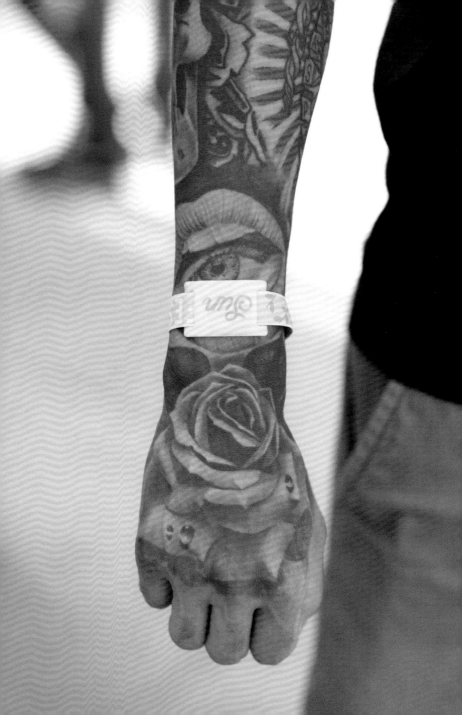

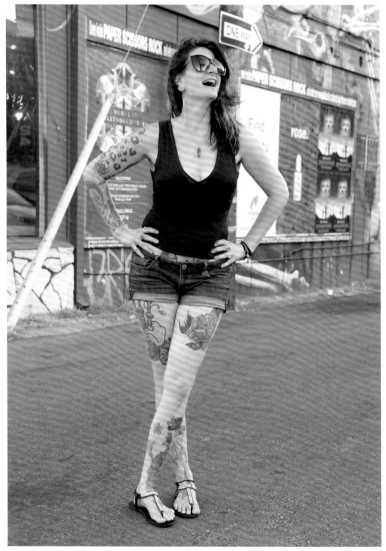

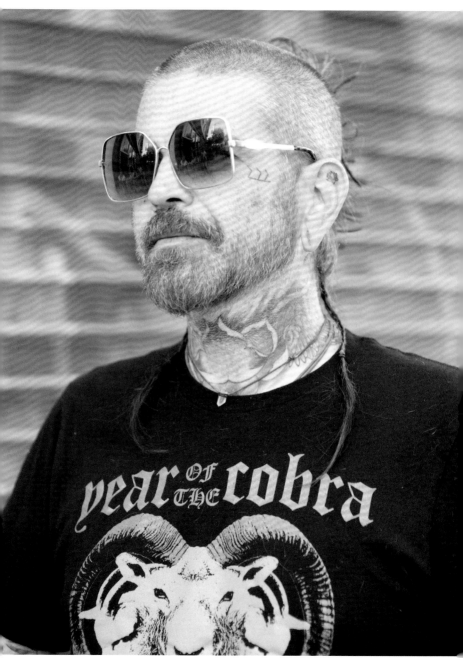

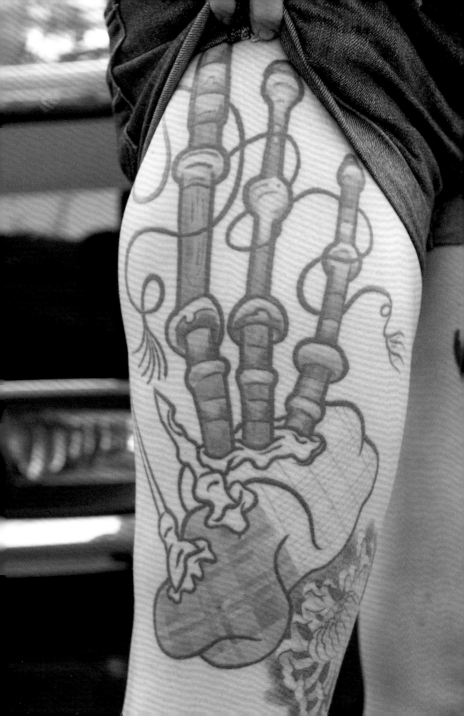

LA's best parlours

Alchemy Tattoo
2854 Sunset Boulevard
Los Angeles, CA 90026
alchemytattoola.com

American Electric Tattoo
2518 Sunset Boulevard
Los Angeles, CA 90026
*americanelectrictattoo
company.com*

Art & Soul
2600 S Robertson Boulevard
Los Angeles, CA 90034
www.artandsoultattoos.com

Broken Art Tattoo
2400 Hyperion Avenue
Los Angeles, CA 90027
*brokenarttattoo.
squarespace.com*

Ink Ink Tattoo
830 Lincoln Boulevard
Venice, CA 90291
inkinktattoo.org

**Kat Von D's High
Voltage Tattoo**
1259 North La Brea Avenue
West Hollywood, CA 90038
highvoltagetattoo.com

Memoir Tattoo
7377 Beverly Boulevard
Los Angeles, CA 90036
memoirtattoo.com

Shamrock Social Club
9026 Sunset Boulevard
West Hollywood, CA 90069
shamrocksocialclub.com

Studio City Tattoo
11032 Ventura Boulevard
Studio City, CA 91604
studiocitytattoo.com

Tattoos by Misha
11239 Ventura Boulevard
#212 Studio #33
Studio City, CA 91604
misha-art.com

The Honorable Society
8424 Santa Monica
Boulevard # B
West Hollywood, CA 90069
thehonorablesociety.com

The Warren Tattoo
8776 Sunset Boulevard
West Hollywood, CA 90069
thewarrentattoo.com

True Tattoo
1614 N Cahuenga Boulevard
Los Angeles, CA 90028
truetattoohollywood.com

Unbreakable Tattoo
11356 Ventura Boulevard
Studio City, CA 91604
tattoounbreakable.com

Australia is home to some of the world's best tattooists, and most are in the cultural hub of Melbourne. It's a place that is firmly on my tattoo wish list, and I can only dream of getting tattooed by some of the artists currently working there. Some studios are so exclusive they won't even give you the address until you've booked in and paid your deposit! Benjamin Laukis creates hyper-realistic masterpieces that look like they're popping out of people's skin; Emily Rose Murray conjures up Art Deco-inspired beauties with a divine colour palette; and Nina Waldron's characters are all in black. These three artists all work in completely different styles, and this perfectly illustrates how diverse the tattoos in this city are. From hippies hanging out in their backyards with a bottle of wine, to pink hair, bum bags and jumpsuits, this chapter is full of people who are unafraid of expressing who they are. Melbourne is a city in which you can feel comfortable enough to truly embrace your own individualism.

Melbourne

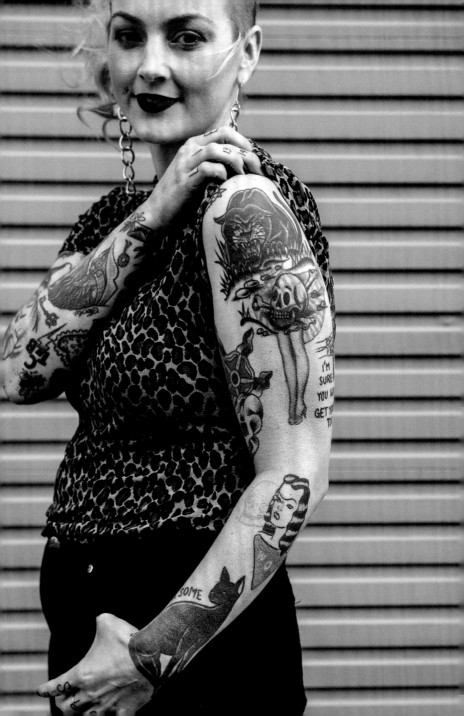

Kelly McCabe
Spotted: Smith Street
Style: Old School/Various

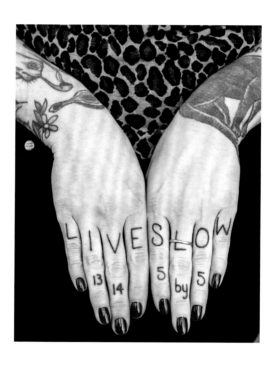

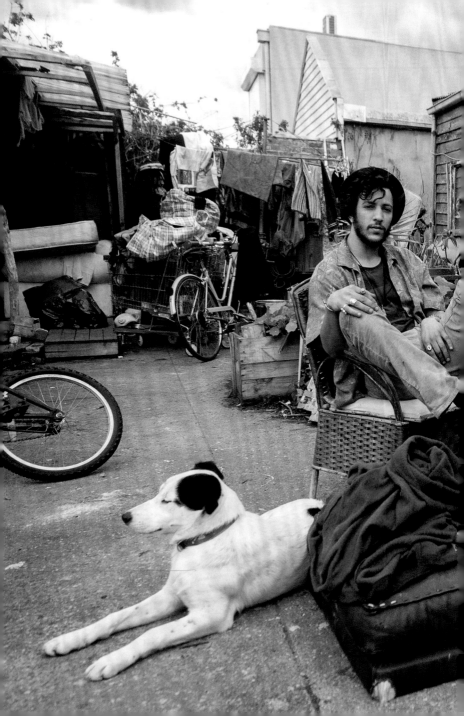

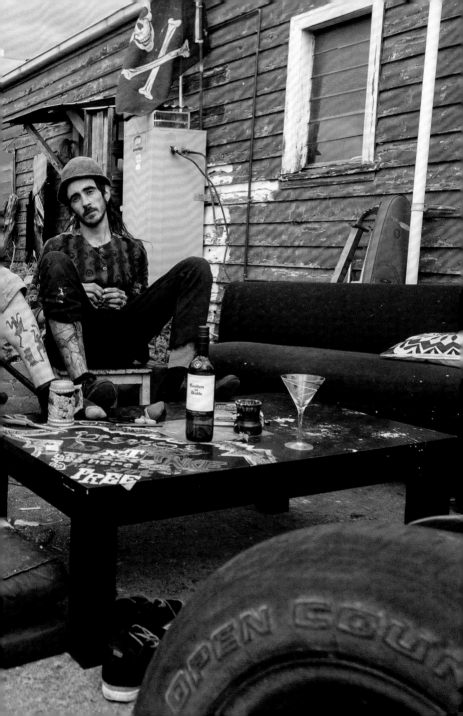

Mehdi Altieri
Artist
←↙

Eric Montoliv Sanchez
Artist
Spotted: Brunswick
←↘

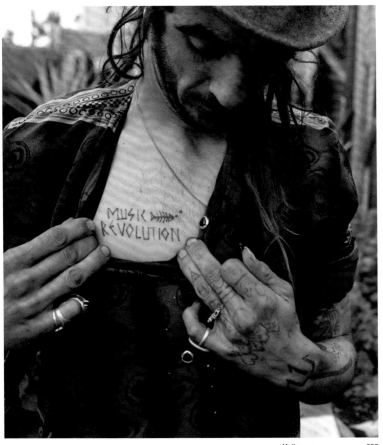

Jenna Rose Bennett

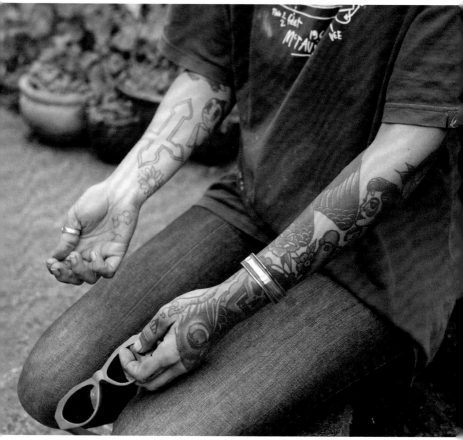

Melbourne

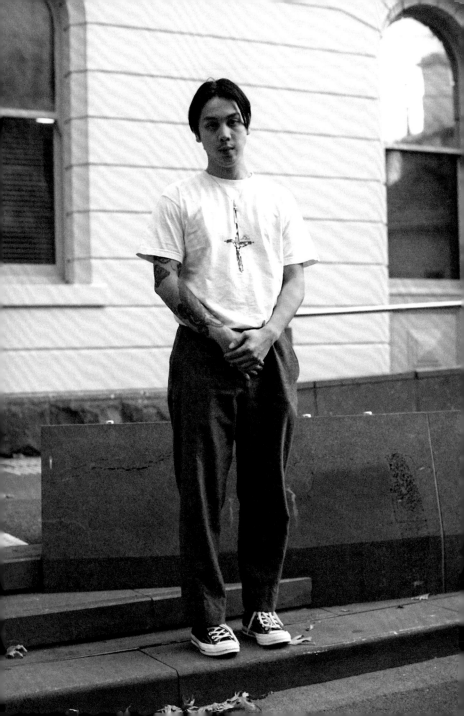

Jimmy Newman
Student/Retail
Style: Traditional
Tattoos by Stuart Cripwell,
Spider Murphy's Tattoo;
Dan Santoro, Smith Street
Tattoo Parlour

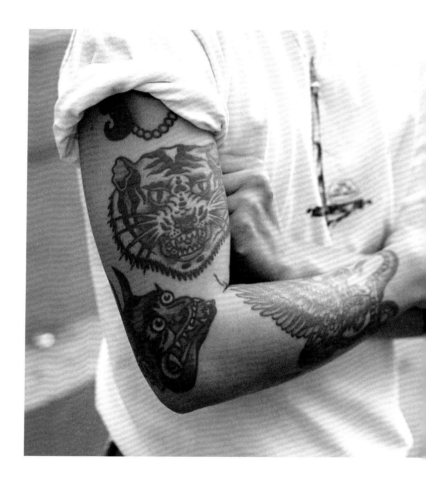

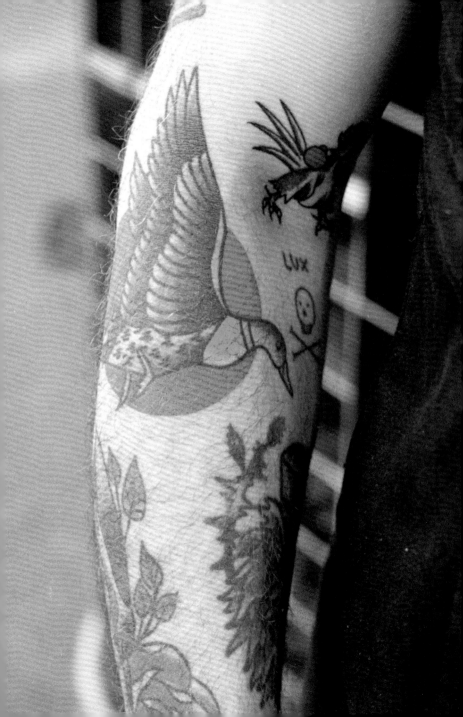

Luke Whatt
Bar Manager
Tattoos by various studios,
including Man's Ruin

'My duck tattoo was
done with three
other friends, two of
whom are now dead.'

– *Luke Whatt*

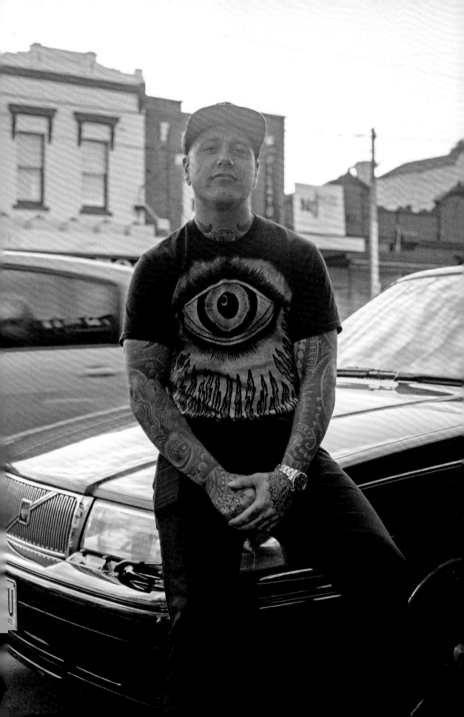

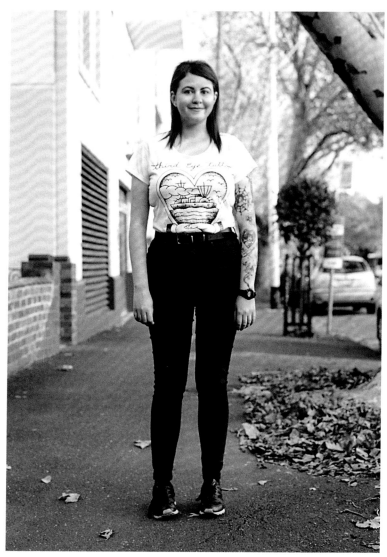

Stephanie Brook
Manager of Third Eye Tattoo
Spotted: Third Eye Tattoo
Style: Neo-Traditional
Tattoos by Jeremy Cook,
J. Cook Designs

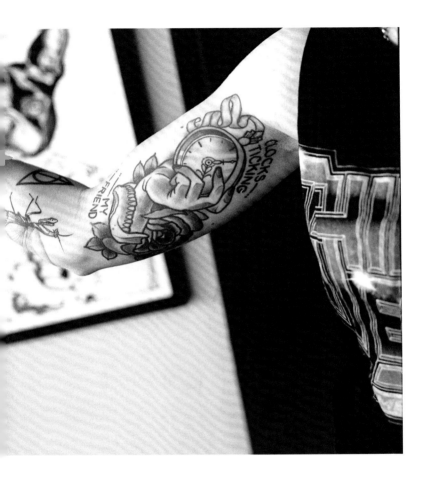

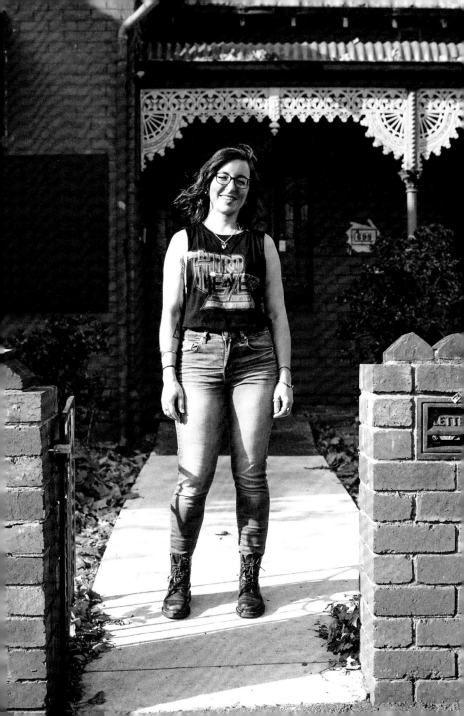

Matthew Kozik
Tattooist
Spotted: Third Eye Tattoo

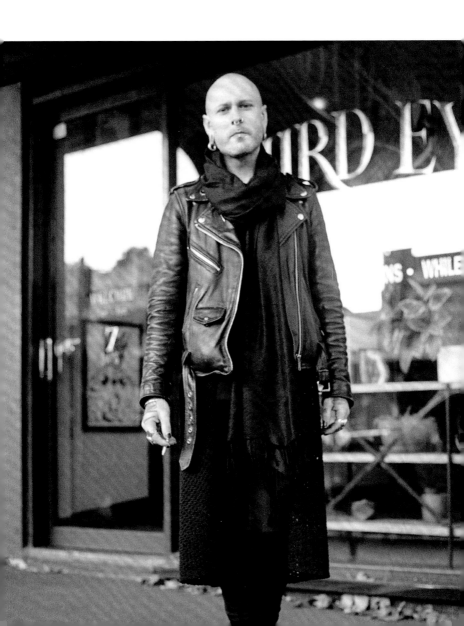

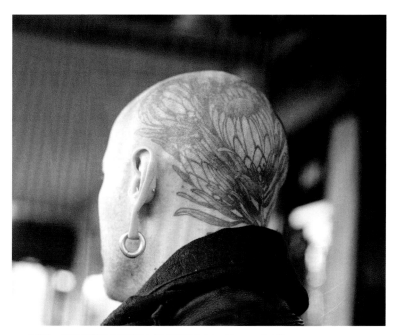

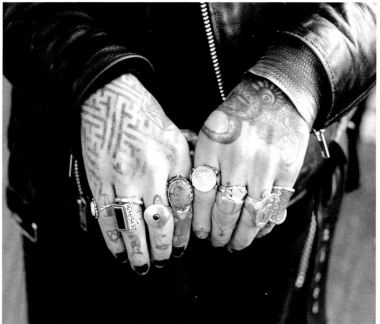

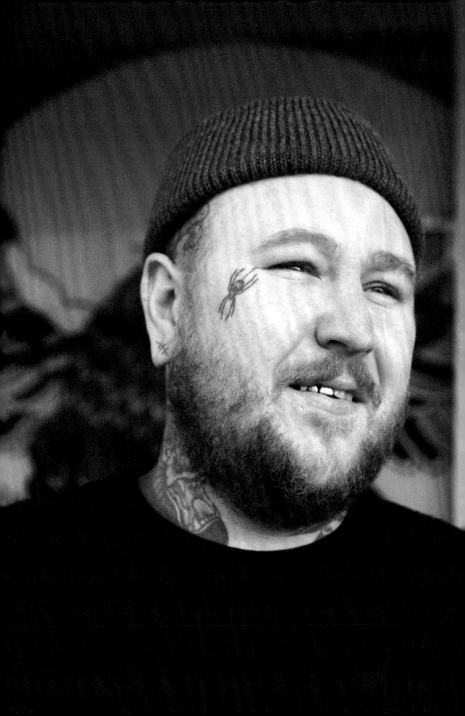

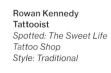

Rowan Kennedy
Tattooist
Spotted: The Sweet Life
Tattoo Shop
Style: Traditional

Claudine Mabalhin
Hospitality/Retail
Spotted: High Street, Northcote
Style: Kaos
Tattoos by Godfrey Atlantis,
Green Lotus Studio

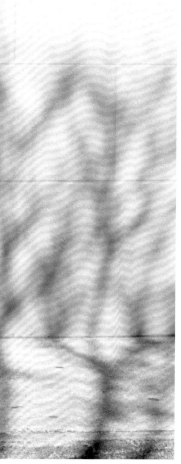

Gerry Clarke
Drummer
Spotted: Fitzroy North
Style: Traditional Black Ink
Tattoo by Nick Rutherford,
Third Eye Tattoo

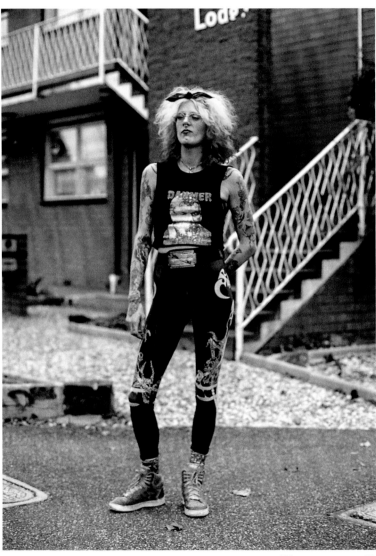

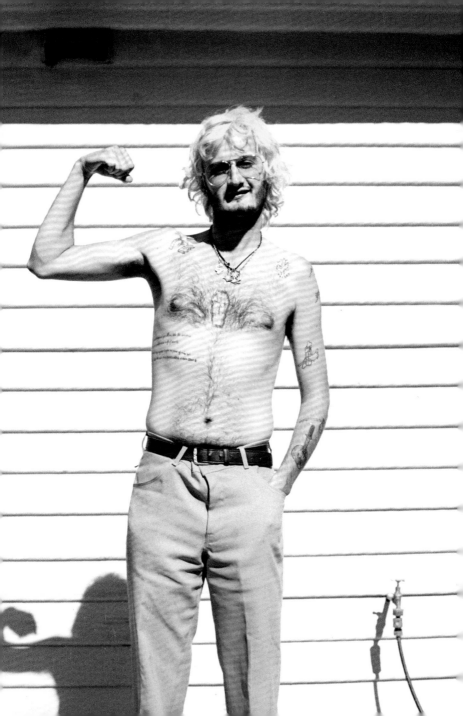

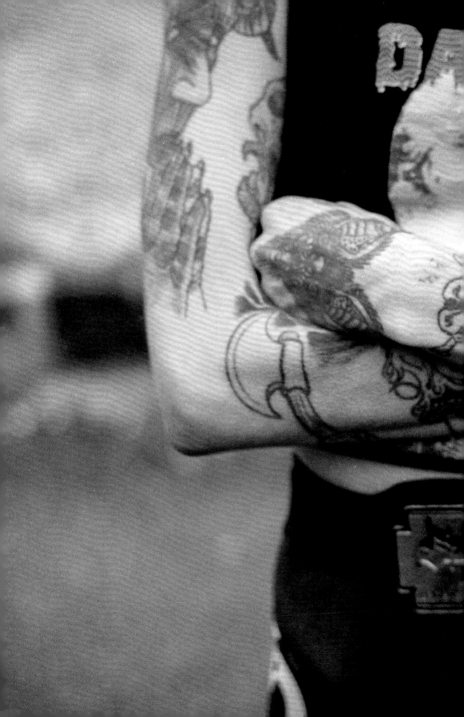

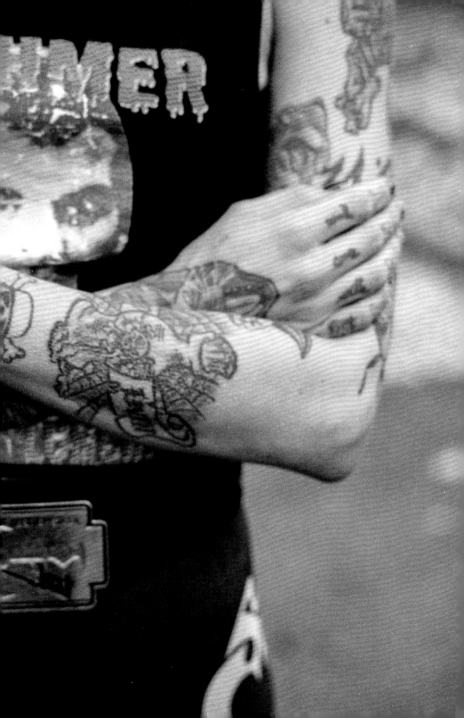

Thomas Charlton
Spotted: High Street
Style: Traditional
Tattoos by Jessica Swaffen,
Oliver Christenson,
Third Eye Tattoo

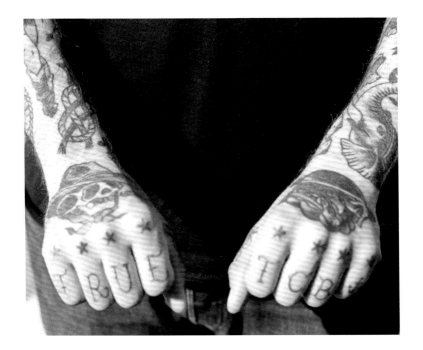

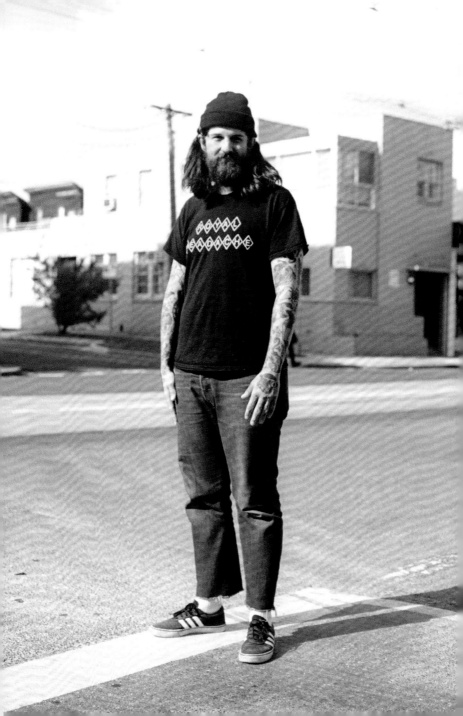

Nick Rutherford
Tattooist at Third Eye Tattoo
Style: Hack
→

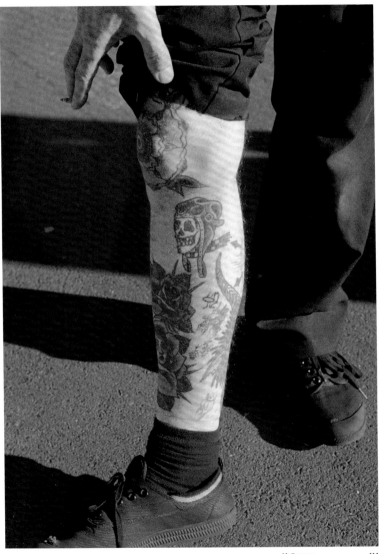

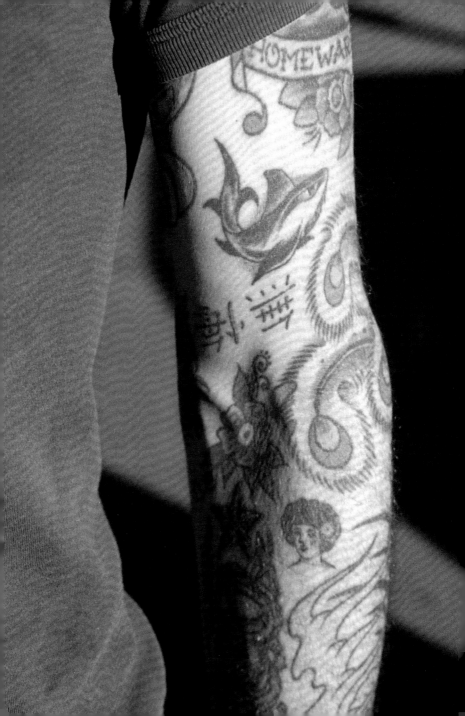

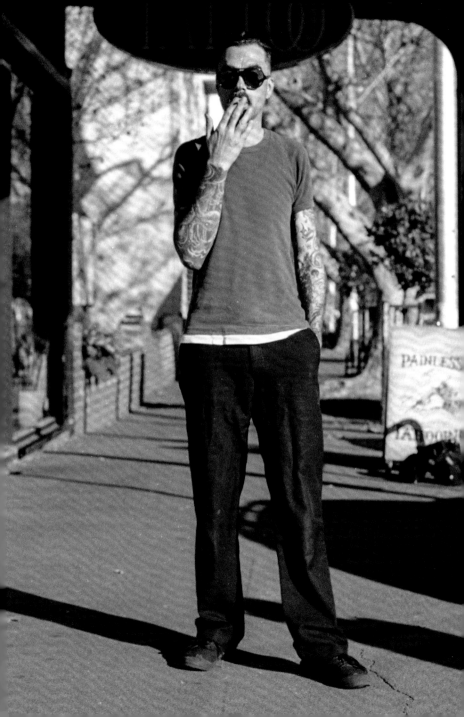

'I just looked away and drank with my mate, and she laid down a tattoo of whatever she liked.'

– Nick Rutherford

Nina Waldron
Tattooist, Sayagata Tattoo
→

I've always loved tattoos. As a kid, I was forever doodling on myself during class, and always knew I wanted at least a couple. The styles, trends and techniques are endless, and you can use them to define or redefine yourself.

My first tattoo was a little creepy goat on my shoulder blade. I've always had a thing for goats, so it was an obvious and easy choice. I got it done in the living room of a friend in Melbourne. The artist's name is Jacob Rolfe and I'm pretty sure he no longer tattoos (such a shame – his drawings were so badass and unique. I would have collected heaps more!).

I have enough tattoos on me now that I get frequent stares and looks. I think being a woman with lots of bold black tattoos shocks a lot of people, and I really enjoy the reaction. I used to get similar reactions from my parents and extended family when I first started building my collection, but now most of them have accepted my tattoos and don't bother lecturing me anymore. They know tattoos are just a part of who I am.

My personal tattoos vary a little, but mostly they are dark and bold and a bit weird. My fashion sense is pretty fluid. I used to wear lots of long floral dresses. I liked the contrast of the pretty, modest styles mixed with my dark, creepy tatts. Throws folks off a bit. But these days I mostly just wear T-shirts I buy off Instagram and jeans. Everything I own is covered in ink splatters; it would be a shame to ruin all my pretty dresses.

I hope that I don't run out of creative juice. I'd like to keep feeling inspired and excited for years to come. Maybe I won't be tattooing in 30 years' time, but I hope that whatever it is I am doing makes me as happy as tattooing makes me right now.

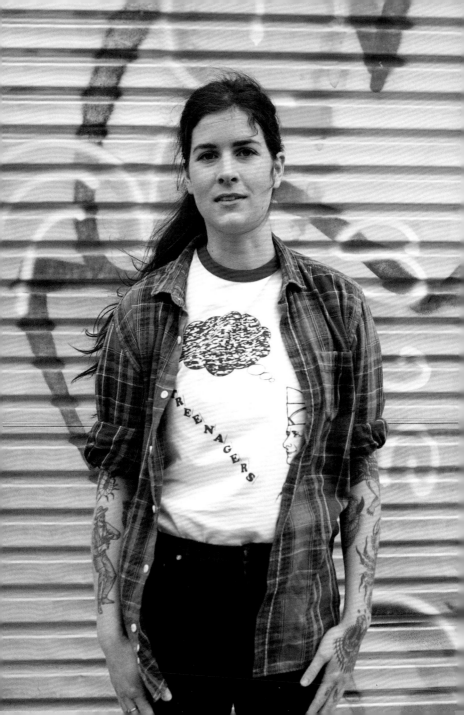

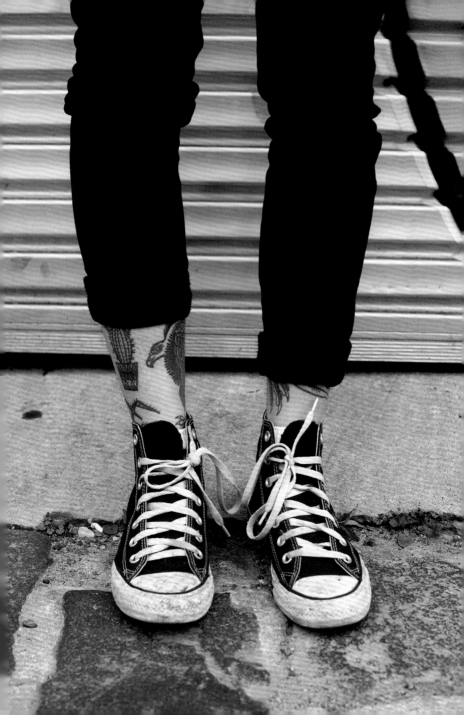

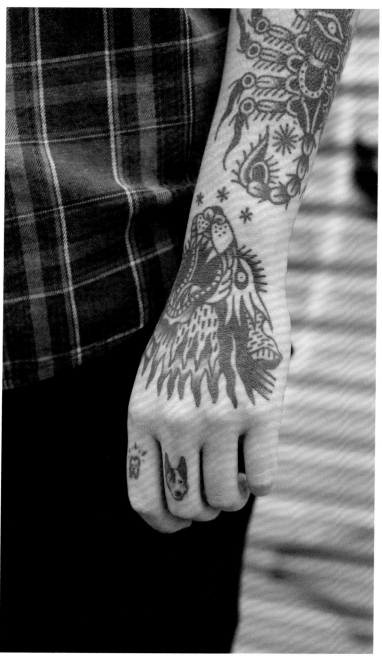

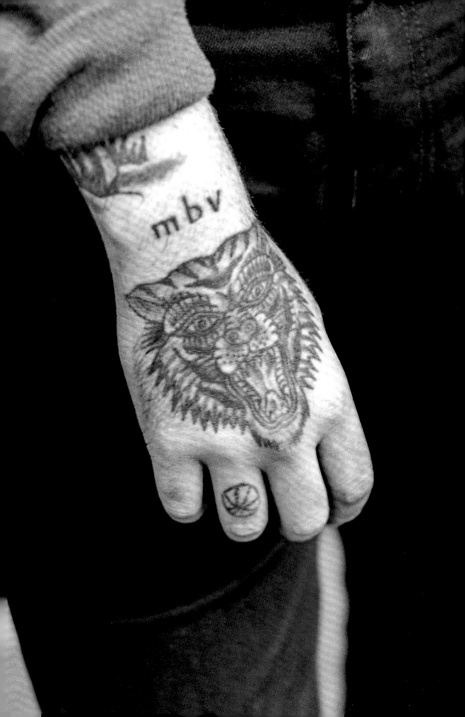

← Sam Conaglen
Artist/Shop Manager
Spotted: Fitzroy
Tattoos by Richard Warnock
Capilli

↓ William Yoneyama
Tattooist

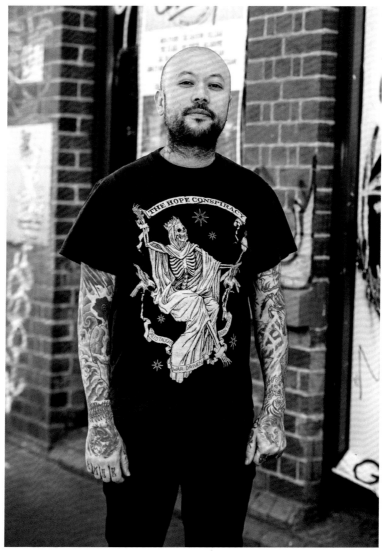

Tazman Ekberg
Bartender/Barista
Spotted: Outside B&M
Style: Single-Needle/Pen/
Realism
Tattoo by Christopher
Wayne Simpson,
Hidden Moon Tattoo

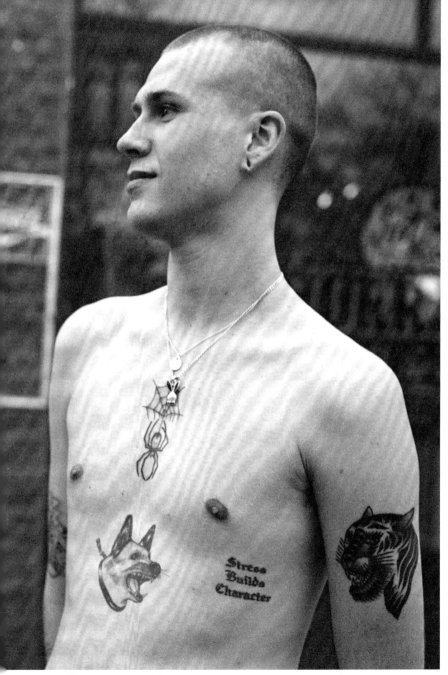

Stitch Obsidian

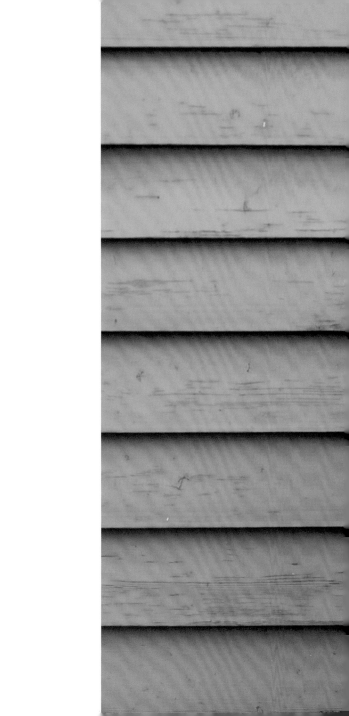

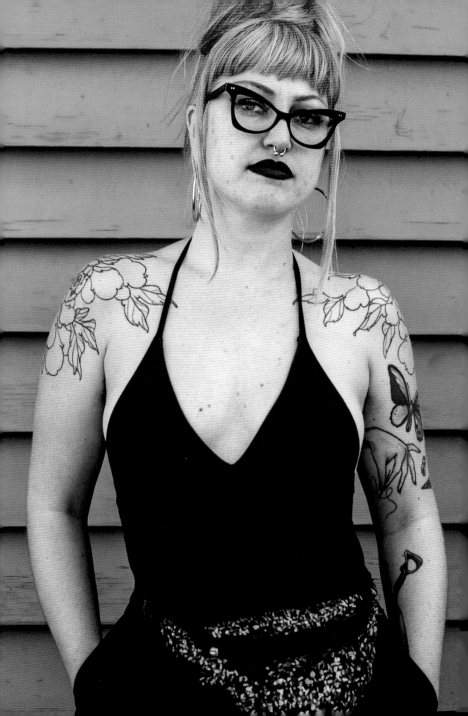

Joshua Dean
Model

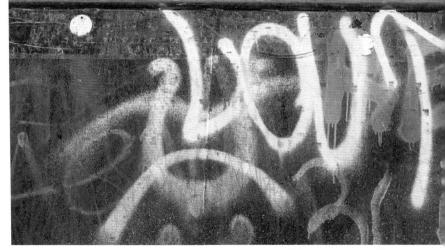

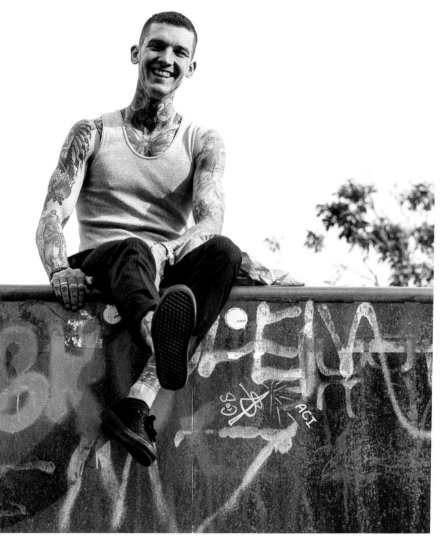

Melbourne

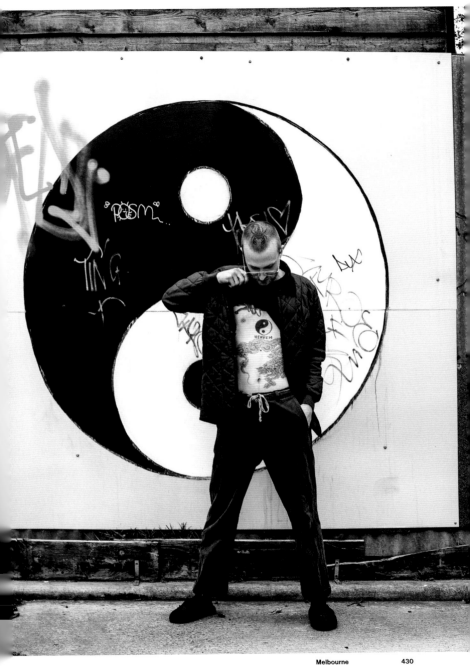

'Tony [Kezam] tattooed the smoke dragon.
Through the kindness and generosity of
his heart, he imparted one of my favourite
and most unique pieces.'

– *Stuart Thompson*

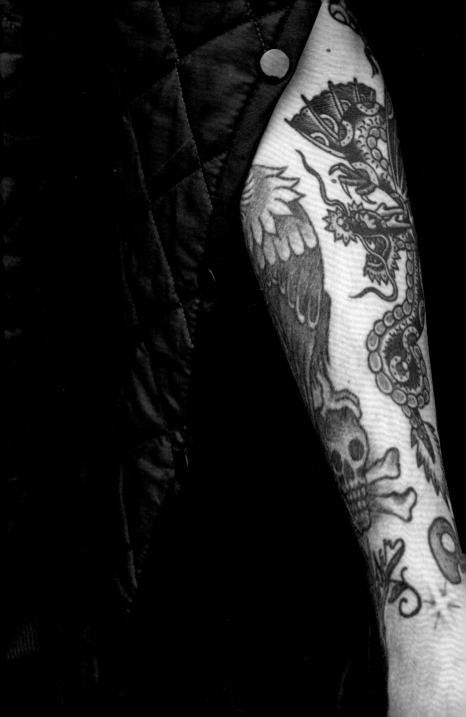

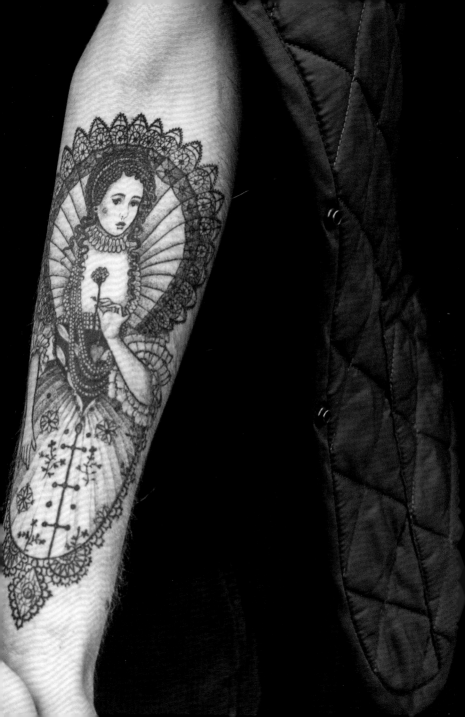

Lyo Ishizaka

NDSOR
SALON

→

ssley St
62 3273

↓ Joe Jones
Bartender/Restaurateur

→ Jade Louise
Laser Tattoo Removalist
Spotted: Collingwood

'One time I got pissed as a fart
and tattooed "Don't be a f**head"
on my thigh. It's still one of the
most inspirational things I have
tattooed on me.'

– Jade Louise

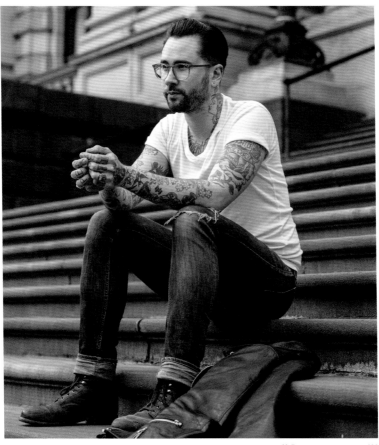

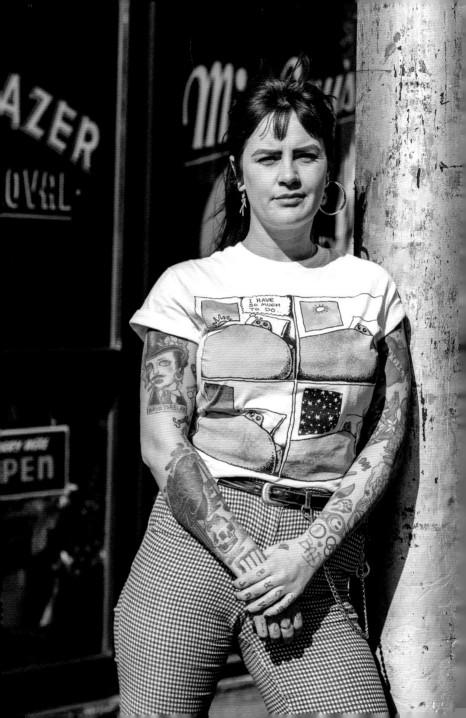

Paul Lilley
Arts Manager
Style: Traditional
Tattoos by Nick Crampton,
Chapel Tattoo; Steve Boltz,
Smith Street Tattoo Parlour;
Steve Byrne, Rock of Ages

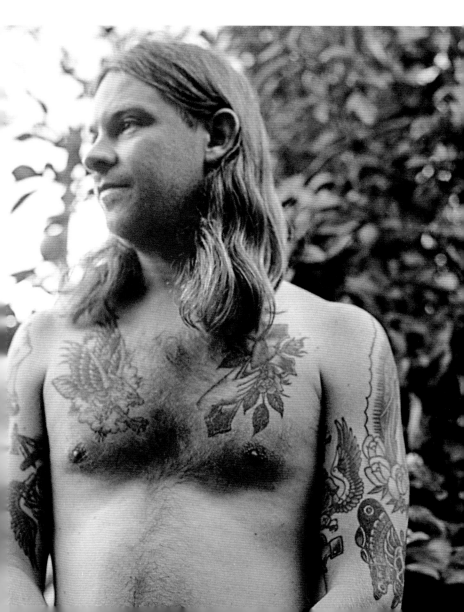

Raz Rosa
Carpenter/Bar Owner
Spotted: Northcote Plaza
Style: Traditional
Tattoos by Pete Pav,
Man's Ruin
→

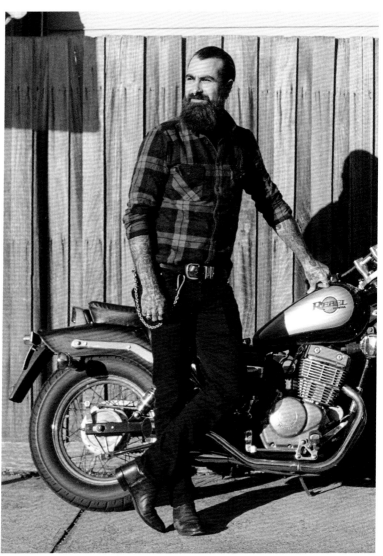

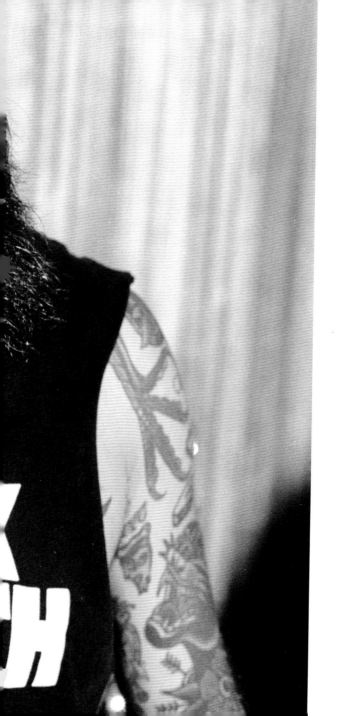

**Fareed Kaviani
Writer and PhD Student**
Tattoos by Guy le Tatooer
→

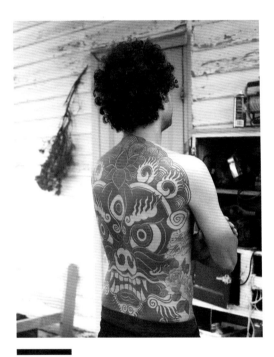

'I don't try to be stylish. I just dress in shorts when it's hot and pants when it's cold.'

– *Fareed Kaviani*

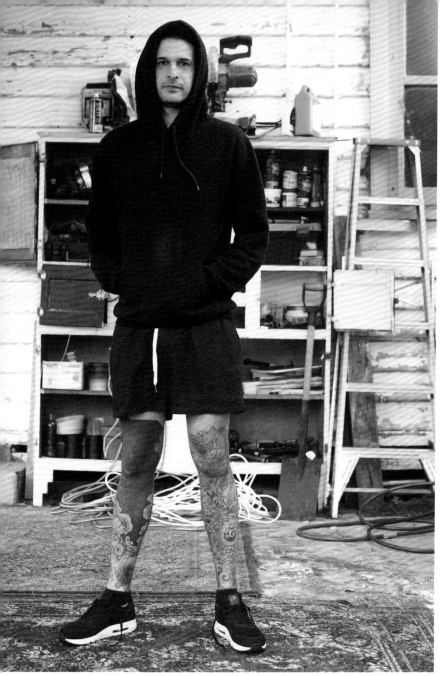

Melbourne

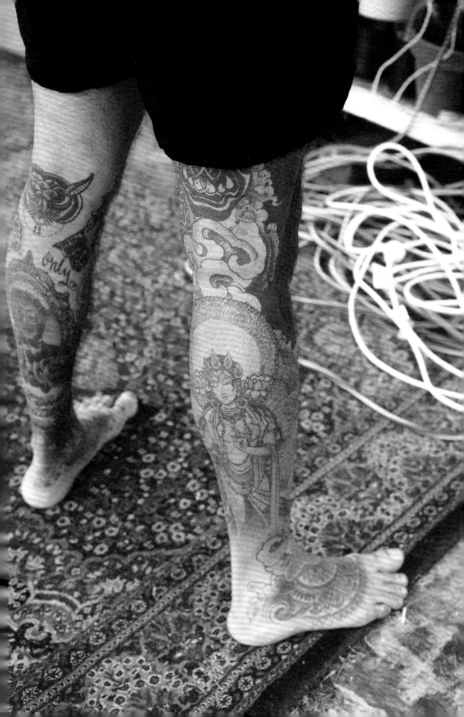

Melbourne's best parlours

Blue Lady Tattoo
Level 1/67 Hardware Lane
Melbourne VIC 3000
blueladymelbourne.com

Chapel Tattoo
155 Chapel Street
Windsor VIC 3181
chapeltattoo.com

City of Ink
216 Clarendon Street
South Melbourne VIC 3205
cityofink.com.au

Hidden Moon Tattoo
474 Little Lonsdale Street
Melbourne VIC 3000
hiddenmoontattoo.com

Hot Copper Studio
Coburg
Melbourne VIC 3058
hotcopperstudio.com

Melbourne Tattoo Company
2/2 Somerset Place
Melbourne VIC 3000
*melbournetattoo
company.com*

Sayagata Tattoo
354 High Street
Melbourne VIC 3070
*instagram.com/
sayagatatattoo*

The Black Mark
Northcote
Melbourne VIC
theblackmark.com.au

Third Eye Tattoo
700 Nicholson Street
Fitzroy North VIC 3058
thirdeyetattoostudio.com

Vic Market Tattoo
324 Victoria Street
North Melbourne VIC 3051
vicmarkettattoo.com

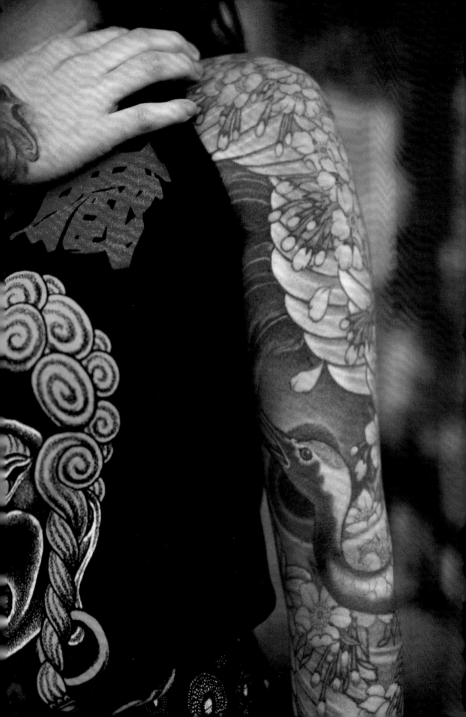

Behind the Scenes

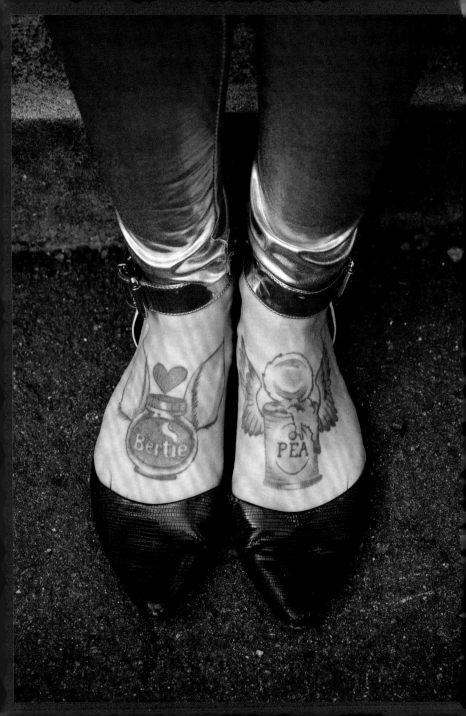

Tattoo Speak

Backpiece
A design that covers a person's entire back.

Blowout
This happens when a tattoo penetrates too deeply under the skin and therefore doesn't heal properly. This creates a cloudy effect around the design, as some of the ink seeps under the skin.

Body suit
A tattoo that covers the entire body: back, front, arms, legs, and sometimes feet and hands – not including the face.

Custom work
A one-off, original tattoo created for a customer. Another tattooist should never copy this design onto another person.

Epidermis
The outer layer of skin through which tattoo needles pass to get to the dermis. Tattoos placed in the epidermis will slowly fade.

Flash
Tattoo shops often have sheets of 'flash' on the walls – designs that customers can choose to get tattooed. Customers can walk in and pick a design, but the designs can also be tattooed on other people.

Freehand
A tattoo that is drawn directly onto skin rather than stencilled on first.

Gloves
Your tattooist should always – without exception – be wearing gloves when they tattoo. If your tattooist is not wearing gloves, walk away and do not look back.

Hand-poked
These tattoos are made without machines. Specialist artists insert ink into the skin with handmade tools and no electricity. The process is much slower, as the ink is inserted one dot at a time. Hand-poked is not to be confused with the term 'stick 'n' poke', which is often done with DIY kits that can be bought online and are largely used without any kind of training. Grace Neutral, whom we photographed in LA (see pages 332–333), is a hand-poke expert and tattoos anything from mandalas to anime characters using nothing but ink and a needle.

Leg sleeve
As the name implies, like a sleeve for your arm ... but on your leg.

Scratcher
Highly disregarded in the industry, a scratcher is someone who sets him- or herself up as a tattoo artist but has had no training and doesn't follow health code regulations, hold a licence or own proper equipment. Often scratchers cause damage to people's skin, tattoo underage clients and charge very low rates.

Unfortunately, anyone can buy tattoo machines online, which is something a lot of professionals in the industry are campaigning against.

Sleeve
A tattoo that covers a person's arm, like the sleeve of a shirt.

Stencil
A tattoo artist creates a stencil of the tattoo design before taking a needle to the skin. The artist draws the stencil with a special ink that transfers to the skin, then goes over it with a needle and tattoo ink.

Tattoo gun
An incorrect and highly disliked term for a tattoo machine. Never, ever say this in front a tattoo artist! Tattoo machines do not kill.

Tattoo machine
An electronic device that puts ink into skin by moving the needle rapidly in and out. Never called a 'gun'.

Tramp stamp
A derogatory term referring to a tattoo on a woman's lower back.

Walk-ins
No appointment necessary! Lots of tattoo shops offer walk-in sessions. So if you fancy acting on the spur of the moment, these are the tattoo shops to visit.

Index of Studios

The tattoo scene is diverse, vibrant, ever-evolving – and well and truly global. Below are some of the studios and artists that have produced the pieces on the people in the preceding pages. Not all of the artists are with studios, not all the studios are still open. Some artists are online, some aren't. Some welcome walk-ins and some only rarely tattoo these days. But whether you use this as a guide to help navigate your own tattoo journey or as a snapshot of the tattoo world at this particular point in history, the list below – stretching from Argentina to New Zealand – celebrates the artistry, skill and creative passion of tattoo artists around the globe.

The entries below are organised by country, city, studio and individual artists – we hope you'll find lots to explore online and on the street as part of your own tattoo journey.

ARGENTINA

Buenos Aires
Nazareno Tubaro Art Studio
Tattoo

AUSTRALIA

Brisbane
Manners Tattoo
 Alison Manners

Melbourne
Chapel Tattoo
 Nick Crampton
Crucible Tattoo Co.
 Adam Traves
Hidden Moon Tattoo
 Christopher Wayne Simpson
Love Tattoo Parlour
 Jessica Swaffen
Man's Ruin Tattoo
 Pete Pav
Third Eye Tattoo
 Oliver Christenson
 Nick Rutherford

Queensland
J Cook Designs Tattoos
 Jeremy Cook

Victoria
Green Lotus Tattoo
 Godfrey Atlantis
Stay Classy
 Adam Clouston

BELGIUM

Liège
Calypso Tattoo
 Daniel DiMattia

Saint-Ghislain
La Main Bleue
 Alexandre Wuillot

CANADA

Montreal
PSC Tattoo
(Tatouage Pointe St Charles)
 Dave Cummings

FRANCE

Cogolin
Guilty Innocent

Hyères
 Mistericol

Lyon
Viva Dolor Tattoo and Ink Gallery
 Topsi Turby

Paris
23Keller
 Eddie Czaicki
Abraxas Tattoo Co.
 Barnaby Williams
Bleu Noir
 Violette Chabanon
 Franck Pellegrino
 Gael
 Jeykill
 Supakitch
 Veenom
Hand In Glove Tattoo Shop
 Cokney
 Hugo Fulop
 Guy le Tatooer

La Maison des Tanneurs
Kurv (Guillaume Kurvi Delafosse)
Matière Noire
Tricky Niko
Mystery Tattoo Club
Easy Sacha
Joey Ortega
Savage Tattoo
Tsul
Tribal Act
Jaxa Tattoo

Toulon
Yosh Spiderdust

GERMANY

Berlin
AKA
Kamil Czapiga
Blut und Eisen
Stefan Halbwachs
Erntezeit Tätowierungen
Thomas Burkhardt
Lowbrow Tattoo Parlour
Annie Frenzel
Loxodrom
Lars Uwe
Taiko Gallery
Guen Douglas
Matthew Gordon
Wendy Pham
Toe Loop Tattoo
Victor Zabuga
Unter der Hand
Maja Earthling

Cologne (Köln)
Elektrotinte
Phil Kaulen

Kassel
Hardcore Ink
Alex Dörfler

ITALY

Bologna
Tattoo Box
Koji Ichimaru

Rome
MalaCalle
Marco Bordi

JAPAN

Tokyo
Three Tides
Horihiro Mitomo

Yokohama
Yellow Blaze
Shige (Shigenori Iwasaki)

NETHERLANDS

Amsterdam
Ben de Boef Tattoos
Haarbarbaar Tattooshop
Jevin de Groot
Hollywood Mark Tattoo
Jorgos Karidas
Nikita Beaux Ink
Nikita (Niki) Verberner
Rob Admiraal
Jan Paul
Salon Serpent
Toby Gawler
Schiffmacher & Veldhoen
Tattooing
Massimo Luciani
Timothy Englisch
Rupa van Teylingen
Henk Schiffmacher
Tycho Veldhoen
Morrison Schiffmacher
Thomas Morgan
Yushi Takei
Tony Salgado
Chris Danley
Sideshow Jen
Tattooshop 't Schoffie
Wes Thomas
Tattoo Studio Friendship
Edu de Leau

The Hague
Sanctus Deus, Syndicat du
Tatouage
Hankey Jee

Heerlen
Bodycorner
Bart van Wageningen

Hoofddorp
Inkredible Tattoos
Sander Bakker

Zwolle
MIA'S Tattoo Vision
Berend-Jan Luft

NEW ZEALAND

Auckland
Ship Shape Tattoo
Matt Jordan
Ten Tigers Tattoo
Richard Warnock Capilli (Capilli Tupou)

POLAND

Warsaw
Theatrum Symbolica Tattoo
David Rudziński

PORTUGAL

Porto
Dragão Tattoo

RUSSIA

Moscow
Negative Karma
Den Yakovlev

SPAIN

Madrid
Robert Hernández

Sang Bleu
Frank Carter
Shall Adore Tattoo

Norwich
Black Dog Tattoos
Jon Longstaff

Nottingham
Epona Art and Tattoo
Theresa Gordon-Wade
Freya Smyth Callard

Portsmouth
Inklination
Chrissy Hills

Sheffield
Tenacious Tattoo
Steph Newton

Southend-on-Sea
Skynyard Tattoo
Philip Yarnell

Truro
Atelier Four
Matt Finch
Radu Rusu

Walton-on-the-Naze
Cherry Blossom Tattoo Studio
Tom Kelly

USA

Austin, TX
Corey James Tattoo
Corey James
Rock of Ages
Steve Byrne

Cincinnati, IL
Crying Heart Tattoo
Dave Halsey

Denver, CO
Sol Tribe Tattoo & Body Piercing
Alice Cardenas

Detroit, MI
Night Gallery
Bob Tyrrell

Grand Rapids, MI
Sovereign Arms
Ryan Stout
Gareth Hawkins
Wealthy St. Tattoo
Johnny Spinoso

Lawrence, KS
Abraxas Tattoo
Carlos Ransom

Los Angeles, CA
American Electric Tattoo
Company
Craig Jackman
California Gold Tattoo
Jeffrey Page
El Clasico Tattoo
Salvador Preciado
Golden Daggers Tattoo
Isabela Verri
Jim Sylvia Tattoo
Jim Sylvia
Lowrider Tattoo
Jose Lopez
The Tattoo Lounge
Jason Stores
Thunderbird Tattoo
Roger Seliner
Unbreakable Tattoo
Sung Song

Mesa, AZ
Urban Art (now closed)
Nicole Marie McCord

Milwaukee, WI
Akira Arts
Jacob James Klapperich
Atomic Tattoo
Ricardo

Montville, NJ
Two Headed Dog Tattoo
Joe Palladino

New York, NY
Allied Tattoo Brooklyn
Joseph Bryce
Bang Bang NYC
Kristi Walls
Black Iris Tattoo
Anka Tompkins
Bound For Glory Tattoo
John Lemon

Flyrite NYC
Mike Lucena
Get Fat Brooklyn
Annie Lloyd
Graceland Brooklyn
(now closed)
Jonah Ellis
Mischief Tattoo
Brandon Swanson
Rising Dragon
Paolino
Saved Tattoos NYC
John Sultana
Tamara Santibanez
Smith Street Tattoo Parlour
Dan Santoro
Steve Boltz

Newport, OR
Sea Serpent Saloon
Dana Melissa Dixon

Orange, CA
Show Pigeon Tattoo
Evie Yapelli

Philadelphia, PA
Seven Swords Tattoo Company
Myke Chambers

Providence, RI
The Torchbearer
Ron H. Wells

San Diego, CA
Chapter One Tattoo
Spencer Harrington

San Rafael, CA
Spider Murphy's Tattoo
Stuart Cripwell

Seattle, WA
Baraka Naga
Jon Osiris
Hidden Hand Tattoo
Jeff Cornell

Wauconda, IL
House of Ink
Alex

Not all tattoo artists are associated with parlours. And many tattoo artists travel and do guest spots in different studios. See below for a list of people mentioned in the preceding pages who you might find on the road, at a convention or – who knows – even in your own hometown.

Marcus Berryman
Kendall Borland
Mister Cartoon
Matty D'Arienzo
Annie Frenzel
Sadee Glover
Matt Houston
Stefanie Hübscher
Saira Hunjan
Sali Ink
KYLAM (Kill Yourself Like A Man)
Andy Madrigal
Nicole Marie McCord
Nipper Tattoo
Ashlea Peach
Lux Phillips
Tomas Reece
Jacob Rolfe
Sans Bavures
Florian Santus
Em Scott
Sick D
Rafael Silveira
Jason Andrew Smith
Gianmavro Spanv
Mia Sublime
Gary Sutton
Ana Tabatadze
Danelle Wulc

Index of Styles

Tattoo artists work in a range of different styles, inspired in some cases by traditional tattoo cultures, and in others by influences as wide-ranging as manga and modern art. Some styles are more established, while others are left open to individual interpretation. Below is a list of the styles on show in the pages you've just perused. Some of these are self-evident, others less so. Some of the people we spoke to reeled off four or five different tattoo styles they'd collected; a lot of people, when asked what style their tattoos were, simply said 'Mine!' So while this list certainly isn't comprehensive, it does help to illustrate the enormously broad pool of ideas and influences at play in the tattoo world today.

Biomechanical (sometimes Biomech)
This artistic movement was popularised by the surrealist painter H.R. Giger in the 1960s, but elements of it can also be seen in the earlier works of Salvador Dalí and Leonardo da Vinci. Typically drawn onto the body freehand (without the use of a stencil), these tattoos are based on the client's own body flow, using mechanical patterns or alien aesthetics. An example of a tattoo in this style could be a piece that makes the flesh look as if it is torn open to reveal a metal skeleton or a machine underneath.

William Yoneyama, Melbourne

Black and Grey
These designs use black ink, watered-down black ink to create grey, and sometimes white ink. The tattoos tend to feature lots of shading, fine lines and spots of white ink for highlights. This technique spans many tattoo styles, including Realism, Watercolour, Geometric, Mandalas and Illustrative.

Jonni Alcantara, Los Angeles
Joshua Atkinson, Kirsty King and Billy Parsons, London
Jamie Brown, Los Angeles
David Cook, Los Angeles
Vüdü Dahl, London
Nais Demaraus and Leusa Forsyth, London
Tazman Ekberg, Melbourne
Clare Goldilox, Brighton
Stitch Obsidian, Melbourne

João Ortiz, Los Angeles
Justin Paraday, Los Angeles
Khan, Paris
Danny Kelly, Melbourne
Nick Rutherford, Melbourne
Hollie Shannon, Brighton
Bianca Staltari, Melbourne
Alexandre Tavukciyan, Paris
Simone Thompson, New York
Ally Toal, Los Angeles
Erika Williams, New York

Black and Grey Penitentiary Fineline
Made famous by Mister Cartoon, who tattoos at Soul Assassins in LA, and inspired by the crude tattoos the inmates of California's prison system give each other behind bars. With no access to coloured inks, prisoners use watered-down black to create shadows and depth. Mister Cartoon's tattoos contain much more detail, and could also be classed as Script or Realism.

Richie Hendo, Amsterdam

Blackwork
These tattoos use only black ink. Often featuring bold, block shapes or fineline minimalistic designs, they can come in lots of different forms – the only common feature is the use of a single colour: black. Blastover tattoos are usually blackwork tattoos, as are 'blacked out' tattoos, when black ink is used to cover the skin – no design, just solid

black – sometimes to cover old tattoos or sometimes just as a statement piece.

Wendel Tjon Ajoin-Meyer, Berlin
Jesler Amarins, Amsterdam
Mark Bannon, Berlin
Alexis Barbuto, London
Sean Bewey, Brighton
Alex Binnie, Brighton
Kendall Borland, New York
Violette Chabanon, Paris
Kristen Chiucarello, New York
Joshua Dean, Melbourne
Quentin Grichois, Paris
Georgie Harrison, Berlin
Dan Hayes, Brighton
Lyo Ishizaka, Melbourne
Marisa Kakoulas, New York
Maria Kociszewska, Amsterdam
Matthew Kozik, Melbourne
Isis Lago, Paris
Georgina Langford-Biss, Brighton
Maisie Manning, Brighton
Julio Cesar Martinez Rojas, Paris
Tessa Metcalfe, Brighton
Grace Neutral, Los Angeles
Jessie Paddick, London
Laura Pardo, Los Angeles
Jonah Rollins, New York
Tinka Samoilova, Berlin
Laurence Sessou, Brighton
Meghan Shadis, New York
Daniel Singh, New York
Theres Smith, Berlin
Steve Taniou, Paris
Alexandra Tomlin, Brighton
Pascal Ummels, Amsterdam
Nina Waldron, Melbourne
Alexo Wandael, Los Angeles

Blackout
Dolly Plunkett, Brighton

Blastover
Blastover tattoos are executed on top of existing ink to create a new, secondary layer of design.

Alex Binnie, Brighton

Dark Trash Realism
Dark and distinctive, this style is characterised by atmospheric horror elements and the macabre. The tattoos of Anrijs Straume, who works at Bold as Brass in Liverpool, are the perfect embodiment of this style; his work often features markings on tattooed characters' foreheads and elements of decay. Examples of pieces by Anrijs include Lana Del Ray and the fictitious Mary Poppins, recreated as horror characters.

Monami Frost, London

Day of the Dead
The Day of the Dead or *Dia de los Muertos* is a Mexican celebration that happens every year from 31 October to 2 November. The celebrations and symbolism used have become common designs in Western culture. Tattoo designs are usually sugar skulls (used to decorate the graves of the deceased during the festivities), which are colourful and whimsical.

Magaña Christian, Paris

Dotwork
Designs that use lots of tiny dots in areas where an artist might normally shade or colour. The tattoos are often geometric and symmetrical. A mandala lends itself to this style but dotwork can be used to create almost any design – animals, flowers, characters, whatever your imagination stretches to!

Valentina Corongiu, Amsterdam
Francis Doody, Brighton
Quentin Grichois, Paris
Marisa Kakoulas, New York
Maria Kociszewska, Amsterdam
Tinka Samoilova, Berlin
Nikita Verberner, Amsterdam

Gay / Queer
Routed in queer politics, this style is definitely on the rise, with tattooers often identifying as being a 'queer tattooer'. Gay and queer tattoos are an exchange between the artist and the wearer – the wearer wants to make a political statement, but so does the artist, so they create a concept together. Empathy is at the heart of queer tattoo philosophies: the wearer is never thought of as a blank canvas, but they become part of a process of communication. Emily Malice, who works at Parliament Tattoo in London, is a great proponent of this approach. She never creates standard tattoo designs but always adds her own twist – her designs often include parted lips and fetish girls.

Rob Aquino, New York
Christopher Hill, New York

Geometric / Mandala / Pattern-work / Sacred Geometry

Delicate, intricate designs that incorporate symmetry, shapes, patterns and repetition. 'Sacred geometry' mimics the shapes found in our natural world and wider universe. Ancient cultures, including Christians, Hindus, Greeks and Egyptians, recognised that certain patterns or geometric shapes are repeated throughout nature – for example, the hexagonal cells of a honeycomb, or the spiral of a snail's shell. Often tattooists who use this style are very strict about their designs, and will only tattoo designs that adhere to sacred symbolism. A mandala is a circular figure representing the universe in Hindu and Buddhist symbolism.

Clare Goldilox, Brighton
Kirsty King, London
Matthew Kozik, Melbourne
Grace Neutral, Los Angeles
Hélaine Sylvain, Paris
Nikita Verberner, Amsterdam

Ignorant

Tattoos in this style intentionally look naïve and DIY. The style emerged from French subway graffiti in the 1990s but is now booming in popularity. FUZI UV TPK, one of the pioneers of the Ignorant Style tattoo, describes the style evolution: 'When I started tattooing, I tried to make tattoos in the same way as I painted graffiti – without rules.'

Isis Lago, Paris
Lux Phillips, New York

Illustrative

This style of tattooing looks like it has been drawn onto the skin with pen, pencil or paints – appearing hand-drawn, rather than hyper-realistic. It can be created in colour or black and grey, and may be based on the work of an artist or illustrator.

Holly Ashby, Brighton
Jamie Brown, Los Angeles
Freya Smyth Callard, London
Vüdü Dahal, London
Francis Doody, Brighton
Nais Demaraus and Leusa Forsyth, London
Lucy Korzeniowska, London
Ivan Kostadinov, New York
Matthew Kozik, Melbourne
Georgina Langford-Biss, Brighton
Claudine Mabalhin, Melbourne
Tessa Metcalfe, Brighton

Rebecca Montalvo, Los Angeles
Remy Nurse, London
Laura Oakes, London
Sarah Otto-Combs, Los Angeles
Laura Shea, Berlin
Britni Sweet, New York
Simone Thompson, New York
Carolin Weinert, Berlin
Erika Williams, New York
Dark Illustrative
Nicola Mary Wyatt, London

Japanese

Japanese tattooing dates back to 5,000 BCE. The tattoos are intricate and designed to cover a whole limb, back or body. Japanese tattooing follows a strict set of rules in terms of imagery and positioning. There is a reason behind every detail in the tattoo, such as the direction an animal/body is facing. Traditional imagery includes cherry blossom, koi fish, lotus flowers, chrysanthemums, peonies, dragons, war dogs and geishas. An expert in this style is Shige at Yellow Blaze in Japan.

Ze Aya, London
Sven Borst, Amsterdam
Tjeerd Braat, Amsterdam
Magaña Christian, Paris
Guen Douglas, Berlin
Charissa Gregson, London
Luke Hallows, London
Virginie Lecesne, Paris
Rogerio Monteiro, Paris
Charlie Paice, Brighton
Flora Amelie Pedersen, Berlin
Rachel Peppiette, London
Wendy Pham, Berlin
Noëlle Schonenberger, Paris
Hélaine Sylvain, Paris
Steve Taniou, Paris
Stuart Thompson, Melbourne

Linework

Seemingly simple, a tattoo consisting purely of linework actually requires a high level of skill. The lines must be executed perfectly, as there is no colour or shading to hide any slips of the needle. Designs can be anything – lines can be curved or straight, and they can include colour as well as the more usual black ink – but to be listed in this category, the tattoo must be created using linework alone.

Sandra Höferer, Berlin

Stitch Obsidian, Melbourne
Theres Smith, Berlin
Vanessa Zolg, Berlin

Marquesan
These are inspired by the tribal tattoos on the Marquesas Islands in the South Pacific. The most common patterns in Marquesan tattoos are abstract geometric (circles, crescents, rectangles) and figurative (animals, plants), tattooed on arms, legs and shoulders.
Bwale Nkowane, Brighton

Mehndi
Mehndi is a form of body art from Ancient India in which decorative designs are created on a person's body using a paste created from the powdered dry leaves of the henna plant. Mehndi tattooing is based upon these designs, but instead uses permanent tattoo ink.
Manni Kalsi, London
Marisol King, New York

Neo-Classical
Inspired by art and literature from the neoclassical period of the mid-18th to mid-19th centuries. Work by art nouveau painter Alphonse Mucha is a very popular tattoo subject, for instance.
Quentin Grichois, Paris

Neo-Gothic
Gothic art is a subset of medieval art that developed in northern France during the 12th century. Tattooists have used the art found in cathedrals, religious symbolism and dark imagery to create Gothic tattoos. Mikael de Poissy's famous stained-glass window tattoos could also be classed as Neo-Gothic.
Judicial Bedabury, Paris
Mikael de Poissy, Paris

Neo-Traditional and Neo-Japanese
The prefix 'Neo' is used to describe a modern take on an older form of tattooing, adding more realistic depth, shading and detail and perhaps using contemporary designs and colour palettes. Neo-Traditional and Neo-Japanese are the most common forms of 'Neo' tattooing. Sometimes referred to as 'Neo-Trad', Neo-Traditional is a modern take on American Traditional,

featuring more realistic depth, shading, colour and detail combined with traditional conventions. Many Neo-Traditional images include portrait-style images of women and anthropomorphised animals – for example, an animal wearing human clothes or smoking a pipe.
Tamara Abou Habib, Paris
Rianna Anoff, London
Mark Bannon, Berlin
Emilie 'Fenrir' Bedart, Paris
Jenna Rose Bennett, Melbourne
Zoe Binnie, Brighton
Stephanie Brook, Melbourne
Jamie Brown, Los Angeles
Alice Carter, Brighton
Elyse Cizek, Los Angeles
Sam Conaglen, Melbourne
Aimée Cornwell, Brighton
Marcy Cruthirds, New York
Joshua Dean, Melbourne
Sabina Dik, Amsterdam
Virginia Elwood, New York
Tashay Gonzalez, New York
Ian Gottschalk, Los Angeles
Hannah Graves, Berlin
Charissa Gregson, London
Quentin Grichois, Paris
Josje van Hagen, Amsterdam
Rose Hardy, New York
Emilie Henaut, Paris
Angelique Houtkamp, Amsterdam
Joe Jones, Melbourne
Boudewijn Jurriaans, Amsterdam
Amelia Kersten, New York
Virginie Lecesne, Paris
Jade Louise, Melbourne
Loena Maas, Amsterdam
Oren Pius, Los Angeles
Bethany Rutter, London
Derryth Ridge, Brighton
Beck Rimmer, Brighton
Macha Romaniuk, Berlin
Jackee Sandelands-Strom, Paris
Leigh Scariano, Los Angeles
Serenity Smith, New York
Alexandra Tomlin, Brighton
Elise Vandertuin, Melbourne
Joëlle 'Space Kitty' Van der Vegte, Amsterdam
Abbie Williams, Brighton
Kat Williams, London
Rosalie Woodward, Brighton
Neo-Japanese
Stephanie Shea, Berlin

New School / Nu Skool

Cartoon-like tattoos that are often influenced by graffiti, caricature and hip-hop art. They may feature bubble-like designs, bright colours and exaggerated dimensions. A notable tattooist in this style is Matt Difa of Jolie Rouge, London.

Willy Bravenec, Los Angeles
Jamie Brown, Los Angeles
Sid Jones, Los Angeles
Francesca Pierdomenico, Amsterdam
Nula Steinfort, Amsterdam
Hélaine Sylvain, Paris
William Yoneyama, Melbourne

Ornamental

Ornamental tattoo design is all about the aesthetic of the end result. This is a decorative design that uses the flow of the wearer's body, rather than focusing on a subject matter. As a result, the same tattoo can never be recreated on another person's body.

Céline Aieta, Paris
Emilie 'Fenrir' Bedart, Paris
Khan, Paris
Marisa Kakoulas, New York
Fareed Kaviani, Melbourne
Grace Neutral, Los Angeles

Portraiture (see also Realism)

A portrait of someone – a family member, a famous person, a friend – truthfully recreated as a tattoo. These can be colour or black and grey. Portraiture tattoos are usually created from a photo – the tattoo artist will need this to create the tattoo. Notable portrait artists are Nikko Hurtado and Benjamin Laukis.

Sid Jones, Los Angeles
Sofia Lejrin, Los Angeles
Rogerio Monteiro, Paris

Realism

This style of tattooing is, as you might expect, intended to look as close to the real-life object as possible. It lacks the bold lines of more traditional tattoos, and uses shading and colour combinations to create a photo-realistic finish. Portraits are a popular subject for realistic tattoos, but the style isn't limited to people – tattoos could just as well show a can of coke, a flower or an animal. Anything goes!

Cristel Ball, Amsterdam
Giverny Deenik, Amsterdam

Lee Dongkyu, Paris
Tazman Ekberg, Melbourne
Sebastian Rosell, Los Angeles
Sian Rusu, London
Marie Jose Sarmiento Espejo, Paris

Scarification

Not strictly tattooing at all. Scarification is an ancient art form, originating from Africa, Australia and Papua New Guinea, where it is linked to tribal culture. It involves cutting a design in the subcutaneous layer of the skin with a scalpel or sharp implement. Other forms of scarification also exist, including branding, where a heated piece of metal is used to press a design into the skin with a single application, and abrasion, where a design is created by abrading the skin with an inkless tattoo machine. Unlike tattoos, scarification is forever – it is irreversible.

Laurence Sessou, Brighton

Script / Lettering

Lettering can be anything from simple letters or words to elaborate, stylised custom pieces that not only spell a word, but also look like works of art. Notable artist Big Sleeps is rightly famous in this style.

Jessica Alviani, London
Cally-Jo, Brighton
Pino Cafaro, Paris
Tazman Ekberg, Melbourne
Khan, Paris
Ivan Kostadinov, New York
Rogerio Monteiro, Paris
Dolly Plunkett, Brighton
Tinka Samoilova, Berlin
Meghan Shadis, New York
Alexo Wandael, Los Angeles

Stick 'n' Poke

Tattoos often done with DIY kits that can be bought online and are largely used without any kind of training. Not to be confused with hand-poked, which are tattoos made without machines. In both instances, the process of getting tattooed is much slower, as the ink is inserted one dot at a time.

Dante Francione, Los Angeles
Rebecca Montalvo, Los Angeles
Eric Montoliv Sanchez, Melbourne

Traditional

Bold, clean black lines with strong, usually primary colours from a minimal palette.

Typical designs include roses, daggers, ships and skulls, but many people are now getting a variety of images tattooed in a traditional style (also known as Neo-Traditional). The medium became fashionable in 1930s America thanks to tattooist Norman 'Sailor Jerry' Collins. Currently, tattooist Paul Dobleman is a master of this style; he works at Spider Murphy's in California. You can see his work on Matt Lodder.

Stefano Abagnave, London
Tamara Abou Habib, Paris
Joshua Atkinson and Billy Parsons, London
Gael Beullier, Paris
Sven Borst, Amsterdam
Tjeerd Braat, Amsterdam
Michelle Carr, Los Angeles
Joe Calixto, Los Angeles
Thomas Charlton, Melbourne
Gerry Clarke, Melbourne
Cris Cleen, New York
Eddy DeMartino, New York
Holly Montana Devine, London
Valentina Fenu, London
Lizzy Guy, London
Ben Haggerly, London
Isa-Yasmijn Hinloopen, Amsterdam
Jondix, London
Rosey Jones, London
Rowan Kennedy, Melbourne
Jeremy Kerhoas, Paris
Isis Lago, Paris
Sofia Lejrin, Los Angeles
Jake Lewis-Hurn, Amsterdam
Paul Lilley, Melbourne
Kelly McCabe, Melbourne
Joseph Merrill, New York
Jimmy Newman, Melbourne
Laura Pardo, Los Angeles
Katie-Rose Petley, Amsterdam
James Redfern, London
Chris Leigh Richards, Brighton
Emiel van Rijn, Amsterdam
Joshua Robinson, New York
Raz Rosa, Melbourne
Danny Roumimpel, Amsterdam
Keely Rutherford, London
Tanja Schulze, Berlin
Dean Smith, London
Nula Steinfort, Amsterdam
Hélaine Sylvain, Paris
Stuart Thompson, Melbourne
Jared Warmington, Berlin
Ashley White, Brighton
Luke Whatt, Melbourne

American Traditional
Isabelle Bernhard, Paris
Dayana Isadora Drillich, Amsterdam
Cellini Kim, New York
Matt Lodder, London
David Meireles, Paris
Sarah Miller, Los Angeles

Trash Polka
A style of tattooing done solely in a black-and-red colour scheme and characterised by collage-like imagery, incorporating scattered moments of realism, lettering, abstract and geometric styles. Some would argue that a tattoo is only in the 'trash polka' style if it is created by Volko Merschky and Simone Pfaff of the Buena Vista Tattoo Club in Germany, as they invented the style.

Bram van Adrichem, Amsterdam

Tribal
Designs influenced by the traditional tattoos of tribes and cultures (Polynesian, Aztec, Maori, Egyptian, etc.). Usually black in colour and often using symmetry and geometric designs, tribal tattoos are a real test of an artist's linework and steady hand.

Gillian Bendanon, Amsterdam (Egyptian)
Sven Borst, Amsterdam (Haida and Polynesian)

Vintage / Antique
A number of tattoos could happily sit in this style, which is inspired by historical periods and artistic movements. These tattoos often include Old World objects such as pocket watches or antique vases, and might, for instance, feature a vintage-style ornate frame. Colours are often muted oranges, reds and golds.

Rebecca Montalvo, Los Angeles
Laura Pardo, Los Angeles

Watercolour
A tattoo in this style looks like it has been done with a brush daubed in watery pastels. New York-based Amanda Wachob is at the forefront of this movement, which is also known as Abstract Expressionist. Her work consists of anything from impressionistic swirls of colour to hyper-realistic renderings of flowers and birds, all executed in a painterly style.

Sian Rusu, London

Social acceptance

Studies show people are totally comfortable seeing tattoos on …

☐ General public
■ Millenials

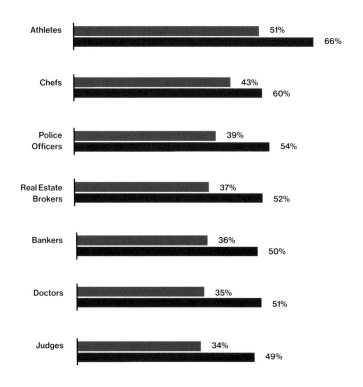

Athletes — 51% / 66%

Chefs — 43% / 60%

Police Officers — 39% / 54%

Real Estate Brokers — 37% / 52%

Bankers — 36% / 50%

Doctors — 35% / 51%

Judges — 34% / 49%

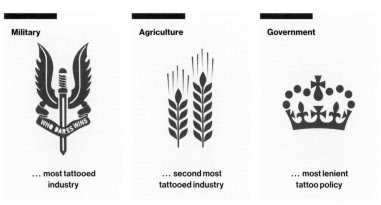

Military

… most tattooed industry

Agriculture

… second most tattooed industry

Government

… most lenient tattoo policy

Working It

No surprise that many of the people profiled here are involved in the tattoo industry – nearly a third of people who supplied their job titles are tattoo artists. But there are some less obvious industries featured too. Below is a selection of the most popular professions among the men and women of the preceding pages.

Top 15 occupations in this book

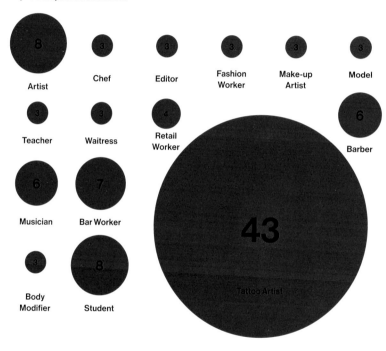

From museum curators to bike messengers, lawyers to dog handlers, architects to a heart surgeon's assistant, the tattooed people in this book represent a fascinating range of industries.

Administrative	4	Food Industry	1	Real Estate	1
Animals	1	Industrial and Engineering	4	Social Work	2
Art and Design	15	Law	1	Beauty and Fashion	2
Business	1	Management	2	Wellbeing	3
Events	2	Marketing	4		
Film and TV	4	Medical	2		

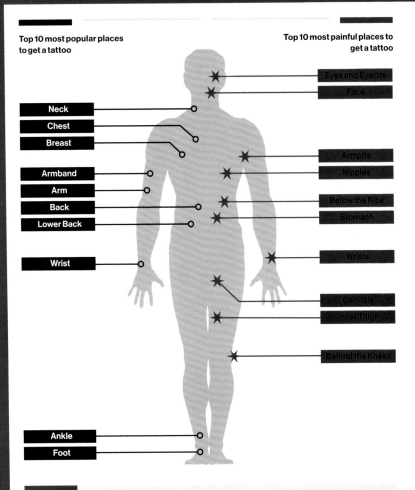

Top 10 most popular places to get a tattoo

- Neck
- Chest
- Breast
- Armband
- Arm
- Back
- Lower Back
- Wrist
- Ankle
- Foot

Top 10 most painful places to get a tattoo

- Eyes and Eyelids
- Face
- Armpits
- Nipples
- Below the Ribs
- Stomach
- Wrists
- Genitals
- Inner Thigh
- Behind the Knees

Men and Women

64%
of women want to date men with tattoos

39%
of men want to date women with tattoos

Women under 35 are almost

50%
more likely to have tattoos than men under 35.

Senior men are

71%
more likely to have tattoos than senior women.

Looking Good

Tattoos can suit anyone and everyone. As you will have seen, people choose tattoos for a huge range of reasons. But surely one of the main reasons that people are willing to put up with the pain of a tattoo is that they look great and can make you feel good. The figures below offer a little insight into the ways men and women view their own tattoos, or tattoos on propective partners.

My tattoos make me feel more . . .

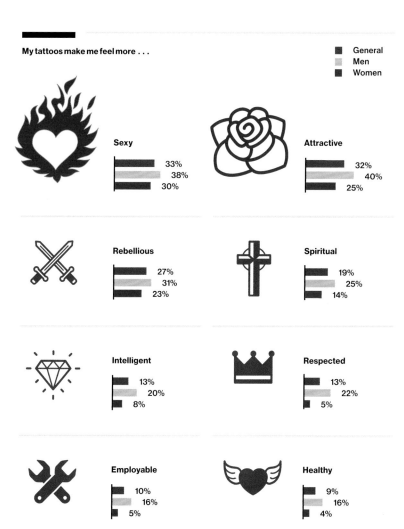

General
Men
Women

Sexy
33%
38%
30%

Attractive
32%
40%
25%

Rebellious
27%
31%
23%

Spiritual
19%
25%
14%

Intelligent
13%
20%
8%

Respected
13%
22%
5%

Employable
10%
16%
5%

Healthy
9%
16%
4%

Russian

Portraits of Stalin or Lenin were thought to provide protection from the firing squad.

The oskal – or 'big grin' snarling tiger or wolf – conveys hostility to authorities.

Thieves' stars convey status. Stars on the knee mean 'I will never kneel to anyone'. Stars on the chest indicate a thief of highest rank.

Each cathedral dome represents a sentence served.

Manacles represent a sentence of more than 5 years.

Polynesian

The enata represents people and relations.

The inverted enata represents defeated enemies.

The turtle symbolises fertility and longevity.

Sharks' teeth convey protection and strength.

The ocean represents death.

Tiki figures are guardians.

Japan

The dragon symbolises wisdom and strength.

The tiger conveys strength and long life.

The koi represents courage and control.

The phoenix represents triumph and rebirth.

The peony symbolises good fortune and prosperity.

What Does It All Mean?

Tattoos have a range of meanings. For many of the people in these pages, their tattoos carry deeply personal significance, whether they act as mementos of their past or markers of progress on their personal journeys. Historically, tattoos from different cultures were assigned specific meanings. Below is a brief introduction to the very wide world of tattoo symbolism – some of which we've captured in the preceding pages, in their classic forms or creatively reinterpreted in a contemporary context.

Naval

A turtle represented crossing the equator.

Sharks represented adversity overcome and embodied qualities of courage and will.

A dragon in this tattoo tradition indicated the bearer had served on a China station.

A swallow showed 5,000 miles sailed and represented the idea of the return.

The iconic anchor was used to mark crossing the Atlantic.

Celtic

The Celtic butterfly represents rebirth and transformation.

The knot is a symbol of unending love.

The bear is a symbol of power.

The eagle symbolises death.

The dog embodies loyalty and good luck.

Never asked a tattooed person…

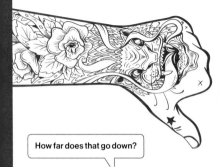

Did it hurt?

Let me think about that. Yes, it did. A needle went in and out of my skin for hours. That definitely hurt.

But you must like the pain?

Nope, I get the tattoo for the end result. Not the pain involved in getting it.

How far does that go down?

Um, that's none of your business actually.

I would never get a tattoo.

Good for you, but I didn't ask you.

Won't you regret that when you're older?

I am old enough to decide that for myself. In fact, I think a person is more likely to regret something they don't do, rather than something they do. I've heard many people say, 'I was thinking about getting tattoo, and wish I had.'

But you're such a pretty girl/boy.

Why thanks. And I still am, actually.

Why did you get that?

Well, for lots of different reasons, actually. None of which I really want to get into while I'm minding my own business walking along the street.

I bet you're well naughty …

I know I am impossibly sexy, but having painted skin doesn't say anything about my other life choices.

Don't you worry about them looking saggy when you're old?

Funnily enough, I don't think I will be worried about that when I am looking badass in my nursing home. I think I'll have bigger issues to worry about. My skin will be saggy anyway; who cares if the ink is saggy too?

Big no-nos:

Do not touch a tattoo.

That tattoo is on someone's skin, on their body. Never touch without permission. Look. But don't stare. It's rude. Very rude.

Dos and Don'ts

Tattoos don't define a person. And while some tattoos definitely make a statement, they aren't necessarily intended to invite comment. Here are a few basic rules for how to treat the tattooed people in your life – or your neighbourhood, or your coffeeshop – with the respect they deserve.

Tattoo laws around the world

Tattoo folk may like to think of themselves as rule-breakers – after all, 25% of people with tattoos say their ink makes them feel more rebellious – but even badasses have to obey the law. And depending on where you are in the world, the law governing tattooing can vary wildly. Below are some of the most unusual tattoo laws around the world.

France: In 2015, rules were changed to allow police officers to have beards and tattoos.

Denmark: It is illegal to tattoo someone's hands, head and neck on Danish soil.

Netherlands: 16-year-olds are free to get tattooed if they have written parental consent, which the tattoo shop must then keep for 10 years.

Finland: To get tattooed under 18, you need a permit.

US: In Georgia, it is unlawful to tattoo within an inch of the eye socket (no permanent eyeliner).

UAE: Tattooing in Dubai is illegal and ink has to be covered in public.

Australia: Members of motorcycle clubs and their associates are banned from operating tattoo parlours.

Iran: Tattooing is legal but challenged by Islamic laws, and people with visible tattoos have been known to be arrested and fined.

Ireland: There is no specific tattoo legislation, but most tattoo shops won't tattoo anyone under the age of 18. Some tattoo shops, though, have been known to tattoo people as young as 14 with parental consent.

Percentage of the population with at least one tattoo

UK	US	France	Germany	Netherlands	Australia
29%	42%	10%	8%	6%	19%

Top 10 most accessible cities to get tattooed

Based on a range of different factors, including the cost of a tattoo and how convenient it is to get one.

1 Cape Town, South Africa
2 Miami Beach, USA
3 Panaji, India
4 Norwich, UK
5 Denpasar, Indonesia

6 Apia, Samoa
7 Marmaris, Turkey
8 Austin, USA
9 Las Vegas, USA
10 Columbo, Sri Lanka

Percentage of tattooed people who have:

51%
Illustration

21%
Symbol

19%
Script

9%
Other

Going Global

While this is by no means a comprehensive survey of the wide world of tattoos, we hope this provides and fun and informative introduction to the art of tattooing around the globe. The tattoo scenes and the broader social attitudes towards tattoos in the six countries we've covered have some similarities – but also some differences, some of which we've highlighted here.

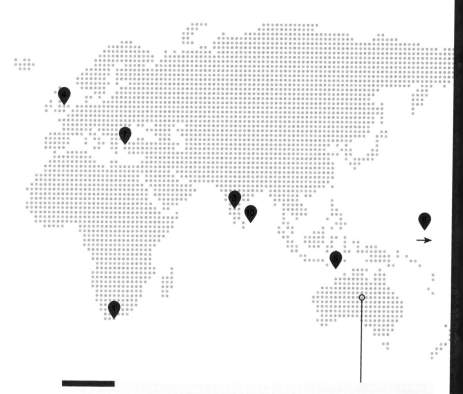

Don't stop at one! Inked Australians have the following number of tattoos.

48% 1 tattoo only

30% 2–3 tattoos

8% 4–5 tattoos

7% 6–9 tattoos

7% 10+ tattoos

Americans likely to have at least one tattoo

33%	35%	25%	43%	21%
Urban	Suburban	Rural	With kids	Without kids

People with tattoos in the US

38%

Under 40

10%

Aged 40–60

Most tattooed cities in the US

1	Miami Beach, FL	6	Austin, TX
2	Las Vegas, NV	7	San Francisco, CA
3	Richmond, VA	8	Honolulu, HI
4	Flint, MI	9	Kansas City, MO
5	Portland, OR	10	Los Angeles, CA

🏠🏠🏠🏠 🏠🏠🏠🏠🏠
🏠🏠🏠🏠 🏠🏠🏠🏠🏠 🏠🏠🏠🏠🏠
🏠🏠🏠🏠 🏠🏠🏠🏠🏠 🏠🏠🏠🏠🏠
🏠🏠🏠🏠 🏠🏠🏠🏠🏠 🏠🏠🏠🏠🏠
🏠🏠🏠🏠 🏠🏠🏠🏠🏠 🏠🏠🏠🏠🏠

approx.
21,000 tattoo parlours in the US
6.5 parlours per 100,000 people

Percentage of Americans likely to have …

■ one tattoo
■ multiple tattoos

Millenials

47%
37%

Gen-Xers

36%
24%

Baby Boomers

13%
6%

Matures

10%
2%

USA vs. UK

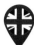

People with tattoos in the UK

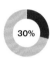

30%

Under 40

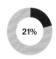

21%

Aged 40–60

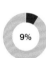

9%

60+

Most tattooed cities in the UK

1	Birmingham	6	Aberdeen
2	Norwich	7	Liverpool
3	Glasgow	8	Cardiff
4	Sheffield	9	Nottingham
5	Bradford	10	Bristol

🏠 🏠 🏠 🏠 🏠 🏠 = 300 tattoo parlours

approx.

1,500 tattoo parlours in the UK

2.3 parlours per 100,000 people

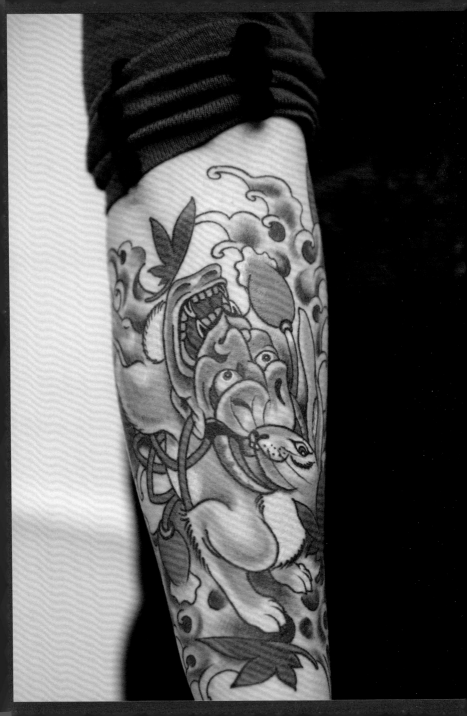

Photography

London & Brighton

Heather Shuker is a London-based award-winning photographer. She launched her career shooting live music events with brands such as Red Stripe and artists including Jamie Cullum. In her ten years as a photographer, she has shot commercial and editorial work for the likes of the *New York Times*, *Vogue*, Virgin Media and *Things & Ink* magazine.

With a passion for the art of photography and a love of design aesthetics, Heather has a unique way of seeing and creates visual interest in her imagery from any location. Working from the studio or the street, she creates distinctive images with beauty and realism.

Heather studied photography at Central Saint Martins in London and was awarded an MA in photography from the University of Brighton. She is one of the founding members of the photography collective MAP6, and her work has been exhibited and published both in the UK and internationally.

heathershuker.co.uk

Paris

Julia Romanovskaya, a self-taught photographer, was born in Ukraine in 1988 and now lives in Paris. Julia started to photograph when she was a teenager and realised at once that her favourite subject is people. Since then, she has worked with *Vogue Paris*, *Vogue Ukraine*, *Elle Ukraine*, *Boys by Girls*, *Indie* magazine, *Le Figaro* and others.

Julia started to explore Paris for a personal project, Friend in City, in 2014 and settled there a few years later. She works mostly in fashion photography and portraits, and always aims to preserve natural and authentic beauty.

In 2016, Julia held her first exhibition of her photos of Paris. The same year she started work on a series about the diversity of beauty, and presented the first part of this in a solo exhibition in Paris. She continues to work on this project.

juliaromanovskaya.com
@ *@j_romart*

Berlin

Lisa Jane is a UK-based award-winning photographer. She has been published internationally and to date has had three solo exhibitions in London. Currently focusing on weddings, Lisa's passion for photography comes from a need to document and tell stories.

Taking inspiration from film, music and the world around her, Lisa aims to capture people's connection to their surroundings, either in a single image or through a collection of images forming a narrative.

lisajane-photography.com
@ *@lisajanephoto*

Amsterdam

Christopher Bradford knew he wanted to be an artist as a child in Gravesend, when he discovered a love of Photon Paint 2.0 on his Commodore Amiga. In the 1990s, at Havering College, he first encountered George Grosz, Toulouse-Lautrec and Ralph Steadman. He developed a love of the smell of ink and how paper feels between his fingers, and realised that typeface is truly lovely if you look at it long enough.

In London around the millennium he worked as a designer at Dynamo Communications, adding bullet points to his CV, including Budweiser, Sainsbury's and Coca-Cola. By 2010, he ran his own creative agency, The New Gentlemen's Club – because, after all, he is a gentleman, and it was new. He is now based in Amsterdam, where he photographs beauty, emotion and atmosphere in the firm belief that life's worth capturing.

shotbythebradford.com
⊙ *@the_bradford*

New York

Brooklyn-based photographer **Elena Mudd** explores the relationship between individual and social identity from a feminist (or humanistic) perspective. The intimate portrait, conceived as a collaborative process with her subject, is her speciality. Her subjects range from family members to strangers she meets on the street. She works with film media, both 35mm and medium format, and with digital.

Her work has been published in print for *A Women's Thing* and online for *Mythos Mag*, *Sticks & Stones Mothership*, *Air Mag* and *B-Authentique*. Clients include Garance Doré, Cup of Jo, Made by Voz and Thomas Sires, amongst others.

Her work has been exhibited in New York City and in a group show, *Eyes That Can See*, at the New City Galerie in Burlington, Vermont.

elenamudd.com
⊙ *@elenamudd*

Los Angeles

French-American and raised in Paris with summers in D.C., **Laura-May Abron** was lucky to spend some of her childhood following her pro photographer father around. Long before the advent of camera phones, she would bring small cameras to school to shoot classmates and eventually started shooting concerts and bands. Her love of music and art drove her towards tattoos and she began shooting for *Rise Tattoo Magazine* in 2012, where she is now a main contributor and helps bring more attention to female artists. Her work has appeared in street-art books, *The London Paper*, *Rolling Stone* magazine and many others. Having studied art and astrophysics, she also dabbles in astrophotography, creates related artworks and enjoys tornado-chasing and shooting storms, along with animals and portraiture. She has lived in Paris, London, Madrid and Los Angeles.

lauramayabron.com
⊙ *@laura_may_abron* and *@laura_may_abracadabra*

Melbourne

Rachael Wright is an award-winning British editorial and commercial photographer based in Los Angeles. Specialising in environmental portraits, music and lifestyle work for clients including *NME*, *Dazed*, ghd and Converse, Rachael uses both digital and film to curate uniquely compelling stories and iconic moments. Her exceptional eye for composition, colour and texture have made Rachael one of the most sought-after photographers on both sides of the Atlantic.

rachaelwright.co.uk
☉ *@rachaeltension*

Greg Holland is a photographer based in Melbourne and raised in the north of England. Working between documentary and fashion, Greg has found that his camera has enabled an intimate view of humans and their expressions of personality. Whether he was playing in punk bands in Burma or tour-managing a Burmese band in the US, his camera always offered Greg a view into strange new worlds and opened doors to new experiences. Shooting predominantly with film to document a more permanent and final image, Greg is currently working on a collection of images for release in book form concerning suburban identities in Australia.

www.gregcholland.com
☉ *@grolland*

Carmen Zammit is a Melbourne-based photographer specialising in food photography, portraiture, lifestyle, travel and design. Her work can be described as minimalist, vibrant and natural. Having worked in London for four years as a studio portrait photographer, Carmen honed her skills photographing people from all walks of life and developed a passion for capturing people's individuality. In her spare time, Carmen takes to the streets of the world, capturing images of local personalities. She also has strong ties to her rural hometown of Broken Hill, New South Wales, and is currently working on a pictorial essay about Outback Australia.

☉ *@carmenzammit*

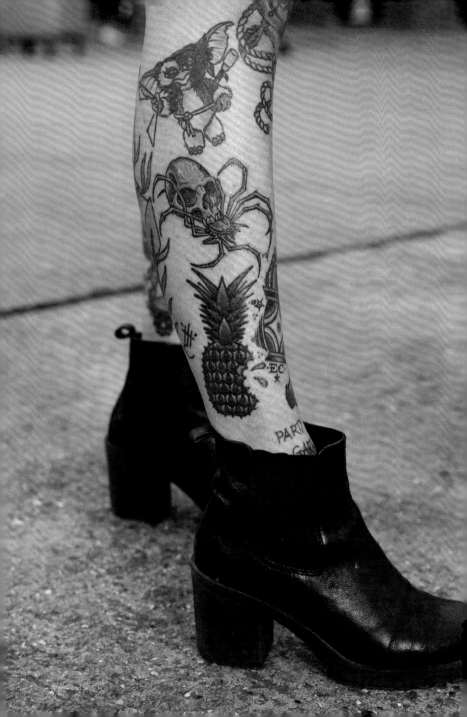

Thanks

Firstly, I would like to thank Elen Jones. Without her, this book would have remained forever a figment of my imagination. When she approached me and asked me to write a 'tattoo non-fiction book', I knew the possibilities were endless. She allowed me the opportunity to hone my idea into the book that exists in the gorgeous printed form that you see before you.

Thanks, too, to Annabel Wright, who has project-managed like a dream, compiling endless lists, schedules, permission forms and reminders. And to Zoë Bather, who has turned the words and pictures into this amazing design.

Of course, massive shout-outs also to the photographers who captured each city in their own unique style. And to the stylishly inked inhabitants of each of the places we visited who let us take their photo and share their story.

I want to say an extra-special thank you to everyone who has ever been involved in the creation of *Things & Ink* over the years. Without Rosalie Woodward, Keely Tarrant and Olivia Snape, the magazine would never have become what it is today. Also, big love to everyone who has ever come to hang out with us in our 'Tattoo Convention Bubble'.

This wouldn't be an acknowledgement without mentioning Mama and Papa Snape, who inspire and support me each and every day. Without their love, throughout my childhood and adult life, I would never have dared to follow my dream of becoming a freelance writer and editor. As they step into retirement after 40 years of running an art gallery – my second home while growing up – I hope they are as proud of me as I am of them and what they have achieved.

Thank you to everyone who has put up with my stresses – because there's always stresses – especially my friend Uzma Arif, who is always ready to listen to my dramas without ever calling me a 'drama queen'. Last, but definitely not least, my husband, who is always supporting me in the background. I love you, James. Without you, writing this book would have been impossible.

10 9 8 7 6 5 4 3 2 1

Ebury Press, an imprint of Ebury Publishing,
20 Vauxhall Bridge Road,
London SW1V 2SA

Ebury Press is part of the Penguin Random
House group of companies whose
addresses can be found at
global.penguinrandomhouse.com

Penguin
Random House
UK

First published by Ebury Press in 2018

www.penguin.co.uk

A CIP catalogue record for this book is
available from the British Library

ISBN 9781785037276

Colour origination by Rhapsody Media
Printed and bound in China by C & C Offset
Printing Co., Ltd

MIX
Paper from
responsible sources
FSC
www.fsc.org
FSC® C018179

Penguin Random House is committed
to a sustainable future for our business,
our readers and our planet. This book
is made from Forest Stewardship
Council® certified paper

Text by Alice Snape © Ebury Press 2018

Design by Zoë Bather
Project management by whitefox
Infographics pp. 462–473 by
White-Card Design Ltd.

Photographs all © 2018
London and Brighton © Heather Shuker
except pp. 30–1, 58–9, 60–1, 94–5, 108–9
and 110–11. Paris © Julia Romanovskaya
except pp. 150–1 and 164–5. Berlin © Lisa
Jane. Amsterdam © Christopher Bradford
except pp. 242–3 © Roald van den Broek.
New York © Elena Mudd. LA © Laura-May
Abron (pp. 326–31, 334–43, 346–9, 354–7,
360–9 and 372–82) and Rachael Wright
(pp. 344–5, 350–3, 358–9 and 370–1).
Melbourne © Greg Holland (pp. 392–417,
424–5, 438–45) and Carmen Zammit
(pp. 386–91, 418–23, 426–37).
Illustrations on. pp. 462–473 © Shutterstock.

Data for infographic spreads on pp. 462-473 from: www.theguardian.com/artanddesign/2010/jul/20/tattoos; www.
theharrispoll.com/health-and-life/Tattoo_Takeover.html; www.totalbeauty.com/content/gallery/most-tattoos/p63192/
page2; www.huffingtonpost.co.uk/2015/10/27/most-tattooed-city-uk_n_8399956.html; www.stapaw.com/tattoos-in-the-
workplace-statistics; www.ncbi.nlm.nih.gov/pubmed/16650594; www.dw.com/en/german-minister-pushes-for-stricter-
rules-in-the-tattoo-industry/a-19365412; www.journals.plos.org/plosone/article?id=10.1371/journal.pone.0024736;
www.myfrenchlife.org/2015/09/03/france-workplace-discrimination-individuality/; www.ifop.com/media/poll/1220-1-
study_file.pdf; www.edp24.co.uk/news/norwich-named-one-of-the-top-10-cities-in-the-world-for-tattoos-1-4802658;
www.renudelaser.com.au/australian-tattoo-statistics/; www.sailorjerry.com/en-gb/tattoos/flash-meanings/; www.
freetattoodesigns.org/celtic-tattoos.html; www.correctionsone.com/prison-gangs/articles/8688136-12-Russian-prison-
tattoos-and-their-meanings/; www.zealandtattoo.co.nz/tattoo-styles/polynesian-tattoo-history-meanings-traditional-
designs/; www.irezumiart.co.uk/irezumi-symbology/; www.tattoodo.com/a/2015/11/10-crazy-tattoo-laws-from-around-
the-world/; www.statista.com/statistics/530572/tattoo-percentages-by-age-uk/